THE
CIVIL WAR
IN PHOTOGRAPHS

THIS IS A SEVENOAKS BOOK

Design copyright © Carlton Books Limited 2002
Text copyright © William C. Davis 2002

This paperback edition reprinted in 2007 by SevenOaks
An imprint of the Carlton Publishing Group
20 Mortimer Street
London
W1T 3JW

A CIP catalogue entry for this book is available from the British
Library.

ISBN 978 1 86200 498 6

Art Editor: Adam Wright
Design: Simon Mercer and Adam Wright
Picture Research: William C. Davis and Joanne King
Production: Lisa French

SEVENOAKS

THE CIVIL WAR
IN PHOTOGRAPHS

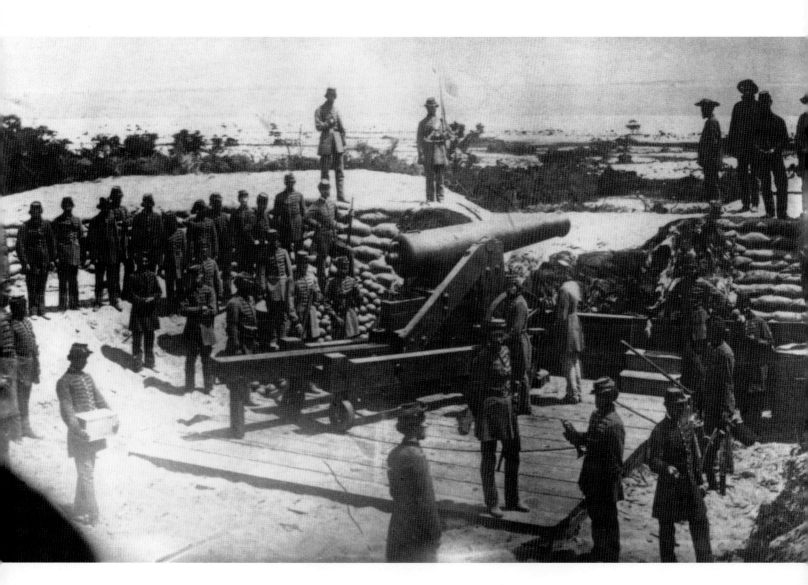

WILLIAM C. DAVIS
VIRGINIA CENTER FOR CIVIL WAR STUDIES

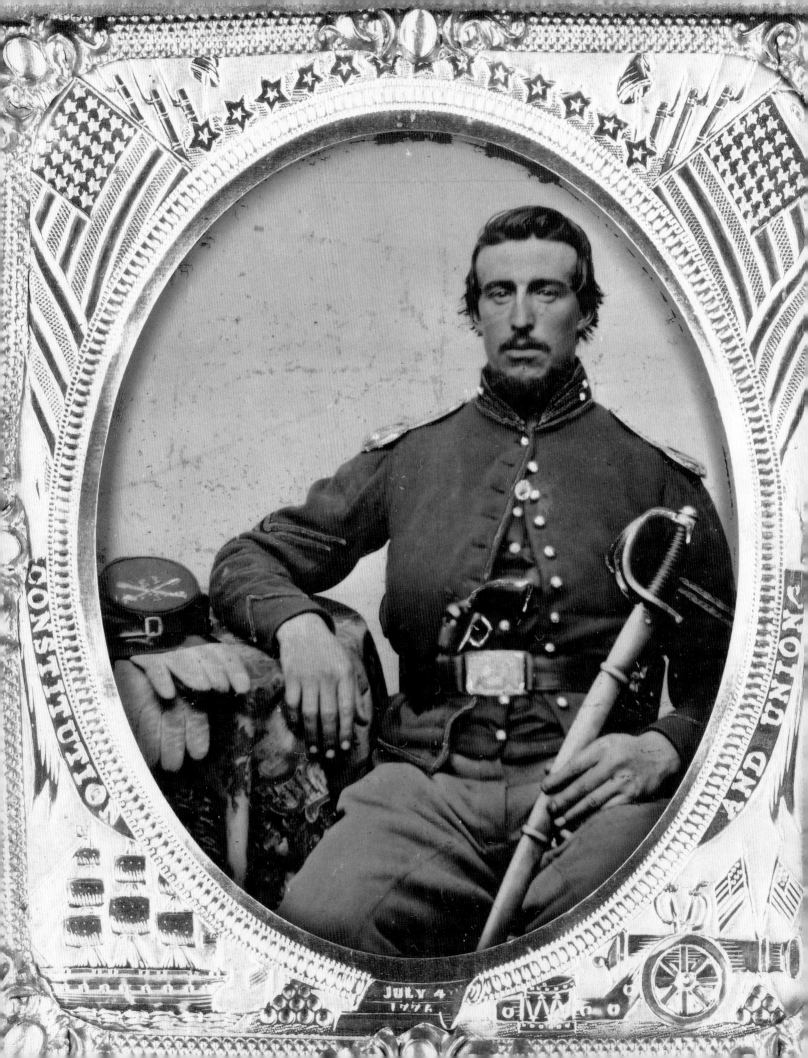

CONTENTS

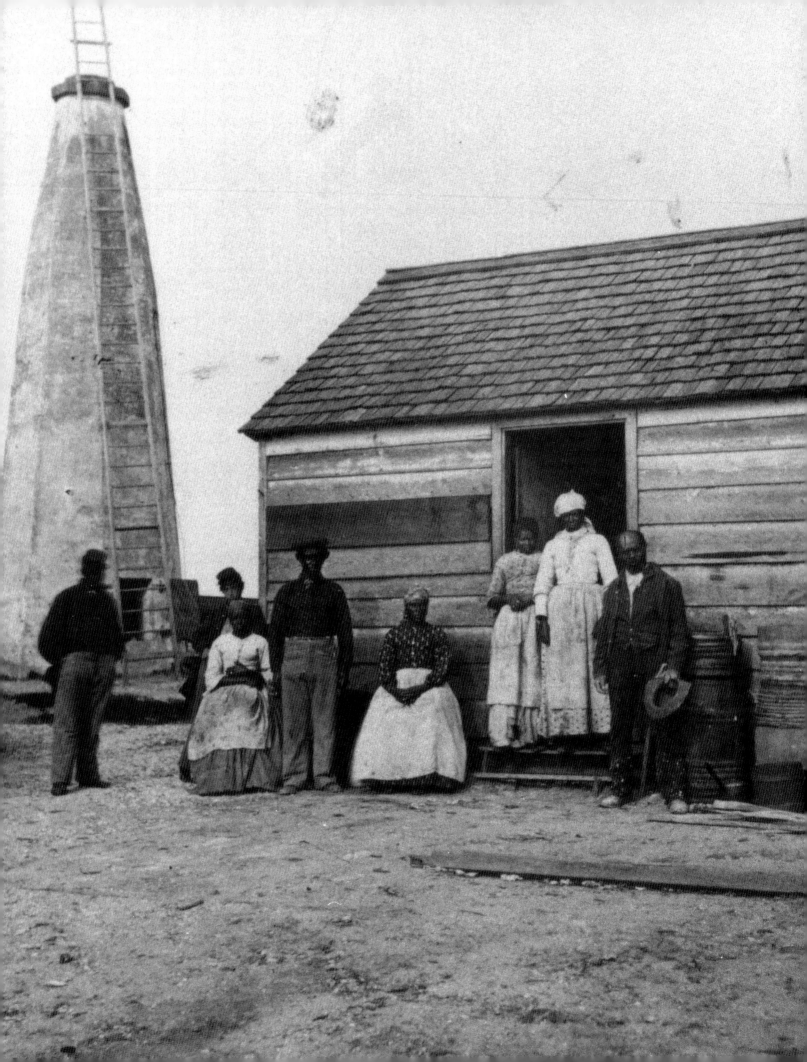

INTRODUCTION

The camera and the American Civil War were made for each other. They came of age together. Indoor photography had been around in several formats since the 1830s, but it was only a decade later that the camera began to be used outdoors, away from the photographer's studio. Even then it was clumsy and difficult. In the war the United States fought with Mexico in 1846–8, the first war photographs were made by an enterprising photographer who produced a couple of dozen daguerreotypes showing United States soldiers in and around Saltillo in 1847. A few years later, during the Crimean War of 1853–6 between Britain and Russia, artist Roger Fenton took his portable darkroom wagon into the Crimea to record dozens of views of British soldiers and battlefields, but still it was difficult, and the coverage very sporadic. All that would change in 1861. For a start, the war was going to be fought on home ground, in a highly settled nation where no army or battlefield was likely to be more than a few miles from some city or community that had at least one photographer. Indeed, as the war commenced there were more than 2,000 professional cameramen—and a few women—plying their trade. At the same time, developments and discoveries had replaced the cumbersome long time exposures required for daguerreotypes with processes like the ambrotype and wet-plate collodion "negative" on glass, that could fix an image in a few seconds. Thus scenes did not have to be posed, but could be more candid, while the materials needed for developing and printing images became much less bulky and complex, so that cameras and darkrooms could travel almost anywhere the armies might go.

And they did. By conservative estimate, at least one million photographs were taken during the four-year Civil War. The overwhelming majority of them were simple portraits of the soldiers themselves, posed in studios at home before they went off to war, or in the makeshift affairs that photographers erected near the camps. Many artists secured permits to follow the armies, and some built their entire business on photographing soldiers, both singly and in shots of whole companies, even regiments. Thanks to the revolutionary introduction of negatives, these photographs could be duplicated endlessly to achieve wide sales and income, and first to last the photographers were professionals capitalizing on a once-in-a-lifetime opportunity.

At least one such photographer would claim that he had a higher goal. "A spirit in my feet said 'go,' and I went," Mathew Brady later claimed. In 1860 he was easily the most famous and prestigious portrait photographer in America,

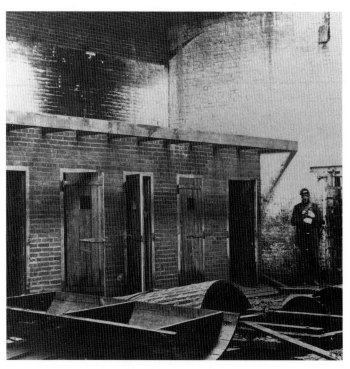

ABOVE Cells in a "slave pen" in Alexandria, Virginia.

though a perennially bad businessman always in debt. He liked to maintain that in 1861 he set out to record for posterity a great historic moment, though there is no question that he also sought immediately to capitalize on the profit potential he perceived in selling mass-produced prints of camp and battlefield scenes to Northern civilians. By this time Brady was so near-sighted that he could scarcely focus a camera, and he probably took few if any of the images himself, though they would all carry the identification "by Brady" or "Brady Studio." In fact, he hired a number of skilled artisans and sent them into the field, chiefly in Virginia. Though Brady's hopes of profits were never realized, his operatives created hundreds of scenes that are irreplaceable records of the war. Indeed, some scenes they literally created, posing soldiers, and even the dead on occasion, for maximum visual effect. They were, in short, inventing photo-journalism.

Some were true artists who chafed at their anonymity working for Brady, and left to cover the war on their own. Men such as Alexander Gardner and Timothy O'Sullivan are among the acknowledged pioneers of photography. Yet there were others who remain unsung, and a host who are all but unknown. Captain A.J. Russell would be the first official United States Army photographer, recording engineering works and railroads for Washington. The team of McPherson and Oliver of Baton Rouge, Louisiana, left behind the best record we have of war scenes on the Mississippi, especially at Baton Rouge, while Andrew Lytle of that same town created an incomparable body of work showing Union warships on the river. Royan Linn set up his darkroom tent atop Lookout Mountain, Tennessee, perhaps the most photogenic spot of the entire war, and became "Linn of Lookout," recording portraits of everyone from common soldiers to ranking generals, with the vast Tennessee River Valley as his backdrop.

The Confederates were pioneers, too. The real "photographer of the Confederacy" was probably Jay D. Edwards, a

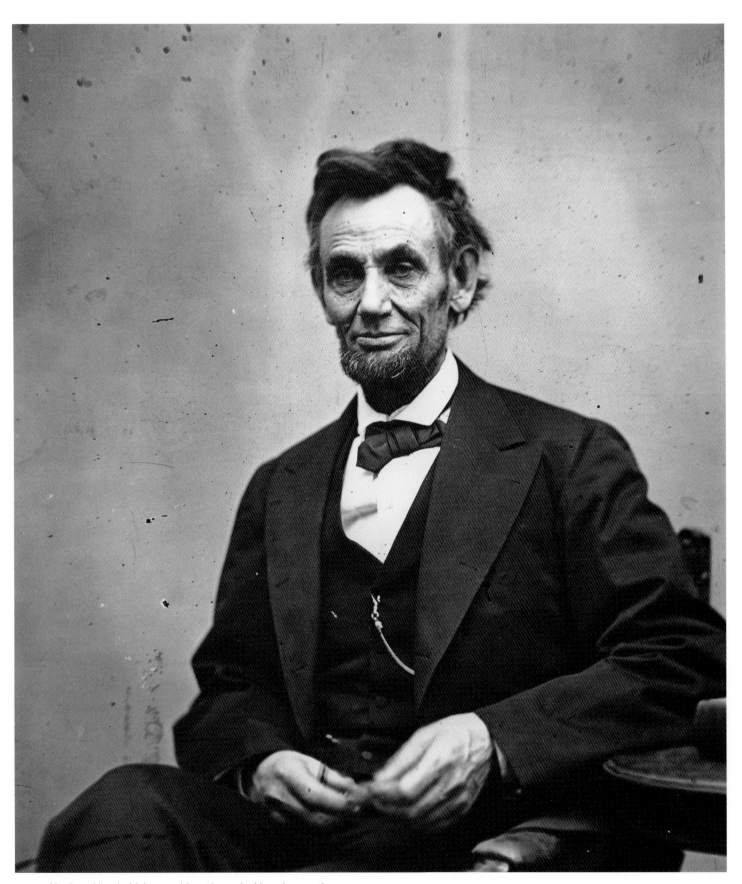

ABOVE Abraham Lincoln, Union president charged with saving a nation.

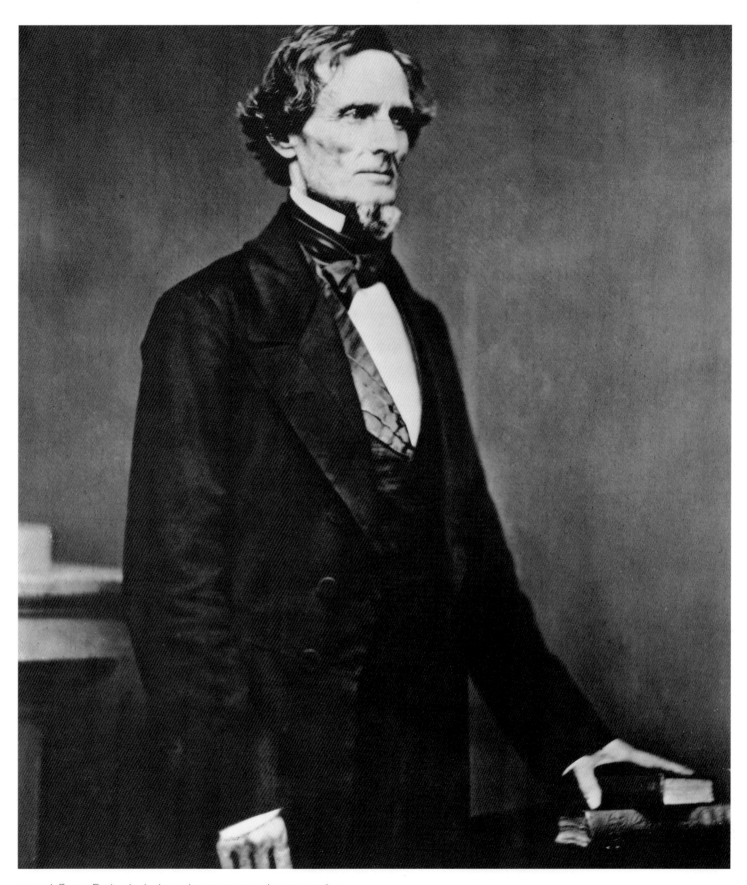

ABOVE Jefferson Davis, who had somehow to try to make a new nation.

Yankee moved to New Orleans, who in early 1861 went to Pensacola, Florida, and took more than 60 images of rustic Confederate volunteers and their batteries and fortifications. His is the best record of the Confederate soldier in the field that we have. The team of Osborn and Durbec of Charleston used their own portable darkroom to go inside all of the forts and works surrounding Fort Sumter, in Charleston, in the days immediately after its bombardment and surrender in April 1861, to leave the most complete record we have of a single engagement of the war. The scarcity created by the Union blockade and the incursions of Union armies soon made photography increasingly difficult in the South. Photographers quickly abandoned outdoor scenes to use their precious chemicals and materials making just the portraits that provided their real support, but now and then an artist such as George S. Cook of Charleston and Richmond ventured out to catch some scene for posterity.

Taken altogether, the record left behind by those intrepid artists is unequaled in the nineteenth century, and only exceeded in the twentieth by the advent of the newsreel camera. Everywhere they could go, they went. Everything they could photograph, they did. As a result, the Civil War is the most fully recorded human experience in history up to its time, a record that allows us today to understand at least a little of what the men and women of the 1860s experienced in their trial by fire.

ABOVE Hurricane Plantation in Mississippi.

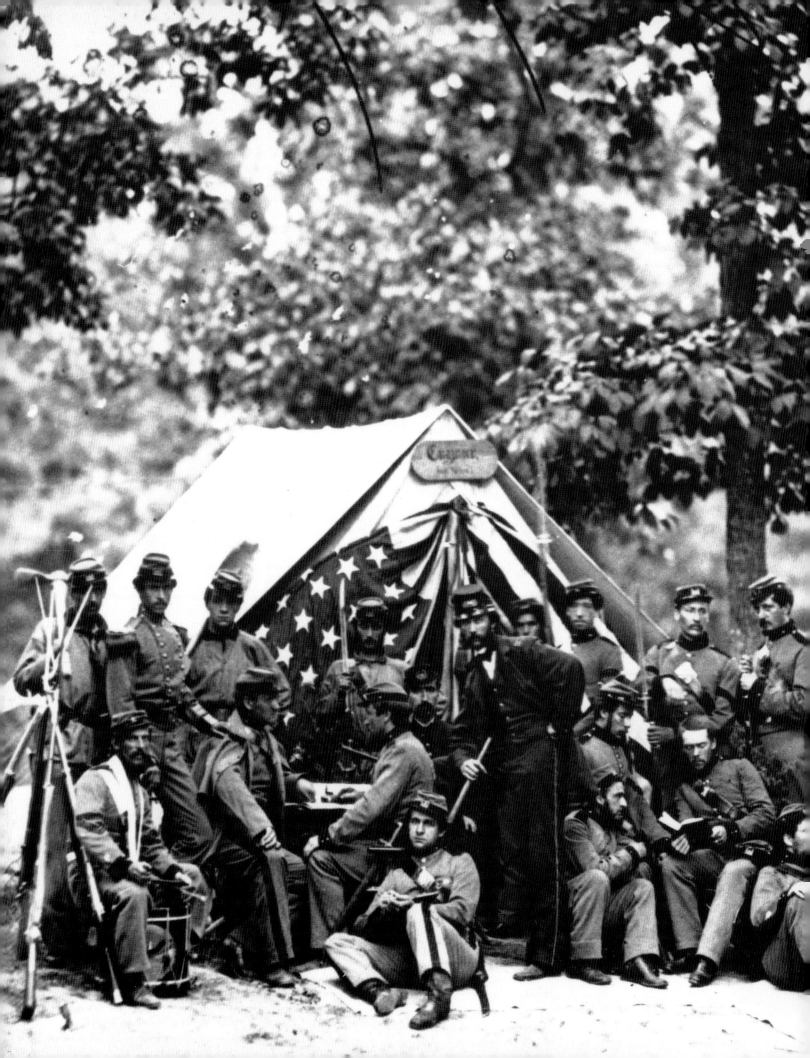

1861

AMERICA
GOES TO WAR
WITH ITSELF

During four years a nation barely out of its adolescence would ravage its landscape and its young manhood, leaving nearly three-quarters of a million dead and hundreds of thousands maimed, more killed than in all of its other wars combined. It was a devastation from which that nation is still recovering today.

Regional differences of geography, economy, and most of all labor, and their impact on national power, propelled the now disunited states toward dissolution. They found themselves pitted against one another time after time over national expansion, trade and import duties, foreign wars and territorial acquisition, and more, especially after 1820, and always in the end the defining issue was slavery—where it should exist, where it might spread. If what started as an even balance of free and slave states was altered by containing slavery's extension, then the South—which had dominated American politics under four Virginian presidents by 1820—would eventually be doomed to minority status in Congress.

BY 1860 THE ARGUMENT over the extension of slavery trumped every other dispute. A new political party, the Republicans, appeared, opposed to slavery or its spread, and after 30 years of failed compromises, neither North nor South felt in the mood for any more. When the Republicans nominated Abraham Lincoln on a platform opposing creation of future slave states, Southern extremists called it a declaration of war, even though Lincoln promised that he could not and would not interfere with slavery where it already existed. The Democratic Party itself then split in two over differences on expansion, thus dividing the Democratic vote in November and ensuring Lincoln's victory.

That finally propelled Southerners across the line. South Carolina voted to secede. Other states quickly followed, and in February 1861 their delegates to a convention in Montgomery, Alabama, adopted a constitution for the new Confederate States of America, elected Jefferson Davis of Mississippi its president, created a government, and began to prepare for war. Thousands of volunteers flocked to new regiments. As each of the states seceded—by April 1861 seven had gone out: South Carolina, Mississippi, Florida, Louisiana, Alabama, Georgia, and Texas—militia or mobs seized Federal buildings, including forts. Only two tiny garrisons refused to yield, Fort Pickens near Pensacola, and Fort Sumter in South Carolina's Charleston harbor.

Lincoln made it clear that any Federal property seized by the "rebels" must be retaken, but when he took office the United States Army had barely 13,000 men in uniform, and he did nothing immediately to build his military, knowing it would be provocative. Still, he was not about to hand over the two forts. The resultant impasse continued for weeks. As negotiations for a settlement stalled and failed, the Confederate buildup at both places continued. Soon it was simply a matter of how long Confederate patience would last, and on April 11, knowing that Lincoln had dispatched a fleet with fresh supplies that might enable the garrison to hold out much longer, Davis at last sent an order to demand surrender of Fort Sumter or else Charleston's batteries would open fire.

The commander there was Brigadier General P.G.T. Beauregard, who had been a good friend of the fort's commander, Major Robert Anderson. Just after midnight on April 12, 1861, Beauregard sent his last message to Anderson, informing him that he would open fire within a few hours. At 4:30 that morning Lieutenant Henry S. Farley fired a signal shell into the air from a battery at Fort Johnson. It burst above Fort Sumter in what some later recalled as the shape of a fiery

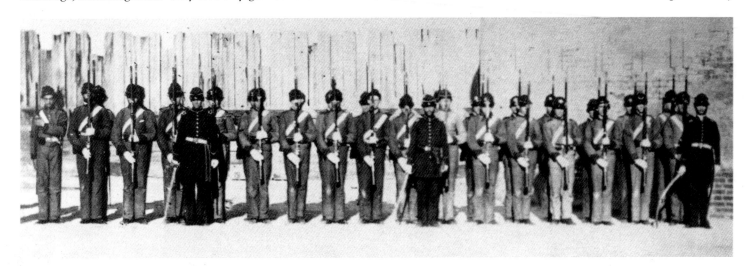

ABOVE Young "Southrons" ready and anxious to go to war, with barely a glimmer of real expectation of the holocaust that lay ahead of them.

palmetto, the symbol of South Carolina, and immediately the batteries opened fire. The Civil War was begun.

The ensuing bombardment lasted 33 hours. Anderson had a mere 85 men and officers, and only a handful of serviceable cannon, while 4,000 Confederates and at least 70 cannon surrounded him. At first he did not return fire, and Southerners ashore were afraid they would get their victory too easily. Finally, shortly after dawn, a Yankee gun boomed back, and the Confederates were elated. Indeed, thereafter, whenever Fort Sumter fired, men in the shore batteries cheered their plucky foe's resistance.

The firing ceased that evening, to resume the next day. Soon the shelling set fire to the wooden structures inside the fort's masonry walls, and the barrage from the Confederates became so heavy that Anderson would not allow his men to expose themselves to reply. Just after noon a lucky shot cut down the fort's flag, which mistakenly led some ashore to think that Anderson was surrendering, and a rowboat went out to the fort under a flag of truce. Convinced that there was nothing more for him to do, he agreed to surrender the fort the following day. On April 14, with not a man injured in the bombardment, Anderson's garrison began firing a 100-gun salute to their flag. At the fiftieth discharge, a cannon went off prematurely and killed poor Daniel Hough and mortally wounded another of its gunners, the first men to die in the Civil War. Anderson's soldiers halted the salute there, marched out with their arms and their colors, and boarded ships to go home. The New York newspaperman Horace Greeley called it the almost bloodless beginning to the bloodiest war in American history.

There would be blood enough, however, and soon. Tens of thousands of euphoric Southern men rushed to enlist, flush with the thrill of victory, and yet fearing that the war was already over and the Yankees would not fight. In Washington, Lincoln issued a call for 75,000 volunteers to put down the "rebellion." That made it clear that he would fight. Faced with the prospect of invasion, wavering Virginia finally

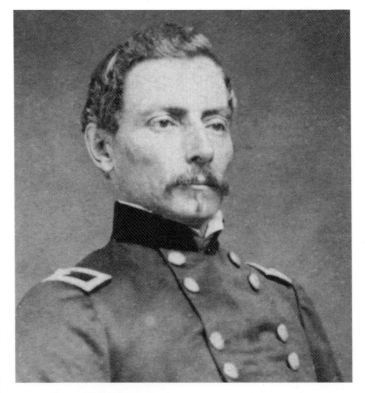

ABOVE General P. G. T. Beauregard

seceded, and soon afterward came North Carolina, Arkansas, and Tennessee. Realizing that Virginia, just across the Potomac River from Washington, would be the first state that Union armies would have to march into, the Confederates moved their capital to Richmond, both to be closer to the scene of action and to reassure Virginians. By so doing, however, they also immediately made Richmond itself the primary Union target, for military thinking at the time was still mired in the concept that taking an enemy capital city was the key to victory. And so in the North a new cry was heard: "On to Richmond!"

The armies that were forming in the North and South were remarkably similar. The average soldier in each was 18 years old, either a farmer's son or else a clerk, capable of at least some rudimentary reading and writing, and fiercely patriotic. These young men enlisted for the same reasons—youthful enthusiasm, the desire for adventure, thirst for glory,

and even a hope of impressing local girls. Yet they also had some more profound motivations. Overwhelmingly, they were not motivated by slavery itself. Most Northern boys did not care enough about the issue to risk their lives, and most Southerners were not, in fact, slaveholders, though they had a strong stake in a society and economy in which slavery was interwoven into their lives. But the dominating motive for Confederate volunteers was defense of their homeland, and for their Northern counterparts defense of the Union. Otherwise, they ate the same foods, read the same books, sang the same songs, and worshipped the same deity. The blood of all was red.

Unfortunately, military technology had just reached the point to make maximum bloodshed a practical reality. Previous wars had been fought with weak and inaccurate smoothbore muzzle-loading muskets. But now the rifle was ubiquitous, its grooved bore imparting greater accuracy and range, while the standard caliber of .58—some went as high as .69 and even .75—meant an enormous lead bullet, powered by a fat charge of black powder, could do incredible damage. A well-trained soldier could fire three times a minute, and already inventors were at work on breech-loading and rapid-fire weapons. Infantrymen still carried bayonets and officers still wielded swords, but the killing in this war would be done by bullets on the battlefield, and by disease in the camps, where hundreds of thousands of raw men and boys would be exposed to every germ imaginable.

Lincoln built his first army in and around Washington preparatory to the march on Richmond. In its way was an army hastily assembled under Beauregard. Meanwhile another smaller Union army was to move into the Shenandoah Valley to the west and occupy a small Confederate force organizing there under General Joseph E. Johnston and prevent him from coming to Beauregard's aid. Lincoln gave command to Brigadier General Irvin McDowell, and by late June McDowell had more than 37,000 men at hand, though poorly trained and equipped. Still, the political pressure on him to advance was enormous, and on July 16 he marched toward Manassas Junction, the only railroad link connecting Beauregard and Johnston. If he took it, he would cut off any aid from Johnston,

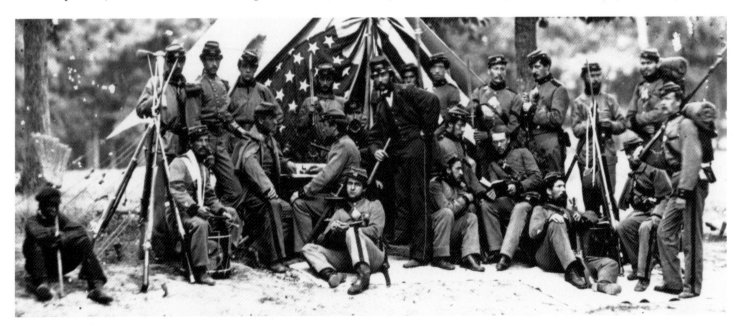

ABOVE Northern boys, too, anxiously volunteered to go to war, dressed more for a parade than for the bloody battles ahead of them.

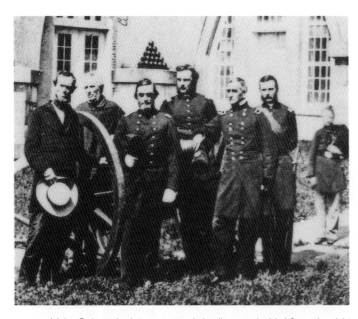

ABOVE Major Robert Anderson, now a brigadier, stands third from the right.

and then he would try to get between Beauregard and Richmond and cut that general off from his railroad supply line. The Confederates would be forced to retreat and McDowell would have a clear road to Richmond and victory.

Johnston easily evaded the force sent to keep him occupied, and even as McDowell started his march, Johnston was beginning to send his own army east on the Manassas Gap Railroad to reinforce Beauregard. Finally, on the morning of July 21, McDowell launched his attack. He formulated a good plan, intending to make a feint at a stone bridge across Bull Run in the center of the enemy line, while sending two divisions around the Confederate western flank to take the enemy left and rear by surprise, cut them off from the railroad, and thus open the way to Richmond. Unfortunately, he would not know until too late that Johnston and his army had arrived. Now combined Confederate forces totaled about 35,000, depriving McDowell of his numerical superiority.

It went well for McDowell at first. By 6 a.m. his diversion was in place and opening fire on the bridge. But then it took his flanking column three precious hours to get in position west of the Confederate left flank to begin its attack. When they did advance at last, they moved south along the lower bank of Bull Run and encountered a half-brigade posted on a hill protecting the road to the bridge. It was Colonel Nathan Evans, who almost single-handedly held them up for hours while Johnston and Beauregard rushed reinforcements two miles to the scene. Finally General Barnard E. Bee's brigade approached, with Colonel Francis Bartow's just behind, and a futile Confederate assault tried to halt the Yankee advance. Themselves forced to fall back, the Confederates retreated toward Henry Hill, overlooking the road.

Just then the Virginia brigade of Brigadier General Thomas J. Jackson arrived to bolster the line. Bee, seeing the reinforcement, tried to rally his men by pointing to their support on the hillcrest and crying: "There is Jackson standing like a stone wall." Within days Jackson would be "Stonewall" Jackson to the ages. He held his position in the face of assault after assault, and by early afternoon Johnston and Beauregard had enough reinforcements on the scene to stabilize their line. Confusion and the timely arrival of Confederate cavalry under Colonel James E.B. "Jeb" Stuart and another infantry brigade from the Shenandoah fresh off the train, finally struck McDowell's own battered right flank and rear and set the Yankees to rout. By 4 p.m. the Union army was streaming back toward Washington in flight and Virginia and Richmond were for the moment safe.

Some believed the war was over. Lincoln would not fight again. Both sides combined had suffered 850 men killed and another 2,700 wounded, and in a day the nature of the war had changed from the chivalry and pomp of Anderson's surrender to the carnage that made Bull Run flow red with blood. An American army was now a mighty weapon of unsuspected power, and perilously unwieldy to handle. If these new leaders and generals were to succeed, they must divest themselves of old notions of warfare, and learn to master that power and to use the weapon their democracy and technology had given them.

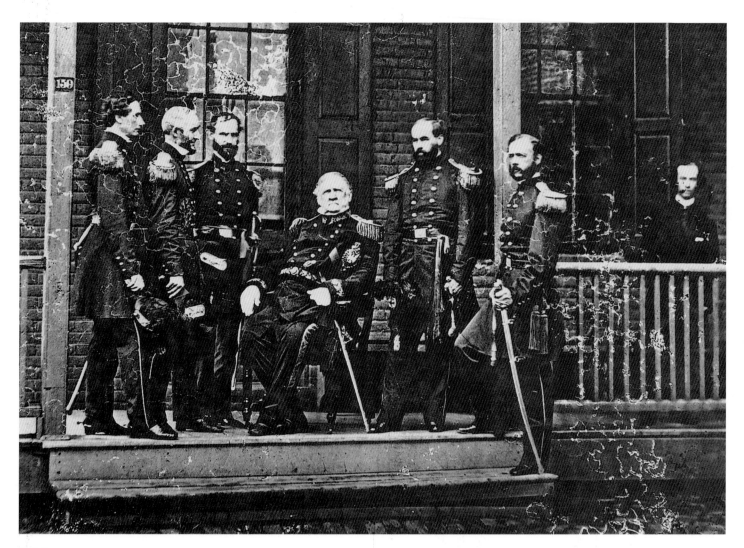

ABOVE

Seated here, the commanding general of the
United States Army in 1861 was Lieutenant
General Winfield Scott, hero of two previous
wars. He was now almost 75, covered with
honors, and too fat even to mount a horse.
But his was the brain that would plan the
strategy to end the rebellion.

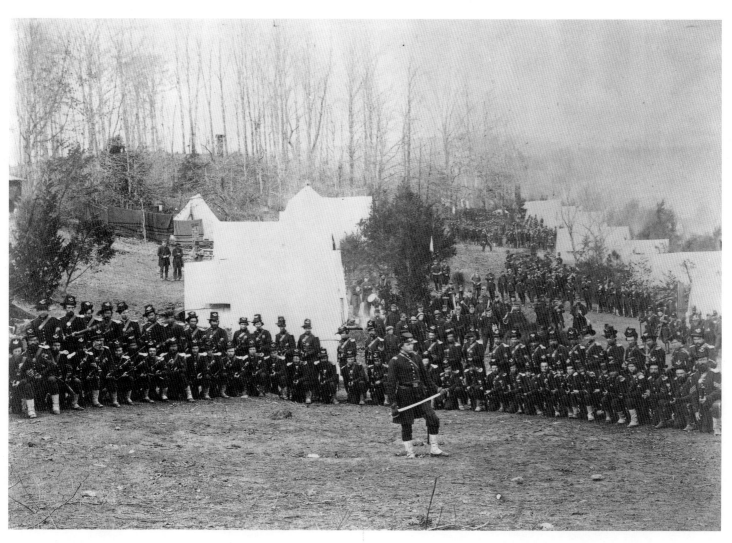

ABOVE

Company H of the 36th Pennsylvania Infantry, one of the first units to volunteer, poses here in 1861 in all its finery, the men in their high-crowned Hardee or "Jeff Davis" hats, and their proud captain before them, saber in hand. The hats and leggings, and even the tents, would soon wear out once the real war began.

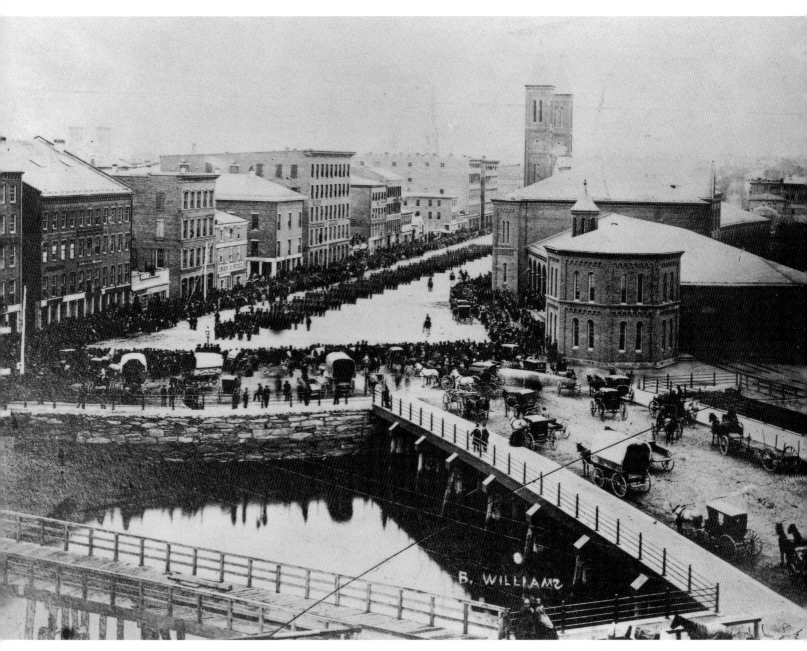

ABOVE

A typical street scene in Northern and Southern cities alike as America went to war, here the 1st Rhode Island Infantry parades through Providence on its way to the train to take it to Washington and the front in April 1861. A throng of citizens on foot and in carriages gather to send the "boys" off with cheers and tears.

RIGHT
RIGHT

When finally the guns opened fire, this is what they did to the land face of Fort Sumter in Charleston Harbor. Taken within a few days of the fort's surrender, this image shows workmen already engaged in cleaning up the rubble and preparing the fort to become a Confederate bastion that would hold out for almost four years.

BELOW

Before they went to war, many a Rebel and Yankee sat for their photographs, like these three young Georgians in 1861, now heavily attired as members of the new 3rd Georgia Infantry. A year from now they would be lucky to have regulation greatcoats, let along scarves. Even now, their hats are a hodge-podge.

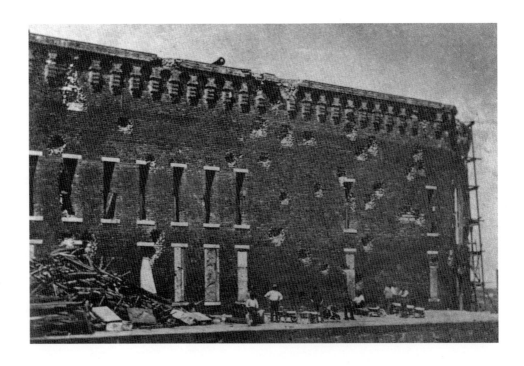

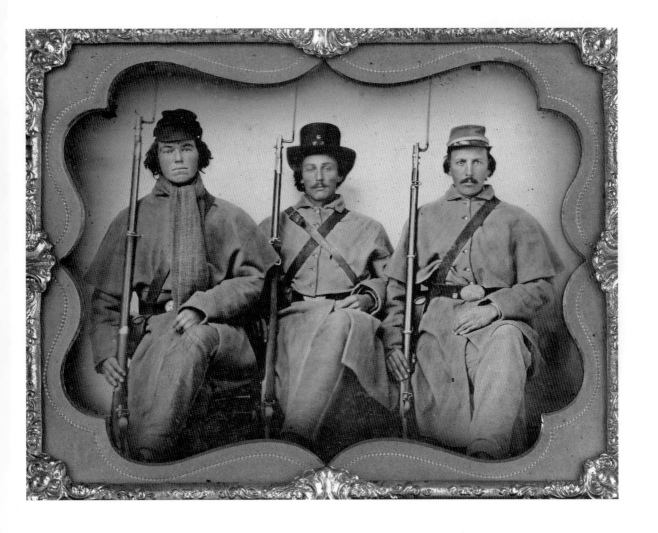

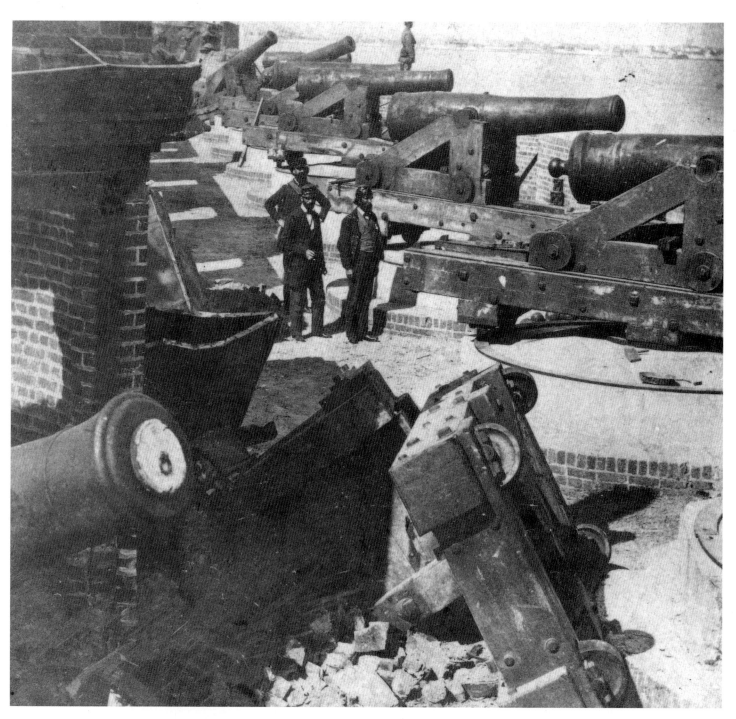

ABOVE
The parapet of Fort Sumter shows some of the
damage done by the Confederate shelling, including
one cannon knocked off its carriage and the carriage
upturned, probably by fire from the so-called Iron Clad
Battery. The Confederate officers inspecting the
damage are wearing blue uniforms rather than gray.

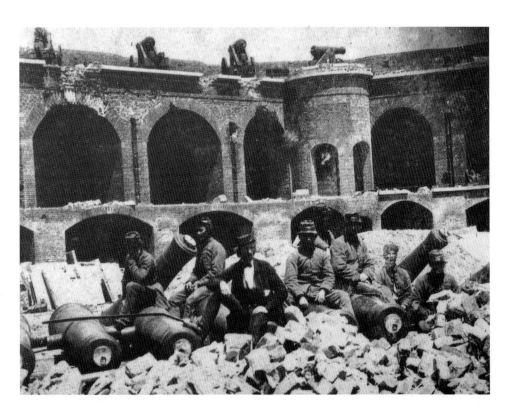

LEFT
The pile of brick rubble in the parade ground inside the fort framed Confederates gaily posing atop some of the captured cannon. The guns angling upward sharply were actually partially buried by the defenders in order to gain elevation sufficient to fire back at the land batteries bombarding them.

BELOW
On April 15, 1861, just the day after the fort's surrender, visitors from Charleston pose on the eastern parapet that faced the city. The figure wearing the top hat is Major Nathan G. Evans, as yet without a uniform. Three months later, he will be one of the Confederate heroes of the first real battle of the war at Bull Run.

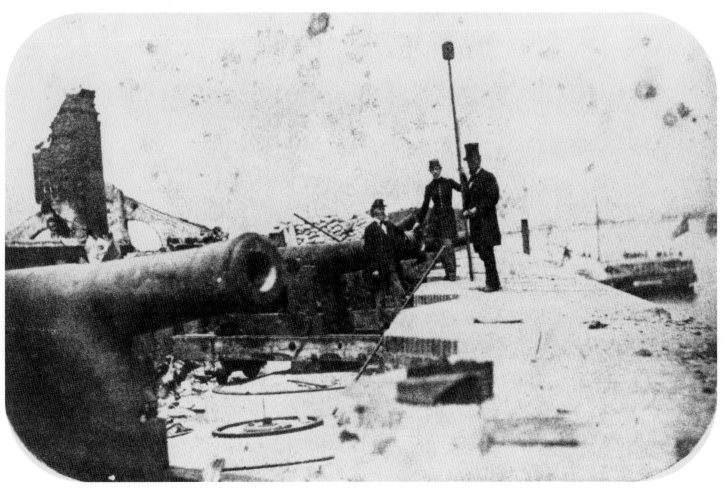

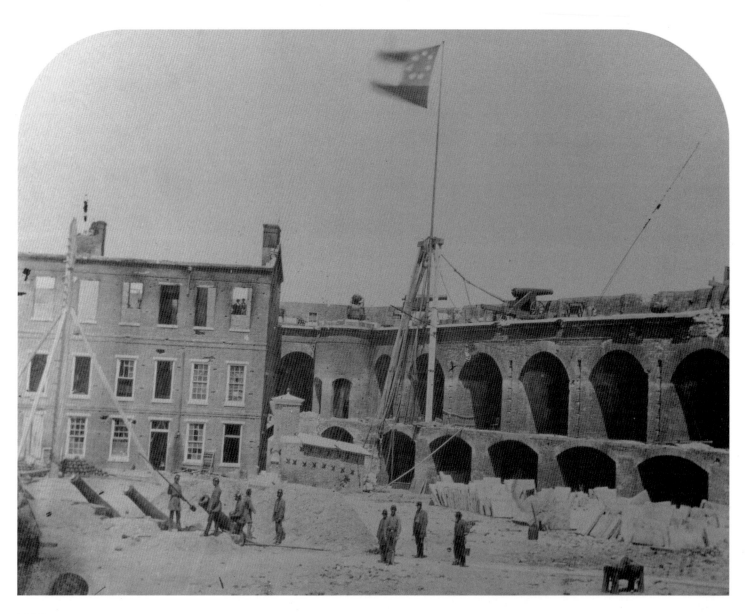

ABOVE
Among the finest of all Confederate
photographs, this one, taken on April 15, 1861,
not only has a better view of Fort Sumter's
interior, with the shot furnace in the background
for heating cannon balls red hot before firing, but
also the makeshift flag pole flies the earliest-
known image of the new Confederate banner.

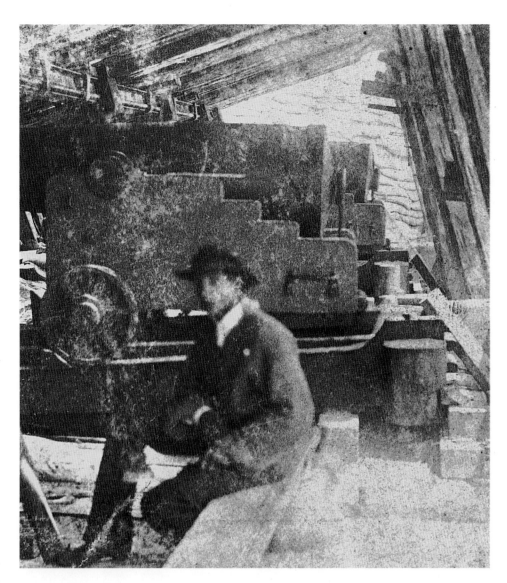

LEFT
On April 17, 1861, Charleston photographers Osborn and Durbec captured this remarkable image of a soldier posing beside one of the massive guns in the Iron Clad Battery. The railroad iron used in the construction is clearly visible overhead. It was from this battery, perhaps this very gun, that one of the first shots of the war was fired.

RIGHT
Osborn and Durbec's view of the Iron Clad Battery, seen from the rear, shows the heavy beams and timbers used in its construction, though already the railroad iron used as its outer armor has been removed, destined, like so much precious iron in the Confederacy, for other needs on other fields.

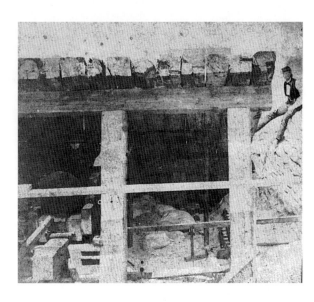

Behind the outer walls of Castle Pinckney, inside Charleston Harbor, victorious Confederates lounge quietly after their victory. Already their fort was being converted into a temporary prison to house Yankees captured on other battlefields, neither side thinking far enough ahead to anticipate the need for real prison camps.

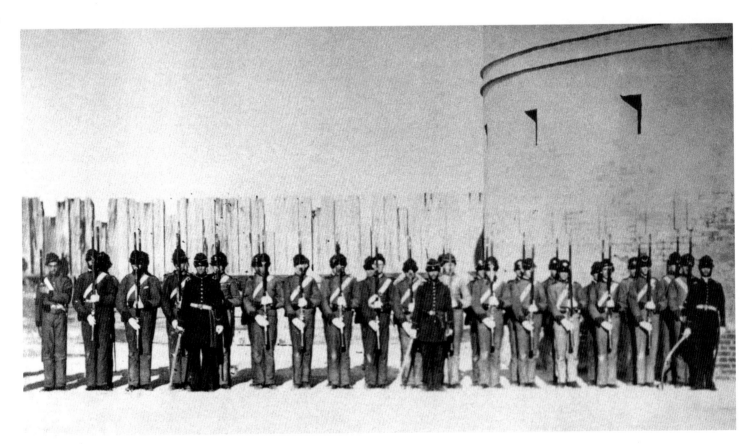

Early in 1861, the Charleston Zouave Cadets, the men in gray and the officers in blue, pose on the parapet inside Castle Pinckney. They stand, like their counterparts at Pensacola, awaiting an action they desperately hope will come before the war, barely started, should come to an end.

The victor of Fort Sumter, newly commissioned Brigadier General Pierre Gustave Toutant Beauregard, taken in Charleston within weeks of the bombardment. He uses dyes to hide his graying hair, and will spend more time posing for the camera than any other Confederate general, but he will be an influential force throughout the war.

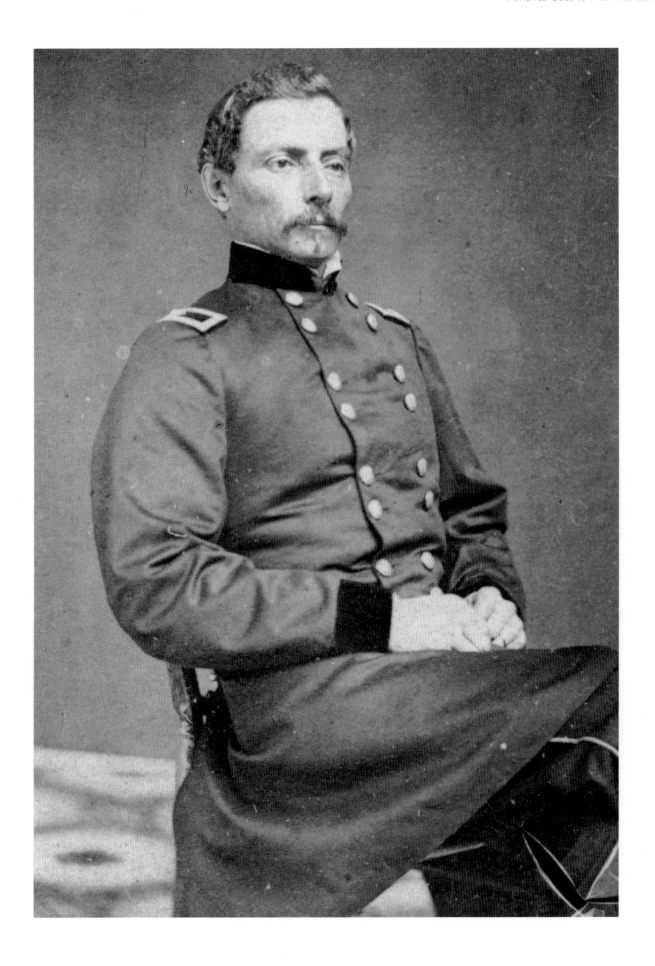

RIGHT
In April 1861, after the euphoria of Fort Sumter, New Orleans photographer Jay D. Edwards went to Pensacola, Florida, and climbed the lighthouse to capture this view of Alabama soldiers in camp behind their four-gun sand battery, its cannon trained on Fort Pickens, the next anticipated target.

LEFT
Even in this distant image, the variety of dress in this new Confederate regiment, the 1st Alabama, is evident in late April 1861. Camped behind Fort Barrancas, whose masonry parapet is just visible in the foreground, the Alabamians are living in tents and "shebangs," shelters made of boards and branches to afford protection from the sun.

LEFT
In the distance stands Fort Pickens, the object of the Confederate buildup at Pensacola. Its commander, like Anderson at Fort Sumter, resolutely refused to leave his post, and since they could be resupplied by sea, this Yankee garrison would be able to hold out until war's end, a constant embarrassment to the Rebels.

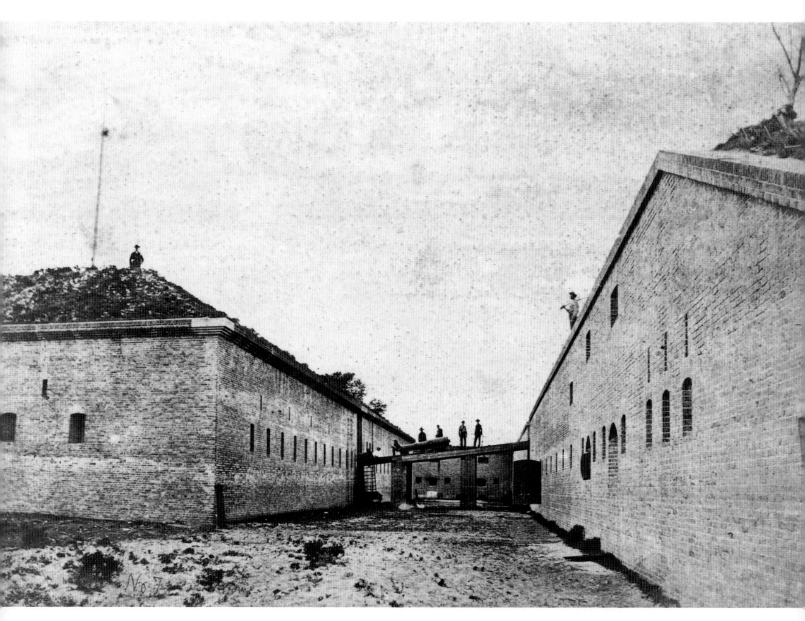

RIGHT

A shirt-sleeved sentry stands his post on the parapet of Fort Barrancas, overlooking other Rebel soldiers laboriously moving a cannon towards its position in the battery trained on Fort Pickens. Ironically, with all the heavy armament at Barrancas, its guns would never fire in this war.

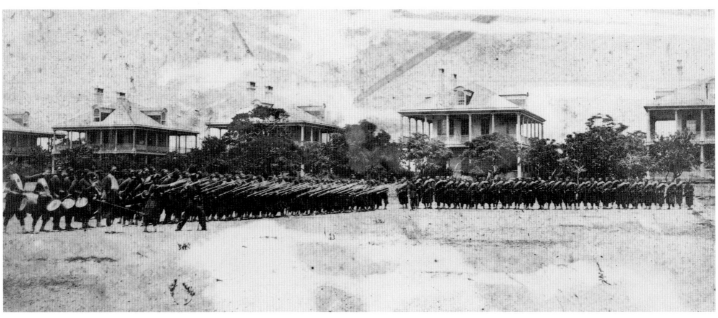

ABOVE

One of Louisiana's first volunteer companies, Gaston Coppen's Louisiana Zouaves, complete with baggy pants and short coats, and tasseled fezzes, parade in front of the old Navy Yard buildings at Pensacola, bayonets fixed, bandsmen at the left, presenting a picture of a fully equipped Rebel regiment not often seen again.

LEFT

In his lighthouse eyrie, Edwards trained his camera on the object of Confederate attention, Fort Pickens, beyond the water in the distance. To their great chagrin, these volunteers would never get to fire these guns, and Fort Pickens would remain in Yankee hands for the duration of the war.

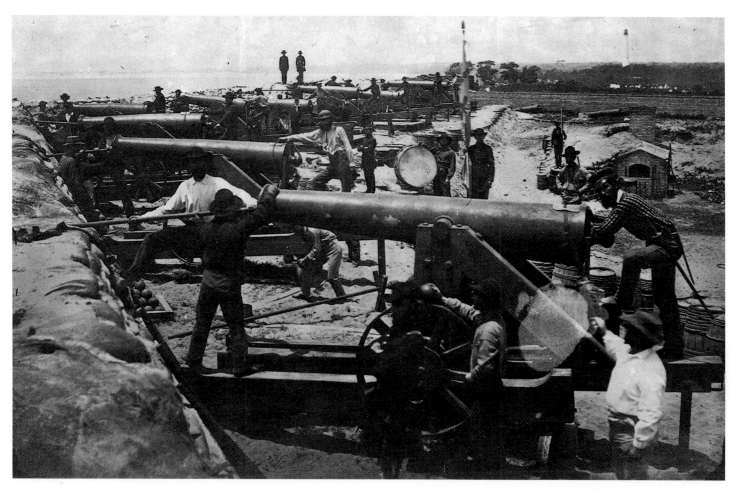

ABOVE
Confederates pose in mock action at their guns
in one of the water batteries trained on Fort
Pickens in the harbor at Pensacola. They craved a
chance to have their own fight, as at Fort Sumter.
They were ready with their banner, their bass
drum, and their cannon balls—and only their
variety of dress belies that they were soldiers.

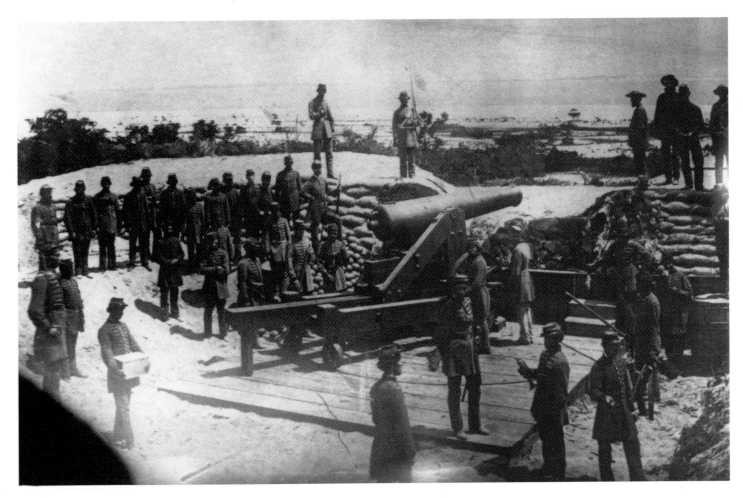

ABOVE
Unlike their brethren on the previous page, these
Confederates came to Pensacola fully and
splendidly uniformed, to man their gun in one of
the sand batteries. They, too, pose as if ready for
battle, their bugler at the ready, a soldier carrying
a box of cannon primers, and the rest standing
by to load and fire.

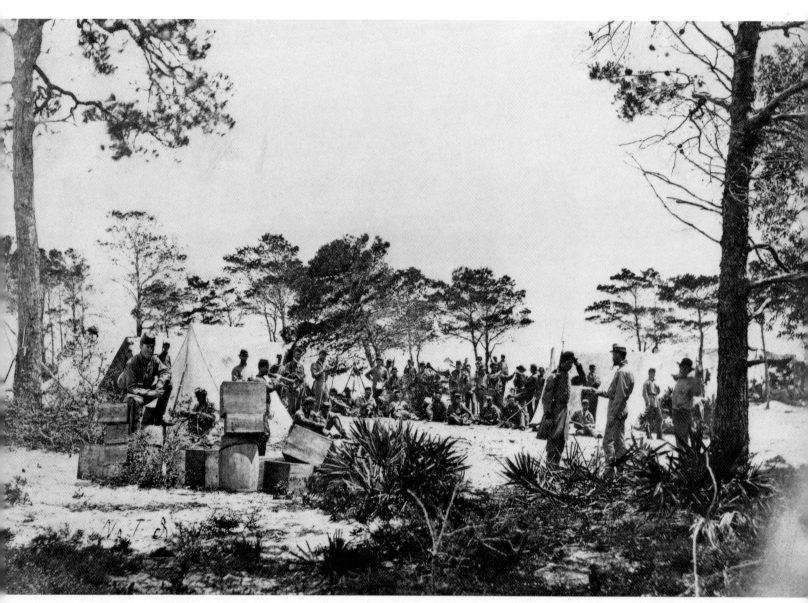

ABOVE

A magnificent image of Company A, the Orleans
Cadets, in their camp near Bayou Grande at
Pensacola in 1861. A bugler poses with bugle to
his lips; a soldier salutes as his officer hands him
an order; a cigar-smoking private perches atop
boxes of hardtack; while others lounge about
with picks and shovels beside their tents or
beneath a "shebang" in the distance.

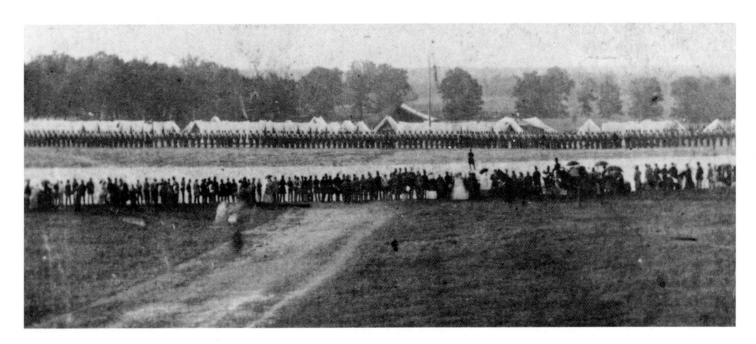

ABOVE

One of the first Union regiments of volunteers
to answer the call in the days after Fort Sumter,
the 7th New York State Militia drills off in the
distance in front of its tents at Camp Cameron,
while the umbrellas and dresses of the people in
the foreground reveal local citizens who have
come out to be an audience.

ABOVE
The first thing approaching a genuine land engagement took place here on July 18, 1861, along the banks of Blackburn's Ford over Bull Run. It would be a small affair, and confused, yet here men died in battle and here the reputations of commanders like James Longstreet began their rise. It was only the prelude to worse to come.

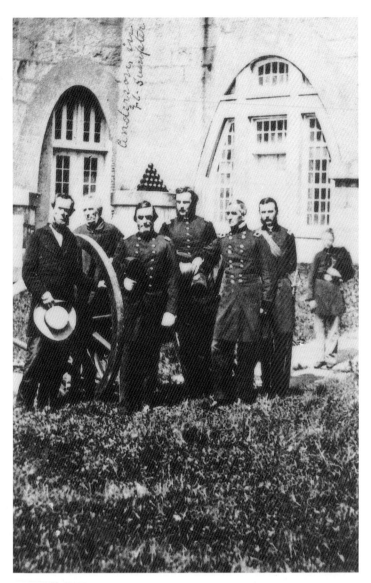

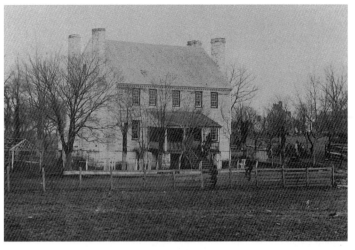

ABOVE

The Grigsby house near Manassas would be the headquarters of General Joseph E. Johnston, the overall commander of the Confederate Army at Bull Run. However, he would spend little time here, instead staying behind the lines funneling arriving regiments to critical points in his lines.

LEFT

Poor Major Robert Anderson, though no blame could attach to him, had no hope of an important field command in the drive into Virginia. Promoted to brigadier general, standing here third from the right in one of the forts near Washington, he had to watch as others led a real army to war.

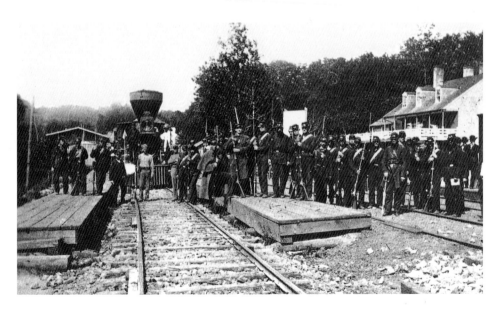

LEFT

The buildup of the Union Army headed for Bull Run depended on the control of vital railroad junctions like Relay House, on the Baltimore & Ohio, in Maryland. Most regiments from the North passed through here, first bound for Washington, and then for enemy country in Virginia.

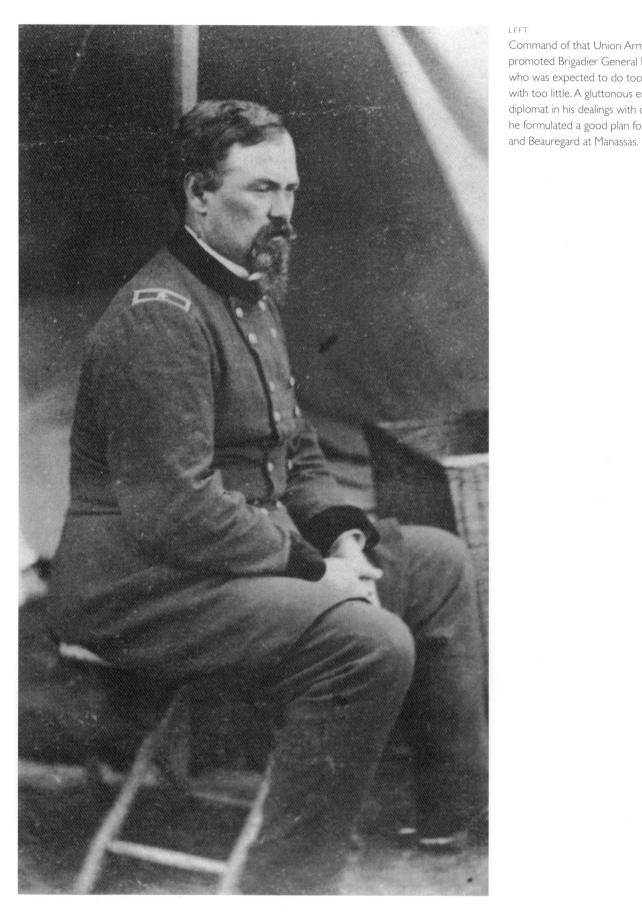

LEFT
Command of that Union Army went to newly
promoted Brigadier General Irvin McDowell,
who was expected to do too much, too soon,
with too little. A gluttonous eater and a poor
diplomat in his dealings with other officers, still
he formulated a good plan for meeting Johnston
and Beauregard at Manassas.

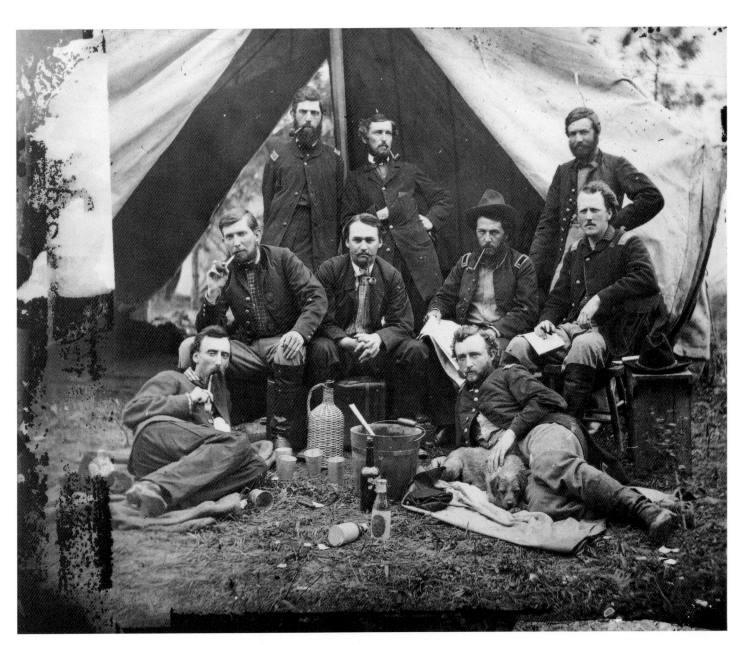

ABOVE
If McDowell would be eclipsed not long after
Bull Run, others at the battle would later rise to
the heights of fame. One young captain, fresh out
of West Point, was 21-year-old George
Armstrong Custer, here lying on the ground
among other staff officers, his hand on a mascot.

RIGHT
Many Georgians like these men of the 1st
Georgia Infantry, posing in front of the
Confederate States Armory in 1861, went to the
Virginia front early in the war. Their blue uniforms
contributed to the critical confusion at Bull Run
over just who was on which side.

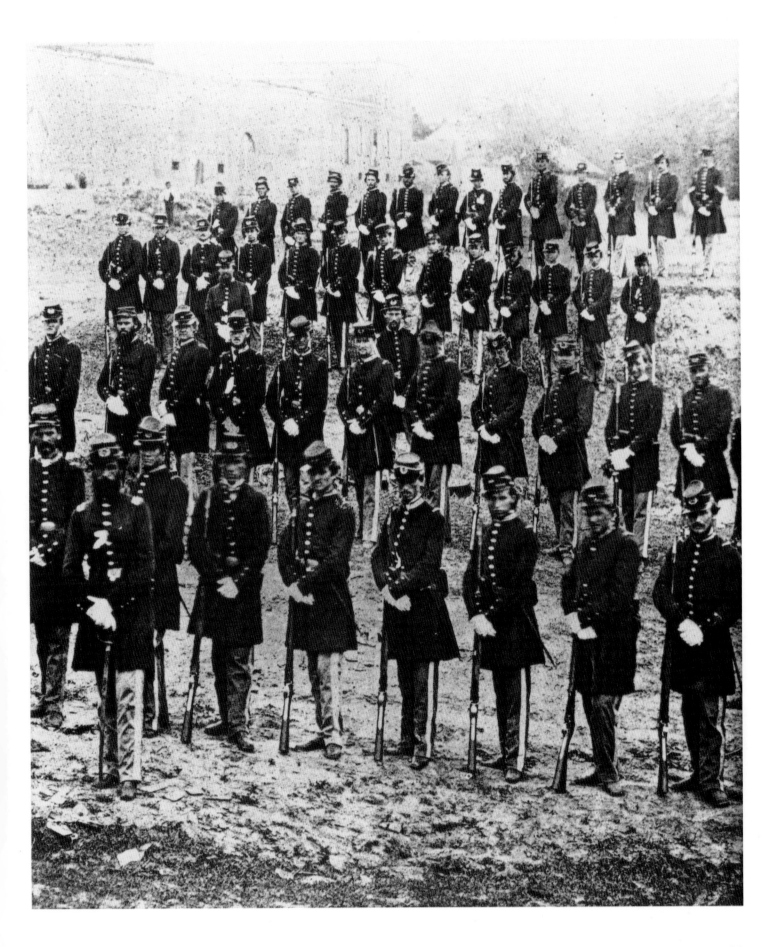

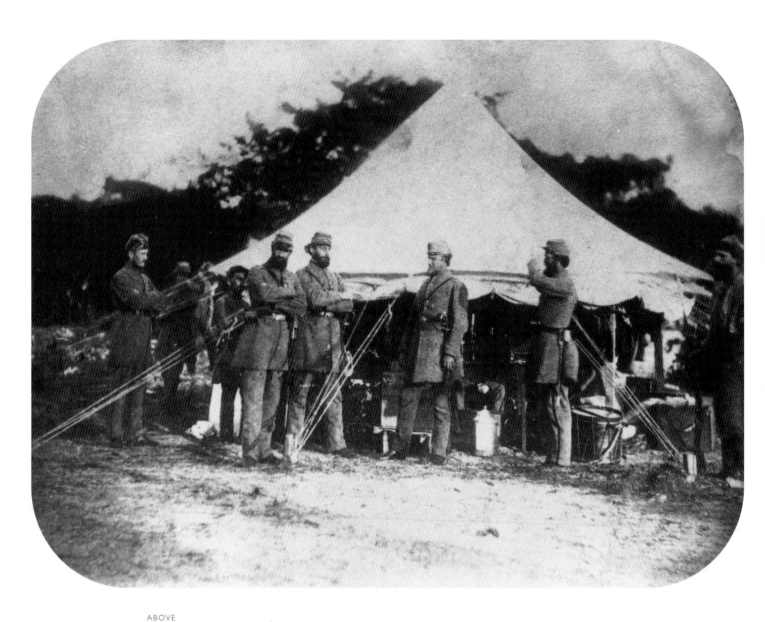

ABOVE
South Carolinians were also involved in the
fighting near Manassas. These officers of the
Washington Light Infantry, a private company
raised in Charleston before the war, would see
service across the battlefront. They go to war
well equipped, and proudly display all their
paraphernalia for the camera.

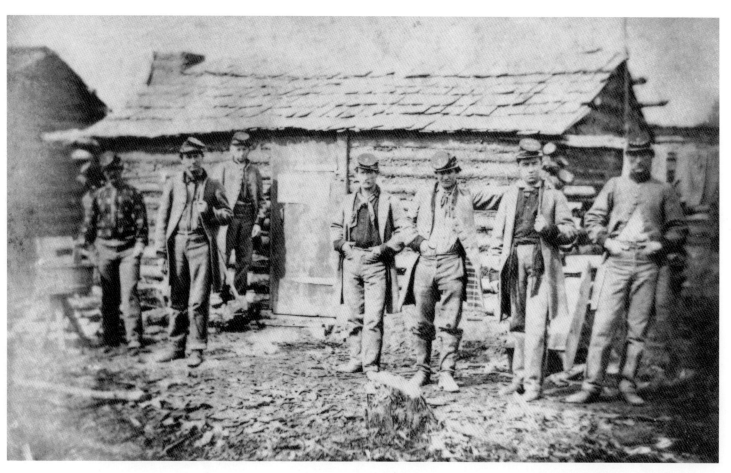

These Texans were not at Bull Run, though they
would join the Confederates in Virginia soon
afterward. Their log hut, however, is typical of the
community of such dwellings that the victorious
Rebels would construct in and around
Centreville in the months following their victory.

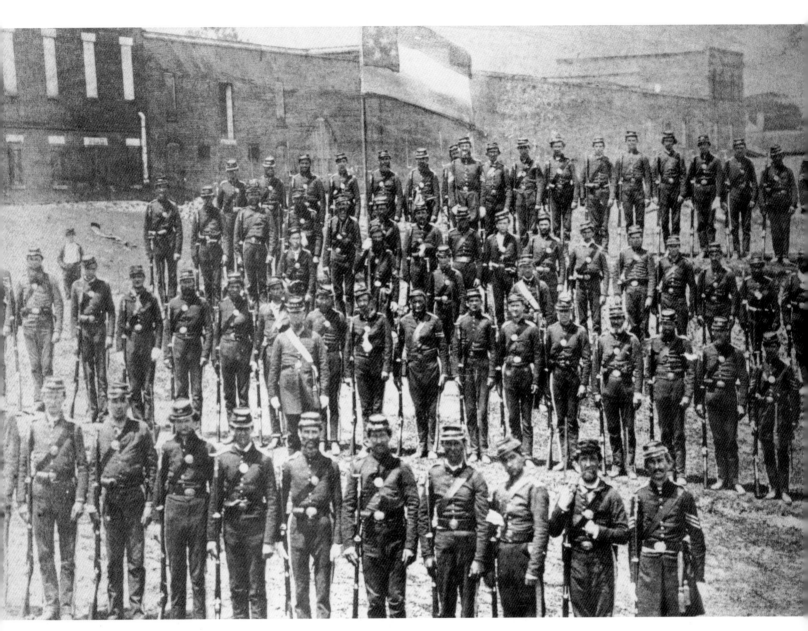

ABOVE
Men of the 4th Georgia Infantry, the Sumter
Light Guard, pose beneath their flag in April
1861 in front of the state armory, ready to leave
for the front in Virginia. In the years to come they
will be heavily blooded, and will never look this
splendid again.

ABOVE

"Liberia," the home of William Weir on the Bull
Run battlefield. His neighbor was Wilmer
McLean, whose home would serve as
Beauregard's headquarters. Four years later,
McLean having moved to Appomattox Court
House, another home of his would host the
surrender of Robert E. Lee.

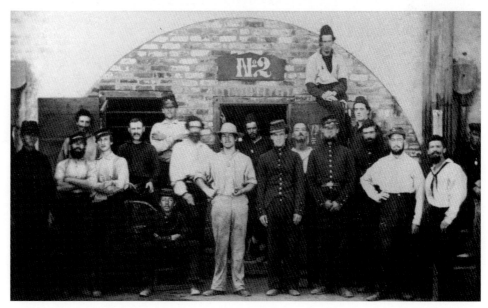

ABOVE

Yankee soldiers from the 79th New York taken prisoner in
the battle along Bull Run were shipped south to Castle
Pinckney in Charleston Harbor, and pose here rather
jauntily in front of one of the casemates that housed
them. The prisoners even gave their quarters ironic names
like "Hotel de Zouave," or, as in this case, simply "No. 2."

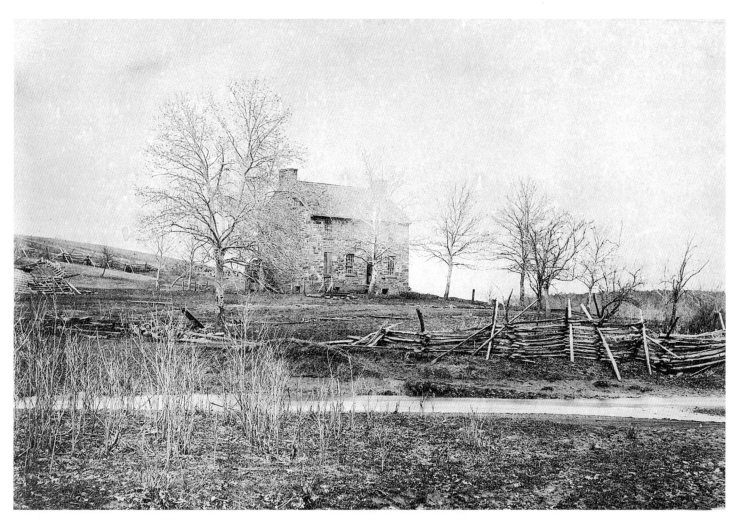

ABOVE

Over those fields in the distance swirled two armies in the war's first great battle, more than 40,000 men intermittently locked in the confusion of fighting. In the end it was a question not so much of leadership as of which mob would give way first, and after a day of near-disaster, the Confederates finally held their ground.

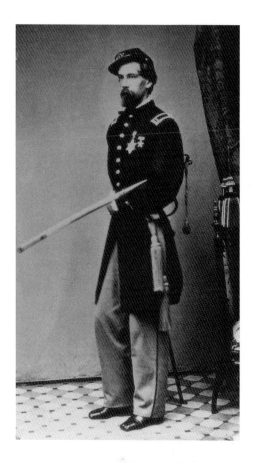

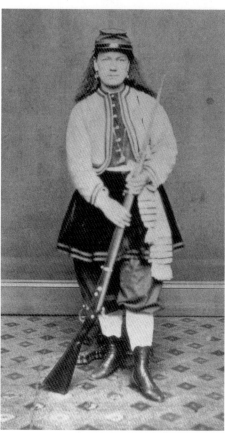

ABOVE
Many of the New Yorkers in the fight had a personal grudge to settle with the Rebels. Their organizer and the Union's first martyr was the youthful Colonel E. Elmer Ellsworth, leader of the New York Fire Zouaves, who had been murdered by a Southern-sympathizing hotelkeeper a few weeks earlier.

TOP RIGHT
Ellsworth had been avenged on the spot by Corporal Francis Brownell, who bayoneted the murderer. Brownell was soon promoted to lieutenant, and poses here in his new uniform.

RIGHT
Even Brownell's wife took on the military spirit, dressing in an altered Fire Zouave uniform as a "vivandière," like many women who paraded with the soldiers at home and sometimes even accompanied them on the march, but not into battle.

LEFT
One of the first advancing Union columns marched past the Thornton House, which appears here eight months later, when the area was finally in Union hands. Like so many other planned movements on the field, Union and Confederate alike, it went all wrong because of the inexperience of those involved.

RIGHT
One of the decisive points of the battle was on Matthews' Hill around the Matthews' house. Here is where Nathan Evans held up the Union advance long enough for Confederate reinforcements to bolster a line on nearby Henry Hill, and there to win the battle.

LEFT
Union forces passed Sudley Church near Sudley Ford over Bull Run twice that day, first on the way to the battle, and then in the rout that followed their defeat. It appears here as seen in March 1862, captured by the famed photographer George N. Barnard not long before Bull Run was destined to see another epic struggle.

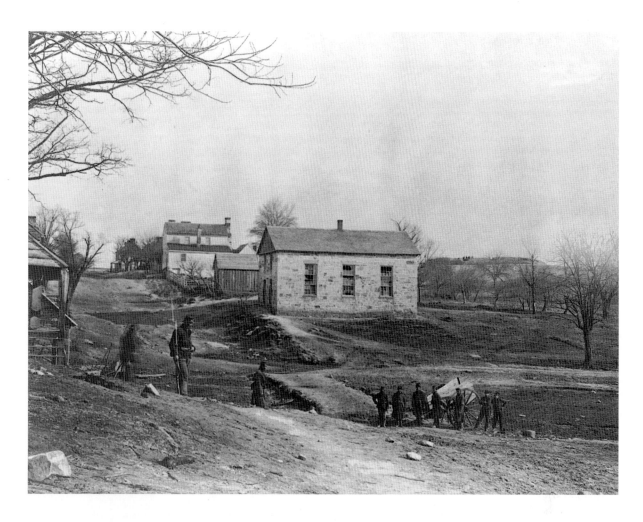

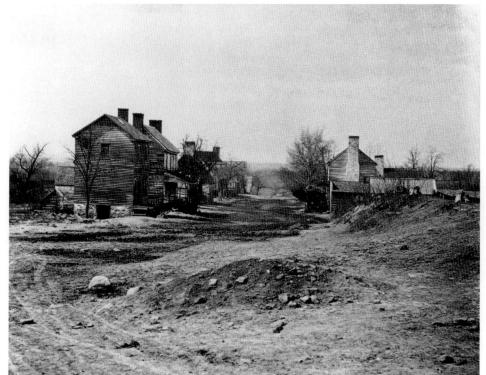

ABOVE
Prior to the campaign, Centreville had been heavily protected with Confederate batteries and earthworks, but they gave it up without a fight when McDowell advanced. During the fight it was held during the battle by a reserve division that never got into the battle, or else the outcome might have been different.

LEFT
As the Yankees raced back through the village in their panicked flight toward Washington, Centreville, shown in a Barnard image from March 1862, provided a cruel reminder of how recently they had taken it without a fight on their way to Bull Run, and of the high spirits in which they marched through.

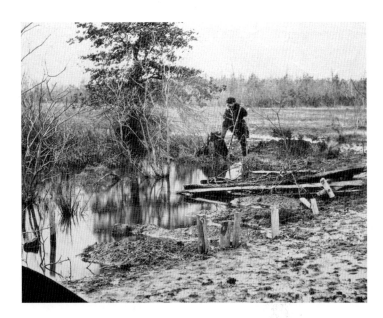

LEFT
A pensive Union soldier gazes down at the rude headboards hastily erected over fallen comrades who were buried on the field after the defeat. In years to come, the dead of the defeated were most often simply thrown into rude trenches or pits in the rush to get them buried before disease could spread to the living.

RIGHT
In the aftermath of the debacle at Bull Run, McDowell naturally had to be replaced. The Union had only one hero so far, not much at that, but the minor achievements of Major General George B. McClellan, shown here with his wife, would catapult "Little Mac" to the forefront, creating one of the most controversial commanders of the war.

BELOW
Even the landscape suffered. The climactic moments of the battle came around the Widow Henry's house. Her home was soon to be a mere ruin, and in the battle she herself was hit by a cannon shell that blew off her foot and left her dying, perhaps the first female casualty of the war.

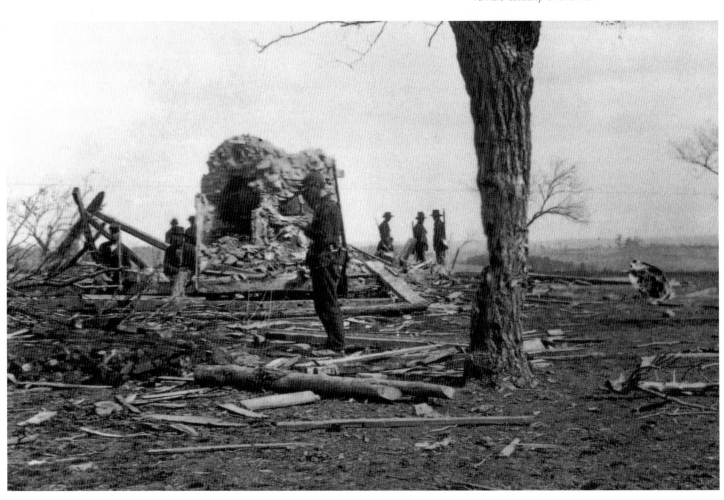

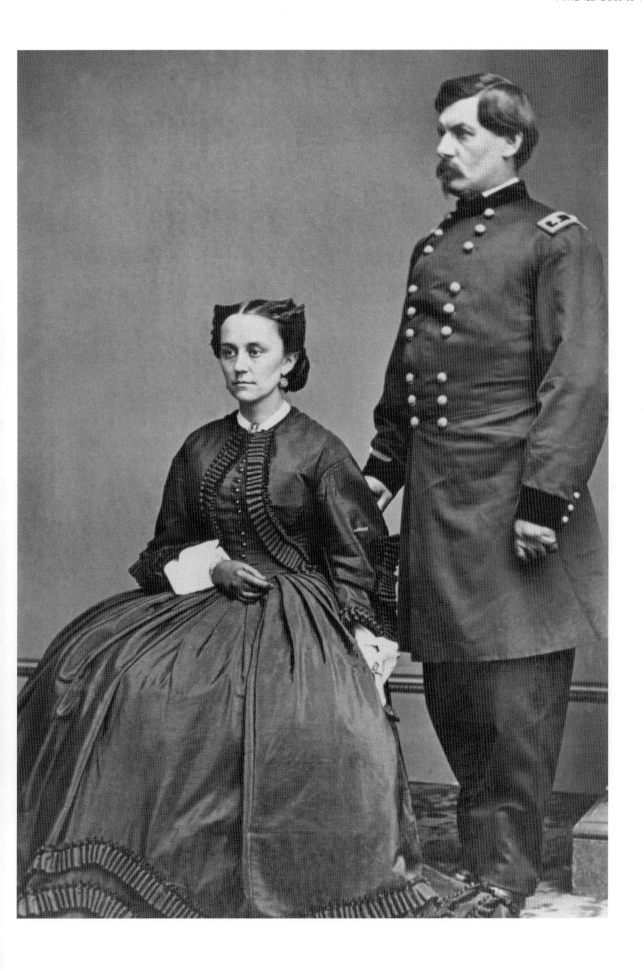

Photographers

The new art of photography came of age just as the Civil War was ready to be its first major subject. Hundreds of photographers would be active during the contest, most at home in their studios making soldier portraits, but dozens of other intrepid men went out to follow the armies and capture the real look of the war. In the process they created some of the first great names in photography, names like Mathew Brady, Alexander Gardner, Timothy O'Sullivan, and more.

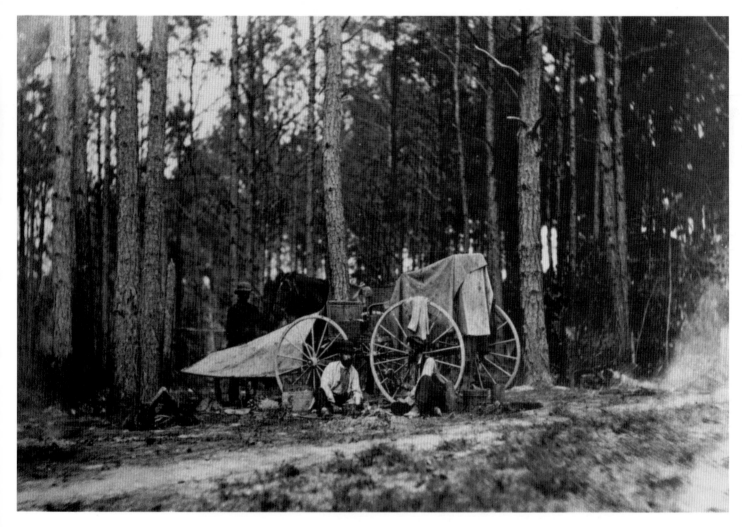

ABOVE
One of Mathew Brady's "what is it" wagons that followed the army in Virginia, with one of his more able assistants, David Woodbury, seated at left. The wagon carried cameras, glass plates, chemicals, and darkroom all in one, and was a frequent sight by the roadside as the regiments marched past.

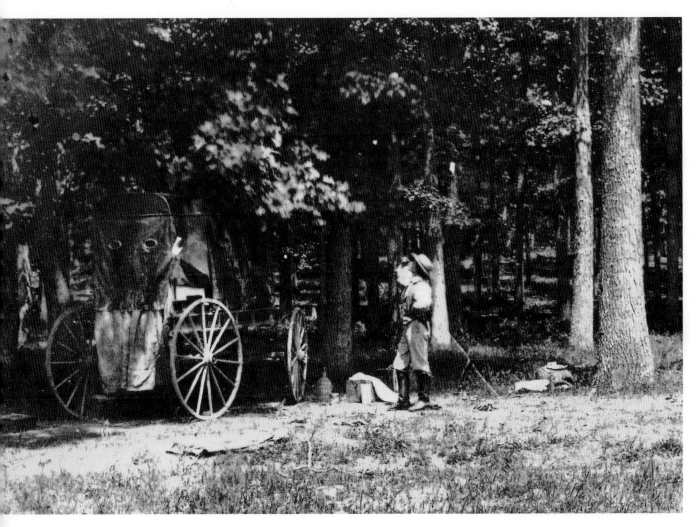

ABOVE
Timothy O'Sullivan pauses by the road in the
summer of 1862 with some of his equipment
and a jug of developer awaiting use. He may, in
fact, be looking upward to view a freshly
developed glass plate image in the sunlight. His
"what is it" wagon is prepared for darkroom use.

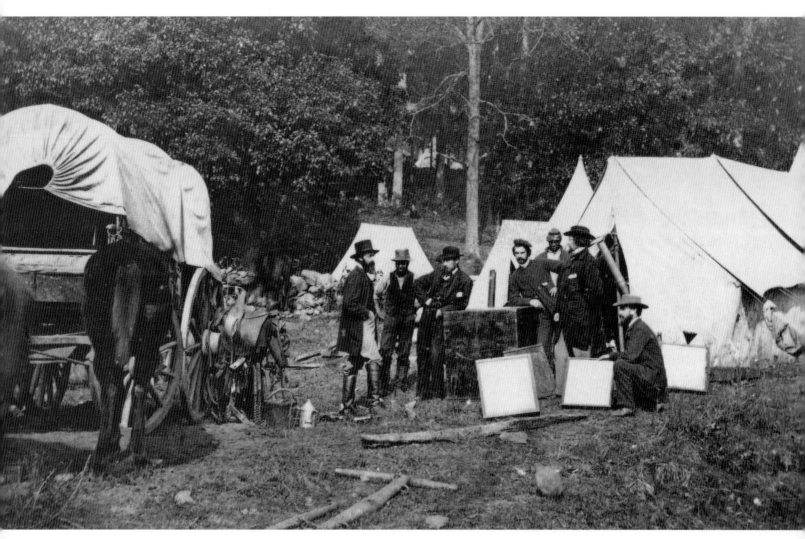

ABOVE
An outstanding view of a group of Brady's
photographers, with Brady himself standing at
right, and Woodbury kneeling beside him. Here
are cameras and their boxes, jugs of chemicals,
and several oversize glass plates ready to be
treated for exposure.

Alexander Gardner had been a Brady assistant, but he tired of not receiving credit for his artistry, and so went out on his own, opening his gallery in Washington, taking his own cameras to the armies, and boldly advertising his "Views of the War" on the wall of his studio.

RIGHT

Much more modest than the grand city studios, and far more typical of photography in the field, the simple tent of a Mr Morse's "Gallery of the Cumberland" welcomed Union soldiers in Chattanooga to have their portraits taken, either to trade with mess mates or to send back home.

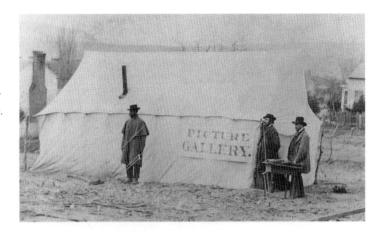

RIGHT

The only known image showing Confederate photographic equipment, this photo, taken shortly after the surrender of Fort Sumter, shows the Trapier Mortar Battery on Morris Island. Immediately behind the mortar on the right can be seen the portable darkroom of Osborn and Durbec.

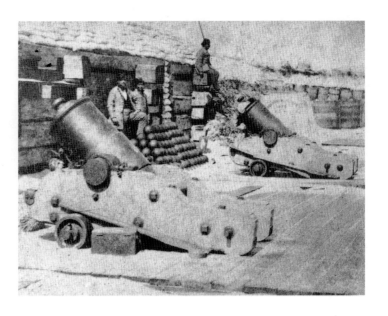

Forts

On a battlefront as vast as the eastern half of the American continent, there were going to be many places that needed to be defended by standing garrisons—railroads, rivers and harbors, important cities, and more. With their mobility, the armies would not need forts, but these other spots were going to have to depend on fortifications of all sorts for their security, and the variety that appeared in the war would be dazzling, and innovative.

RIGHT
A typical block house of the kind that Union forces erected, especially in Tennessee and Alabama, to protect important rail lines and junctions from raiding Confederate cavalry. Most of these appeared at railroads' most vulnerable points, the bridges where they crossed rivers and gorges.

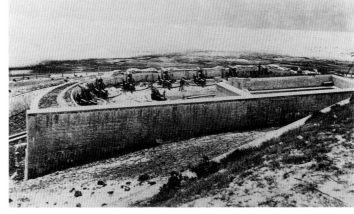

ABOVE
Fort Barrancas, so heavily armed by the Confederates in early 1861, was in fact a former Spanish fort that was at least sixty years old. If these eight guns crammed onto its upper parapet had ever gone into action, it would have been difficult indeed for the gunners to keep from stumbling over each other.

RIGHT
One of the water batteries at Pensacola reveals its less formal construction, being simply sandbags piled on one another to shoulder height, covered with canvas and earth. Such fortifications were meant solely to protect men and guns from enemy artillery, and not to defend against an actual attack.

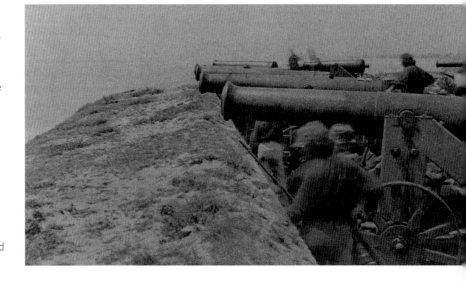

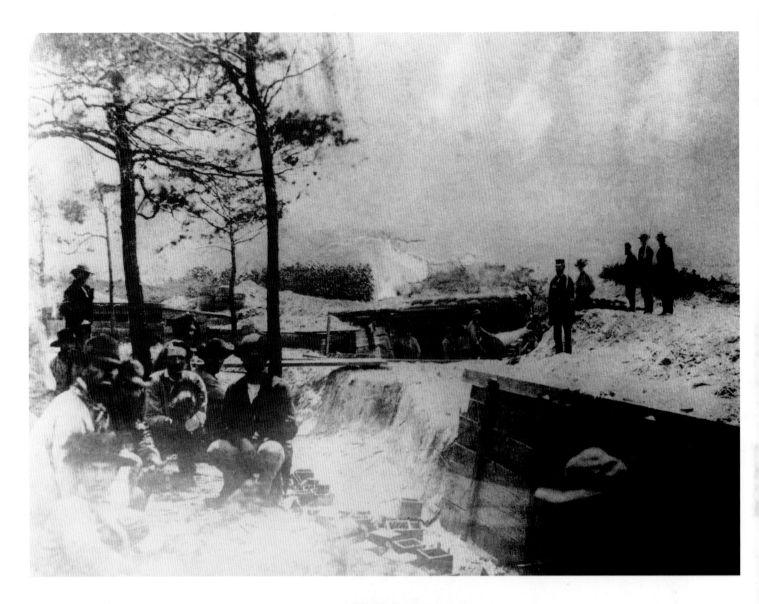

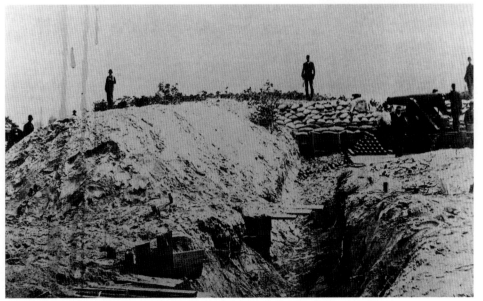

ABOVE

A typical connecting trench or traverse connecting two gun emplacements in the Pensacola sand batteries. Rough boards act to keep the walls of the trench from eroding, while "bomb proofs" in the distance afford the men protection from both sun and enemy fire.

LEFT

This view of a sand battery for a gun on the right shows the underground tunnel in the foreground that connects with the battery on the left. Shoring keeps the tunnel from collapsing, but the unfinished nature of the sand above it, not to mention the cannon balls scattered in the trench, reveal that this is a work in progress.

The Confederate Soldier

Johnny Reb, as he quickly came to be called, was perhaps the most individualistic soldier America ever produced. Largely that was because he had to depend so much on himself, with a government that was never able fully to provide for him. Many a soldier went to war with his own weapons, in his own clothing, and even living on his own money or credit, and replacements and compensation could be a long time in coming, if indeed they ever arrived.

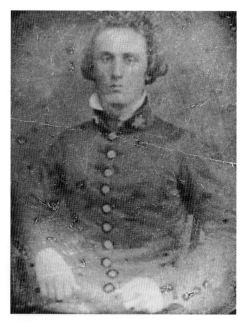

ABOVE

Out of this ghostly image peers a young Confederate officer, his face betraying the innocence of so many as they went off to war. Almost one in every three Southern men who went to battle would never come home again, a fearful toll that blighted a whole generation.

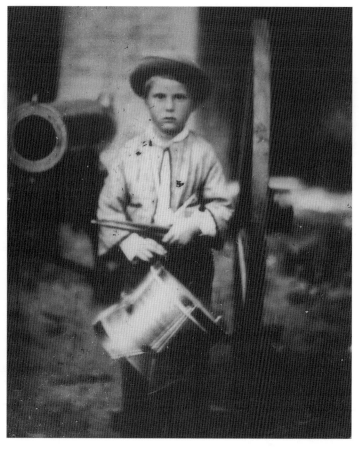

ABOVE

At first men had to be 18 in order to enlist, and in the Union it stayed that way, though many lied about their age. In the Confederacy the age limit went down to 16 by the end of the war. But hundreds of mere children managed to get into the war as fifers and drummers, like this Southern boy posed before a smoothbore cannon. All too many of them would be killed.

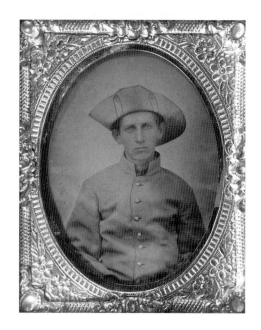

RIGHT

This determined-looking young fellow in gray wears what is almost certainly a hat he brought from home. Everything, from slouch hats and Hardee patterns, to things like this that appear to date back to Revolutionary War tricorns, were to be seen in Confederate regiments.

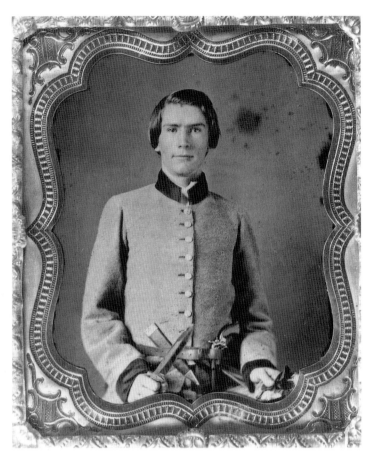

ABOVE
Neither knives nor pistols were regulation issue to Confederate infantrymen, yet many a "Southron" brought his own with him to war, as has this young man, possibly an artilleryman, who carries a pistol in his belt and a knife in one hand and gloves in the other.

ABOVE
His beard making him appear to be a grizzled old veteran, and his Mexican War era hat and flintlock musket reinforcing the picture, this Confederate is a fine example of the antiquated weapons and uniforms that some Southern men took to war with them.

LEFT
The letters "CG" on his kepi cap suggest that this well-bedecked Confederate was a member of some unit called Cadet Grays, or Confederate Guard, or perhaps a unit named after a town like Columbus, Georgia. He wears a pre-war militia uniform that will not last long in the rigors of the war.

The Union Soldier

Unlike his Confederate counterpart, Billy Yank went to war generally well armed and equipped, and would be kept so throughout his service. At the outset the myriad styles of his dress would mirror that of Southerners, though standardization soon set in. Even then, Federal soldiers could be almost as individualistic, and some were outright gaudy, especially officers who could flout regulations to make displays of themselves.

LEFT

A Yankee soldier, probably a cavalryman, stands boldly cap in hand, brandishing a saber in one hand while in his belt he has shoved a modern "Volcanic" pistol, a repeating weapon that was a precursor to the famous Winchester rifle soon to follow.

RIGHT

General Philip Regis Denis de Keredern de Trobriand dressed in a manner befitting his name. The son of a baron who lived the romantic notion of a European nobleman to the hilt, he was not much of a general, but dressed like something out of a comic opera.

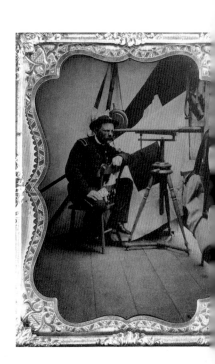

LEFT

This Billy Yank appeared to be prepared for entertainment at any time, with what looks to be a deck of cards in one hand and his violin near the other. Soldiers who could play any instrument were popular in camp, in an era when music was a part of everyone's life.

RIGHT

Equipped with canteen for a long vigil, and with signal "wig-wag" flags on the wall behind him, this signal officer peers through a telescope to enhance what remained in this war the most reliable source of intelligence, the human eye. Typical of the age, even a utilitarian military telescope had lathe-turned legs.

ABOVE
These two friends from the same unit are part of a modified Zouave outfit. Gone are the baggy pants and the ornate "frogging" on their short jackets, but they still wear small caps with tassels and rather more buttons on their jacket sleeves than are necessary.

ABOVE
Two smiling young men, possibly artillerists, in a typical soldier pose, one with his arm around another. The badge with the "X" on their shell jackets could mean anything, though it is not likely to be a corps badge, for this is not the badge of the Union X Corps.

LEFT
Every brigade, and many regiments, had their own bands, the musicians serving as litter-bearers and hospital stewards in action, if they were not playing to inspirit the men. No one but a rifleman made more noise than this fellow with his bass drum

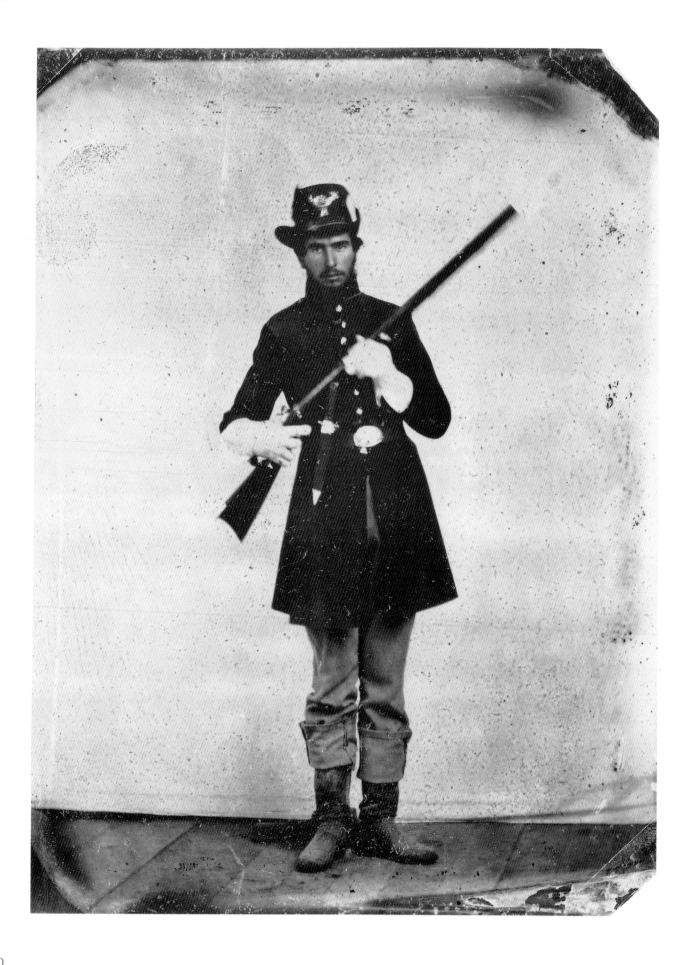

Looking rather innocent, and perhaps a bit awkward, this Billy Yank poses in an early war image with distinctly non-issue white gloves and a dagger. His rifle, too, is smaller than regulation, while his trousers are too long or too tight to fit over his boots, and so he has rolled them up.

The Union soldier in full gear, ready for the march and the battle to come. This corporal has his knapsack on his back, canteen, haversack, and bayonet at his side, leggings on his ankles, and the look of determination on his face. This is the man who will take the Union to final victory.

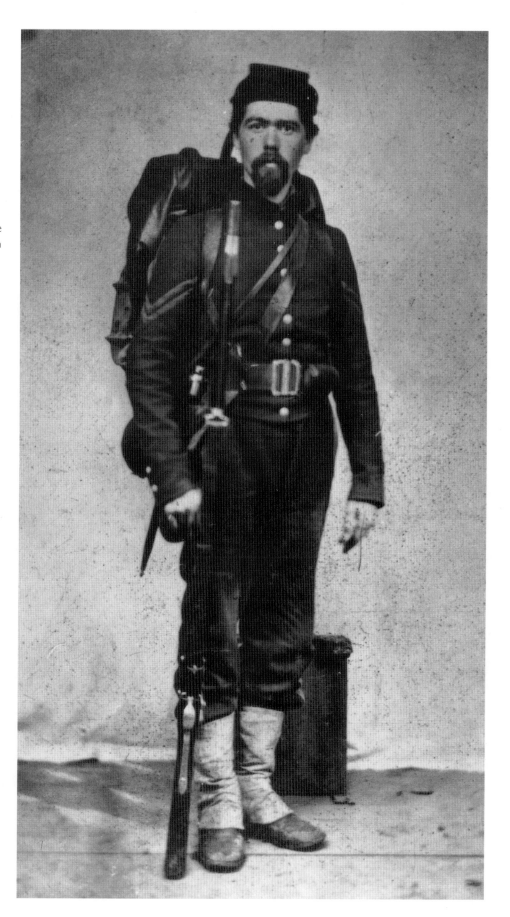

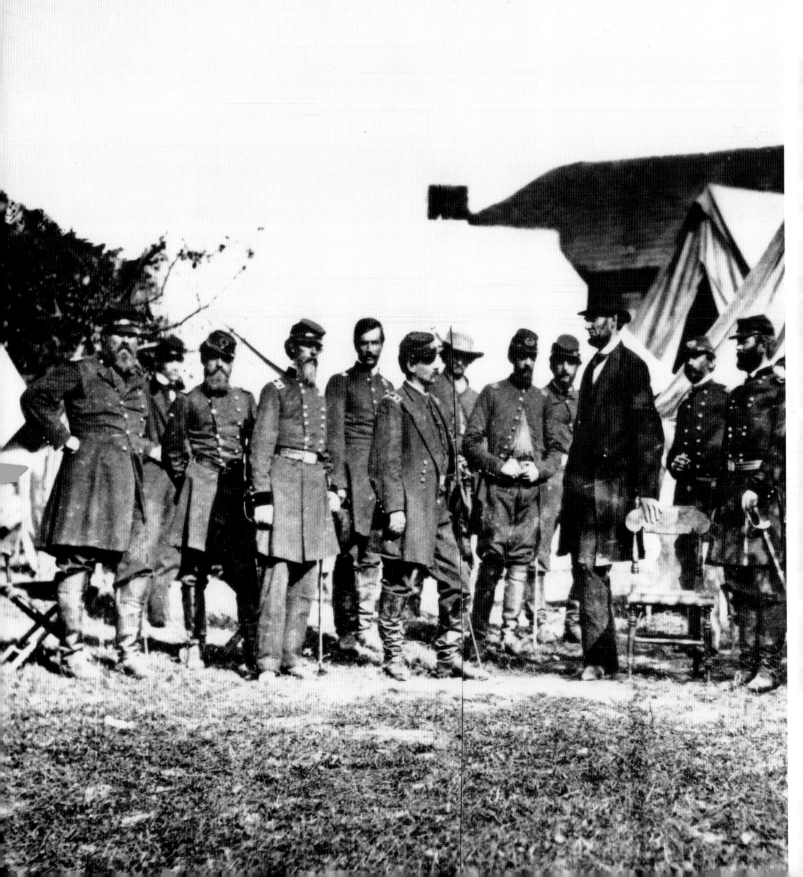

1862

BATTLEFIELD AND LEARNING GROUND

Just as at the beginning of World War II, a kind of "phony war" followed the Confederate victory at Bull Run. Stunned and shocked by the ferocity of the fighting, both sides recoiled. The Union realized it was going to take time and organization to win, and the Confederacy could only await its next blow. Both sides' dreams of a short war were about to be dashed in the fighting of 1862.

Fort Sumter and Bull Run were not the only fighting in 1861, but they were the only engagements of note east of the Mississippi. West of the great river, in Missouri, smaller armies vied for control of this slave state that had not seceded, and in a confused battle at Wilson's Creek in August, and later in the siege and capture of Lexington in October, the Confederates seemed to gain the upper hand, but not for long. The eyes and attention of the rest of America and the world would rarely focus on this far-western theater of operations, and then not for long. The real war as far as most were concerned was happening in the East, and for many of these that meant Virginia.

YET FOR SO MANY MONTHS nothing at all happened there. Following the disgrace of Bull Run, McDowell had to be replaced, and Lincoln appointed charismatic young Major General George B. McClellan, fresh from winning a couple of minor skirmishes in what later became West Virginia. "Little Mac" exuded confidence, and he soon built his Army of the Potomac into the best-trained and equipped army the continent had ever seen, numbering more than 100,000 by the spring of 1862. Unfortunately, as time went on, he showed no inclination to use it, as if in fear of damaging his creation.

Meanwhile there was real action to the west, in Tennessee, and decisive action at that. Union grand strategy, the so-called "Anaconda Plan," called for a blockade of all Confederate ports to starve the South of foreign imports, while at the same time seizing control of the Mississippi and its tributaries. That would allow the Union, like a giant constructor, to squeeze the South until it could no longer sustain itself. The principal tributaries were the Tennessee and Cumberland Rivers, which emerged from the mountains of eastern Tennessee and Kentucky, cut south across central Tennessee (and into Alabama in the case of the Tennessee River), then flowed back across Kentucky to empty into the Ohio River at Paducah. They thus provided natural pathways of invasion for Union troops supported by naval gunboats and transports.

The value of these rivers was obvious to both sides. Confederates erected earthworks to protect both, Fort Henry on the Tennessee and Fort Donelson on the Cumberland, but as of February 1862 neither was ready to receive an attack. Meanwhile a rising young Yankee named Ulysses S. Grant, whose only experience had been a little skirmish at Belmont, Missouri, the previous November, had seized Paducah and planned to move up the rivers. With about 15,000 men and the assistance of a gunboat flotilla, he moved up the Tennessee early in February, but Fort Henry was so vulnerable, owing to its incompletion and high water, that Union naval forces took it easily before Grant's infantry arrived. Instead he immediately

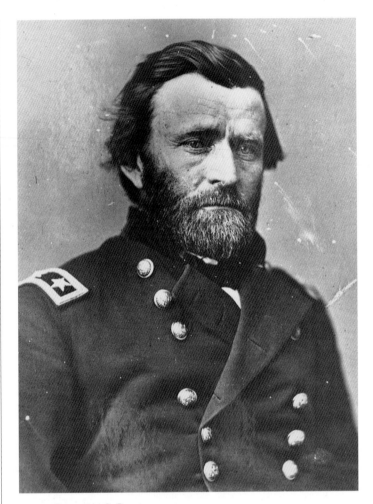

ABOVE General U. S. Grant

marched his infantry overland the 12 miles to Fort Donelson, while sending the gunboats back down the Tennessee to Paducah, to enter the Cumberland and steam back up to support his attack.

Donelson proved harder to take. Grant first proved its defenses on February 12, then attacked the next day, without success. On February 14 the gunboats attacked, but the well-placed cannon in the fort disabled some of the ships and sent the others back out of range. Still the fort was surrounded and could not hold out. After an abortive attempt to break out, its commanders asked Grant for terms, and he replied that he

demanded "unconditional surrender," which soon became his nickname. In a single stroke, control of those two vital rivers was lost, the Confederacy had to abandon middle and west Tennessee and its foothold in Kentucky, and Grant was made the man of the hour. Thereafter victory would ride with him.

Shortly after his victory Grant moved south toward Mississippi. Meanwhile, McClellan had finally been spurred to action and launched a brilliantly conceived plan to take Richmond by using transports to move his army down the Chesapeake and then up the York and James Rivers to take the enemy capital from its rear. That he could do so at all was in part thanks to a revolution in naval technology. The Confederates had taken the hull of the captured USS *Merrimack* and converted it into the first real ironclad, renamed the CSS *Virginia*, covering it with heavy sheet iron to protect its guns. It almost destroyed a Union wooden fleet in Hampton Roads, Virginia, early in March, but then the Union's own ironclad, the USS *Monitor*, appeared opportunely to stymie the *Virginia*, thus leaving McClellan with sufficient control of the James River to carry out his campaign.

He was successful at first, taking Jamestown and Williamsburg and laying siege to Yorktown, but his caution allowed far inferior forces to retard his advance while Johnston's army was rushed to meet him. Thereafter neither McClellan nor Johnston showed much pluck, the latter steadily falling back in the face of the former's glacial advance. By late May, however, McClellan was almost in sight of Richmond. Then, on May 31, Johnston was wounded in action at Seven Pines. The next day command of his army was turned over to General Robert E. Lee, changing the face of the war in the East completely. Within a few weeks Lee launched a sustained counteroffensive in the Seven Days' Battles that drove McClellan back toward his supply base on the James and relieved Richmond from the worst peril it would face until 1865. At the same time, the South had a new hero.

It had two heroes, in fact, for weeks before, out in the Shenandoah, "Stonewall" Jackson had outmarched, outmaneuvered, and outfought three separate small Union armies with his own little command, in the fabled Valley Campaign that secured him as a legend for all time. He joined Lee for part of the Seven Days' Battles, and then Lee launched his combined army in a campaign into northern Virginia to push back another Union army commanded by General John Pope. In battles at Cedar Mountain in August, and then on the old fields of Bull Run at the end of that month, Lee all but shattered Pope and sent him, too, retreating for Washington.

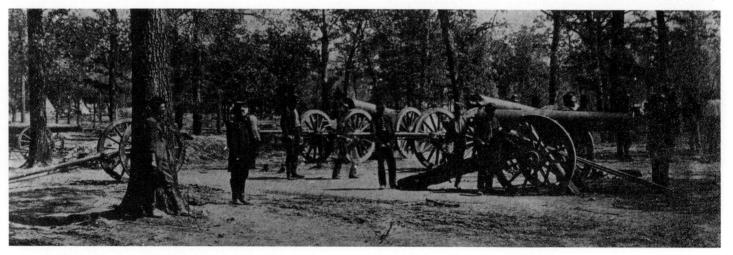

ABOVE Siege cannon on the battlefield at Shiloh display Union might and determination to press the war to a conclusion.

ABOVE Cedar Mountain, Virginia. The lounging Union soldiers belie the bitter fighting in those fields.

Not content with that, Lee then invaded Maryland, hoping to enable that slave state to join the Confederacy if it wanted, and also intent on taking the war to the enemy. Damaged but not yet discredited, McClellan managed to get his army back in time to meet Lee near Sharpsburg, along Antietam Creek, on September 17, in what proved to be the bloodiest single day of the war—indeed in all American history. Though outnumbered, Lee stood his ground and "Little Mac" squandered his advantage by his timidity. In the end, Lee was able to extricate himself and withdraw back to Virginia, but behind him more than 4,000 men had been killed. Still, it was the first Union victory of the war in the East, and it gave Lincoln the opportunity he needed to issue his Emancipation Proclamation, which helped turn the war for the Union into a crusade for freedom. The defeat also ended Confederate hopes of British diplomatic intervention and possible military assistance.

Events out in the western theater lent further authority to Lincoln's action, though most of the world paid too little attention to what happened in the Mississippi Valley. After his victories Grant advanced his army to Pittsburg Landing on the Tennessee River, only a few miles from Mississippi. There, on April 6, for once overconfident and careless, he was surprised by a shocking attack led by an army assembled by Confederate General Albert Sidney Johnston. In what many participants said was the hardest fighting of the war, the Rebels steadily pushed the Yankees back, past Shiloh Church, from which the battle would take its name, and almost into the Tennessee itself. Approaching darkness and command confusion caused by Johnston's mortal wounding halted the advance overnight, just as a reinforcing army of Federals under General Don C. Buell arrived on the other side of the river and began to cross to aid Grant. In the morning Beauregard, now in command, found his own army exhausted and Grant's fresh and powerful, and was pushed off the field in retreat.

That fall, just days after Antietam, Grant would take Iuka, and later Corinth, both in Mississippi, setting up his march on his ultimate goal, Vicksburg, the bastion protecting the Mississippi River itself. Memphis had already fallen, and so had New Orleans, and by late 1862 Union naval forces controlled all of the great river except a corridor less than 200 miles long between Vicksburg and Port Hudson, Louisiana. Take Vicksburg and the other must inevitably fall, and the anaconda's squeeze could become fatal.

Still the war was not going entirely the Union's way. Lincoln finally relieved the insufficient McClellan from

command when he refused to move again after Antietam. In his place the president appointed Major General Ambrose Burnside, well-meaning but not up to army command. But Burnside knew he was expected to advance, and in late October he launched an advance south that brought him to Lee's defenses on the south bank of the Rappahannock at Fredericksburg. In fact, Burnside planned a good campaign that might have caught Lee off guard, but logistical failures in Washington delayed the anticipated crossing of the river until Lee was in the best position he would ever hold on the heights behind the town. As a result, the ensuing battle of December 13 was a near disaster. Burnside took heavy casualties just getting across the river, and then launched massed attack after attack against Lee's impenetrable defenses. At the end of the day the Federals had gained nothing but 13,000 casualties, one of them Burnside's own tenure. Nine weeks later, at the dawn of 1863, he would be replaced by Major General Joseph Hooker, who would have to try to retrieve the fortunes of this ill-fated army.

Meanwhile, out in the west, even Grant hit a roadblock when his supply base at Holly Springs, Mississippi, was destroyed by a Confederate raid, forcing him to halt his advance on Vicksburg even after he had already sent his chief lieutenant, Major General William T. Sherman, on an expedition almost to the gates of the city. Now Grant, like Hooker, would have to wait for 1863 to try again. The good news was that Confederate hopes, too, were tarnished. Beauregard's successor in command of the western army, now called the Army of Tennessee, was General Braxton Bragg, who had led a campaign into Kentucky hoping to take the Bluegrass State away from the Union. But Kentucky did not rally to his standards, and after the Battle of Perryville in October, Bragg was forced to withdraw. Still not entirely discouraged, Bragg tried to retake central Tennessee with an advance to Murfreesboro in December. The Army of the Cumberland, commanded by Major General William S. Rosecrans, advanced south to meet him, and the two armies ended 1862 beginning a battle along Stones River that would last for portions of three days and end inconclusively, but with Bragg retreating.

Defeat on the Rappahannock, a setback in northern Mississippi, and a stalemate in central Tennessee were not encouraging prospects for the Union at the end of 1862. The Confederacy had skirted disaster that spring, yet rebounded and seemed almost invincible on its own soil in Virginia, yet none could ignore the constant erosion to the west and the loss of its rivers. At the end of the first full calendar year of war, neither side could be a predicted winner yet, or so it appeared. Each expected that the New Year would bring a decision, as indeed it would.

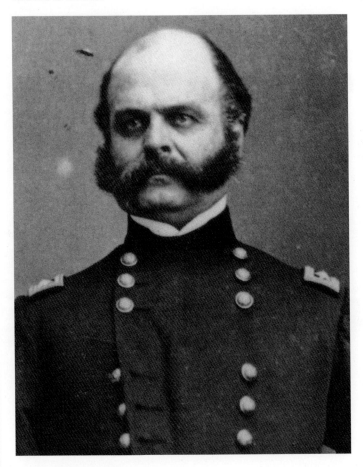

ABOVE General Burnside

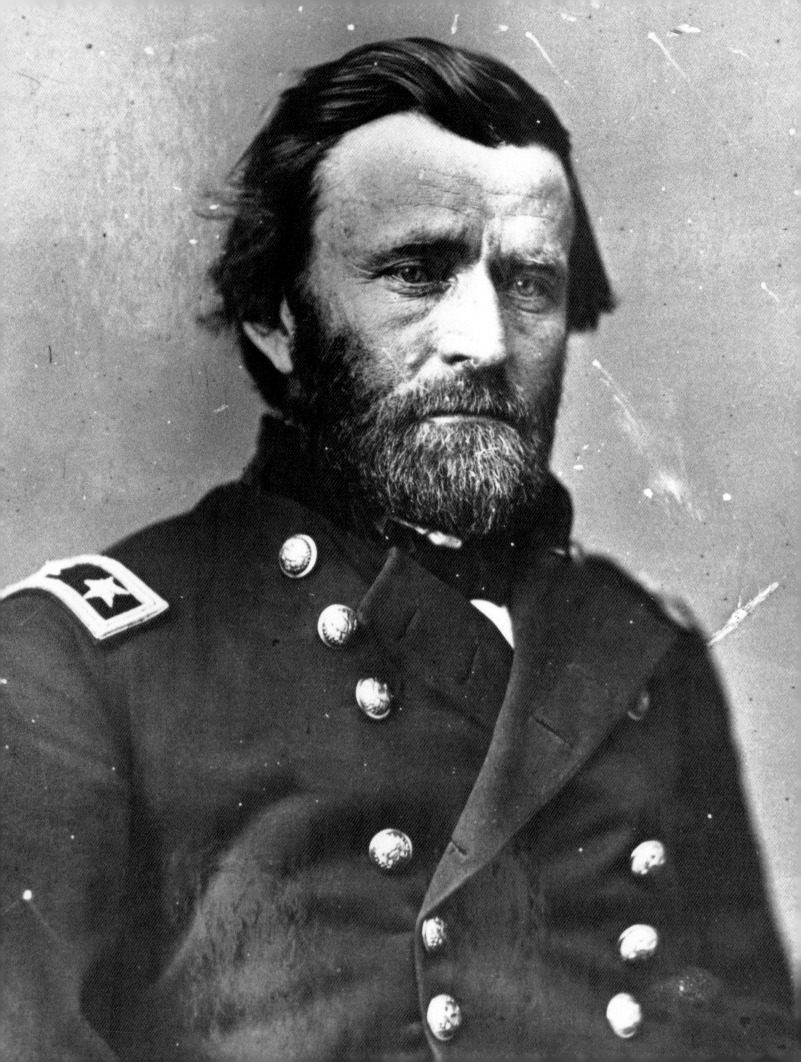

LEFT

Major General Ulysses S. Grant, whose demeanor of quiet calm and determination betokened, as one of his soldiers remarked, a man who "looked as if he meant it." For Grant, the "it" was pressing the war to victory, and at Forts Henry and Donelson he was launched on his way.

RIGHT

No photographer was with Grant when he made the fight at Shiloh, and this, captured some months later, is the only battlefield image that survives. Surprised and pushed back to the Tennessee River on the first day's fight, Grant struck back and drove on to victory. He would never be surprised in battle again.

BELOW

Johnny Clem was a nine-year-old Ohio boy who ran away from home in 1861, and became an overnight sensation after he was in the battle of Shiloh. The "Drummer Boy of Shiloh" appeared on mass-produced photographs like these throughout the war. He stayed in the army, rising to the rank of major general by 1916.

FOLLOWING PAGES

Captain A.M. Rutledge, standing in the center, commanded a Tennessee battery whose officers posed with one of their guns here on July 4, 1861, a date just as important to Confederates as to Yankees. At Shiloh their battery helped pound part of Grant's army into submission.

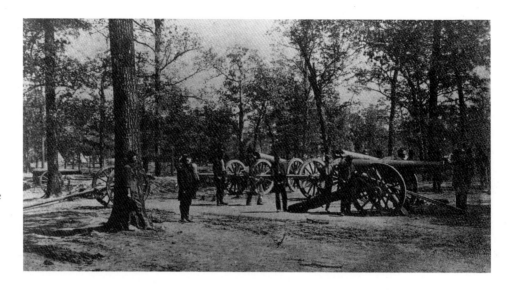

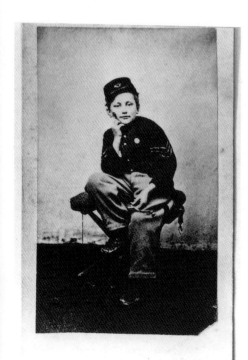

69

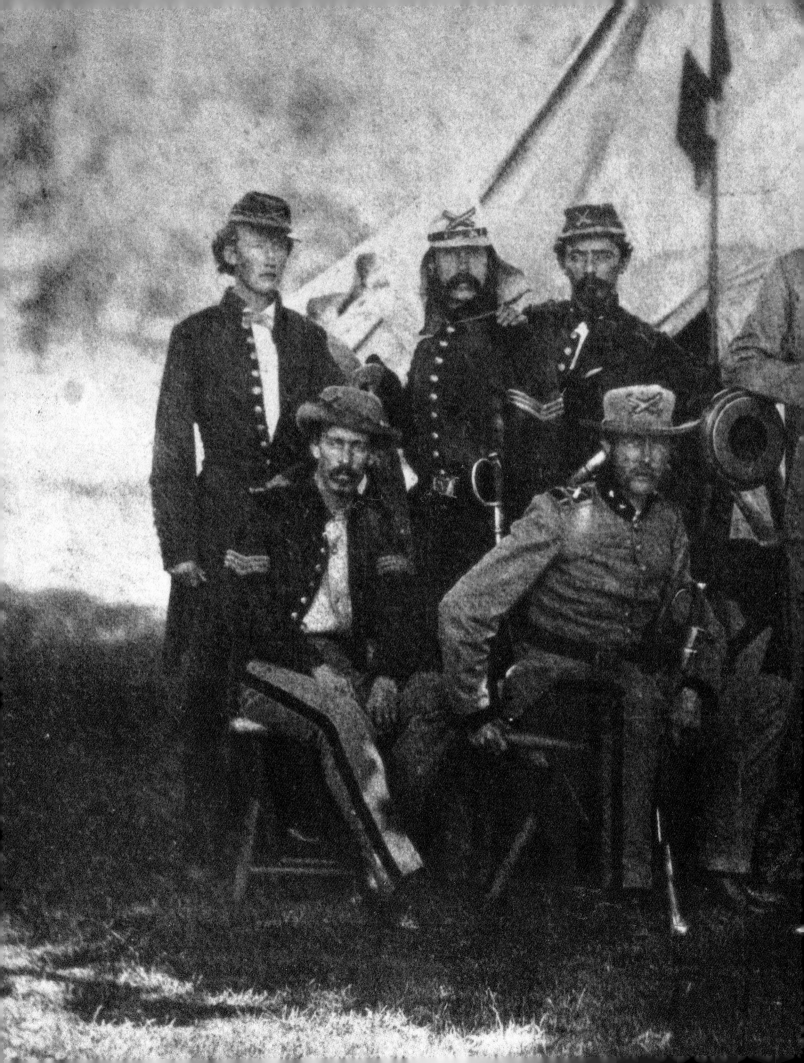

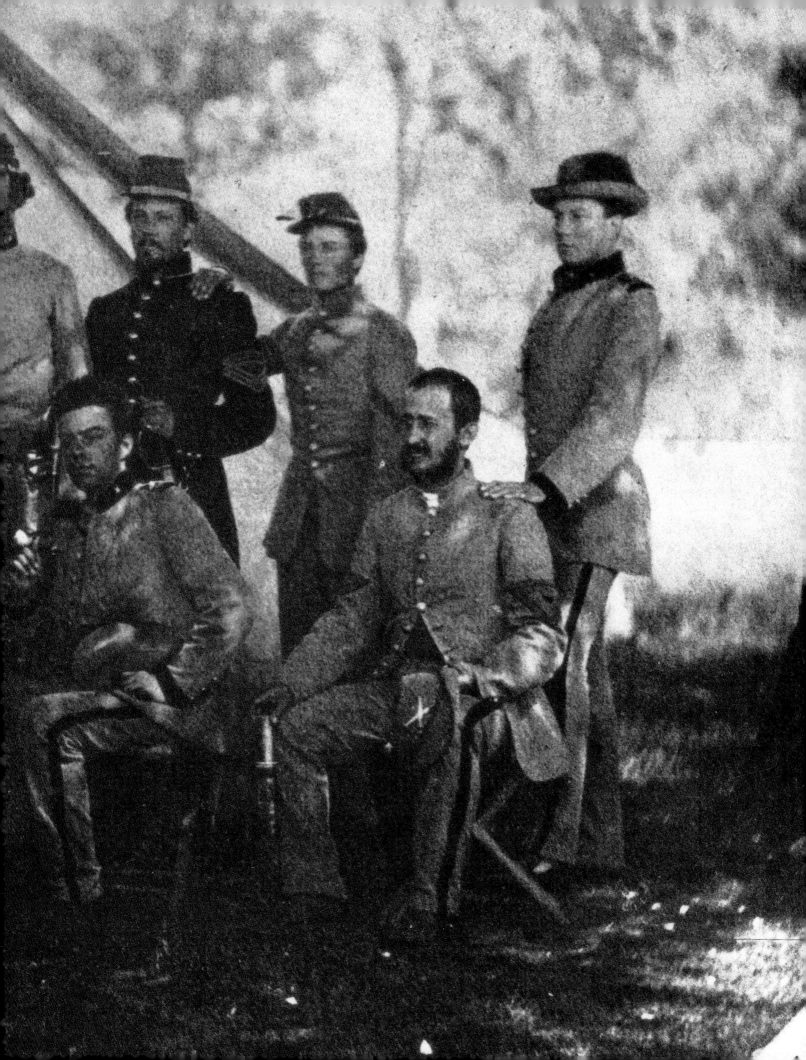

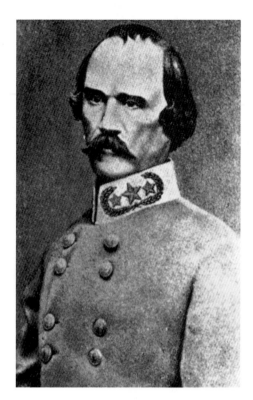

LEFT

General Albert Sidney Johnston was, until his death, the senior ranking field officer in the Confederacy, and the man whom President Davis expected to be his greatest general. His early and unnecessary death at Shiloh was the beginning of an enduring controversy over what might have happened had he lived.

BELOW

The beaten Confederate Army, now under Beauregard, retreated to its base at Corinth, Mississippi, shown here several months later, after Grant's forces had taken it. Its importance to both sides lay in those railroad tracks, for where the rails went, the armies could follow speedily.

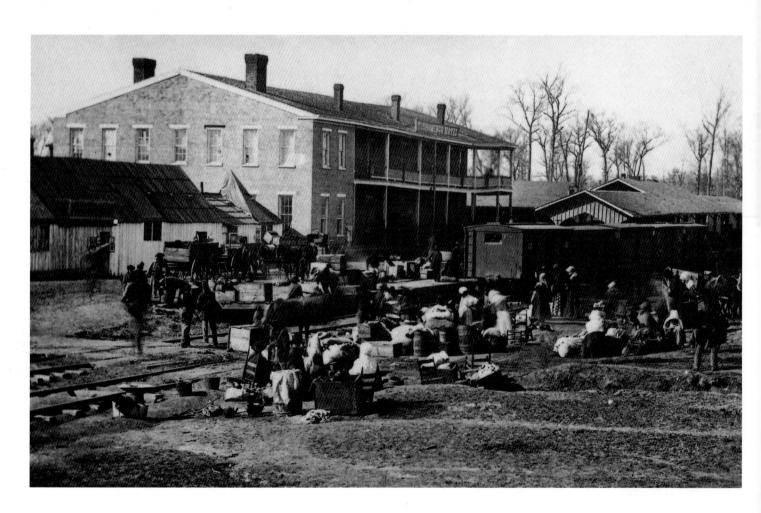

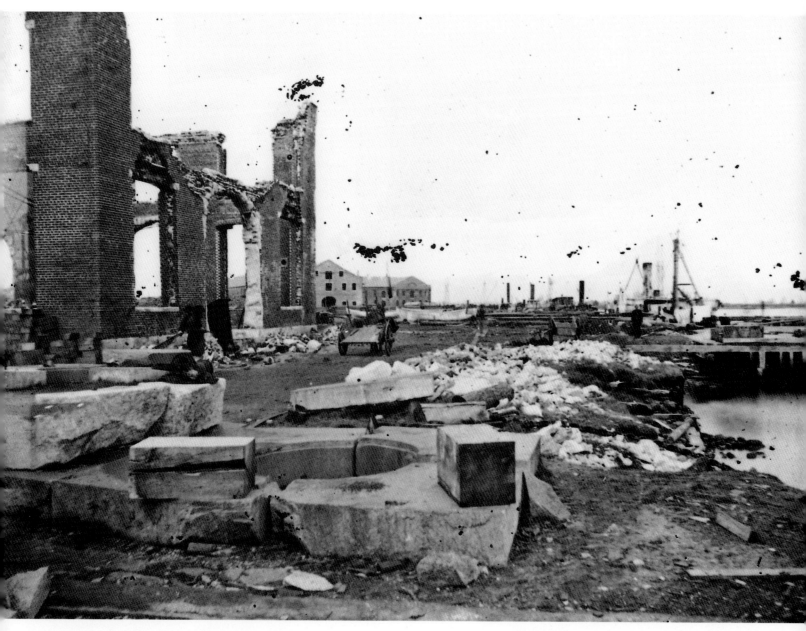

ABOVE
On May 9, 1862, the Confederates had to
abandon Norfolk and the Gosport Navy Yard, as
McClellan's army began its glacial advance up the
Virginia Peninsula. Before they left, the
Southerners destroyed almost anything that
they could not take with them.

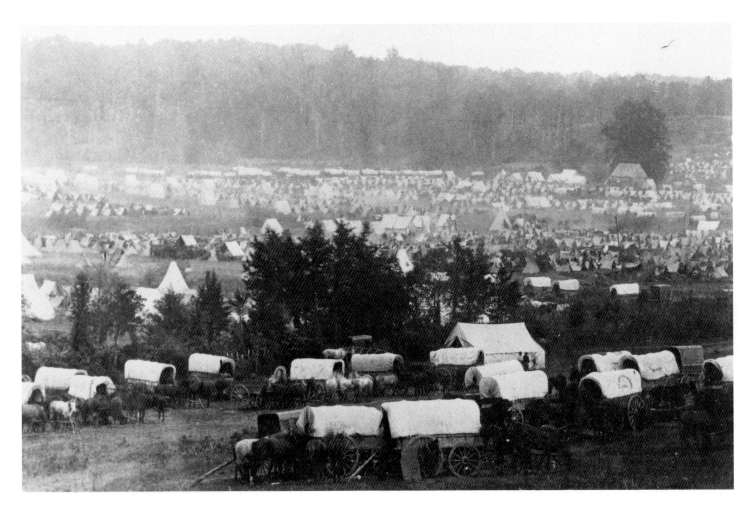

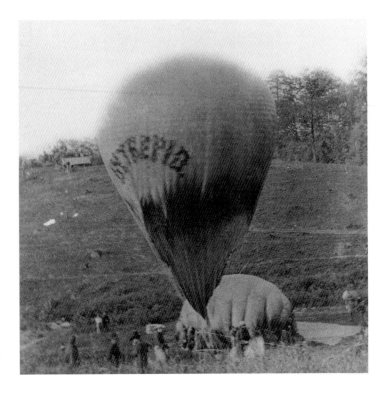

ABOVE
McClellan created a massive supply base for his
army at Cumberland Landing on the Pamunkey
River, and James Gibson captured images like this
one to give testimony to the size and complexity
of a major army on campaign. In time, McClellan
would have more than 100,000 men with him.

RIGHT
"Little Mac" hungered for information, though
unfortunately he seemed only to believe those
dispatches that reinforced his caution. He enthu-
siastically employed Professor Thaddeus Lowe's
gas balloons, sending them up repeatedly to scan
enemy lines in the distance.

BELOW
Confederates defending the port on the York River at Yorktown created a number of shore batteries, and used whatever they could to provide their defenses. The usual material was sandbags, but now and then they took advantage of bales of cotton. When they evacuated and destroyed their batteries, the cotton created a fluffy debris.

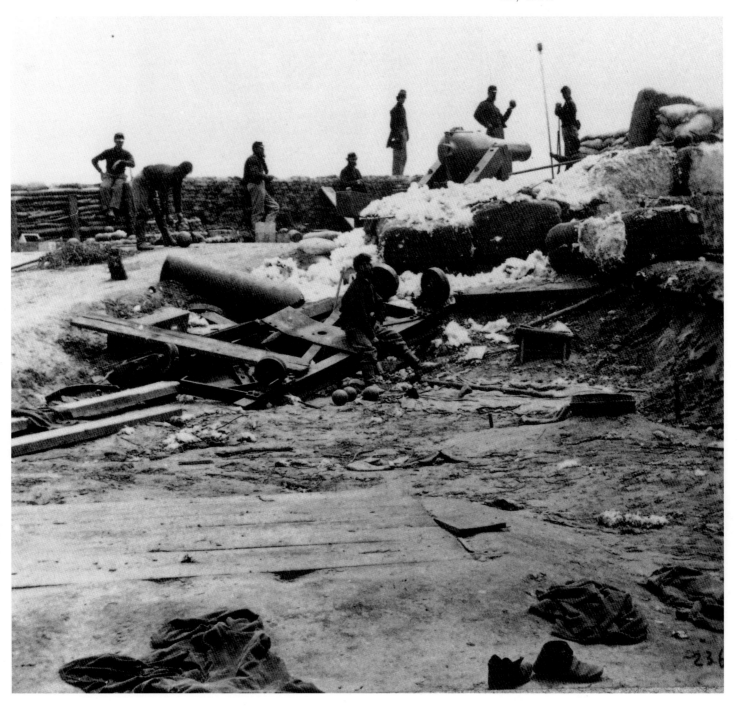

RIGHT
General John Bankhead Magruder, Confederate defender of Yorktown, was called "Prince John," for reasons obvious in his photograph. He was also boastful and prone to the bottle, but a good officer who delayed McClellan's advance far longer than could have been expected.

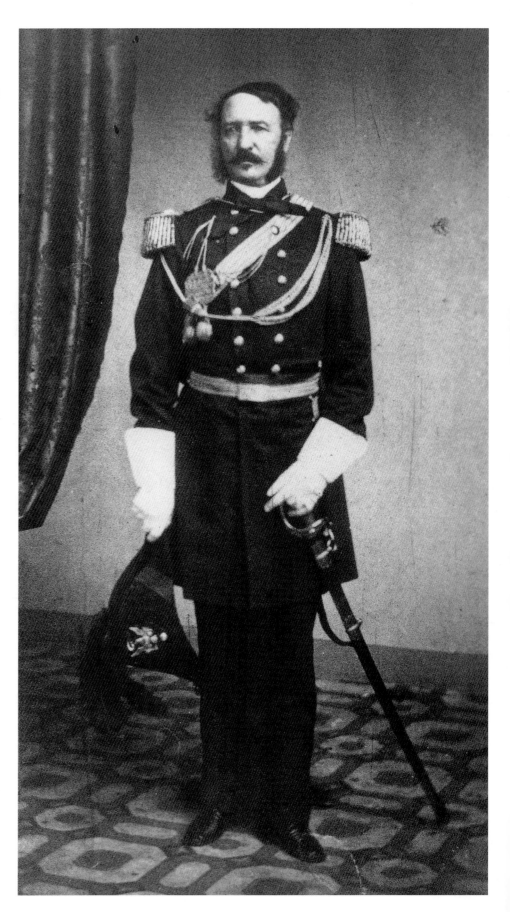

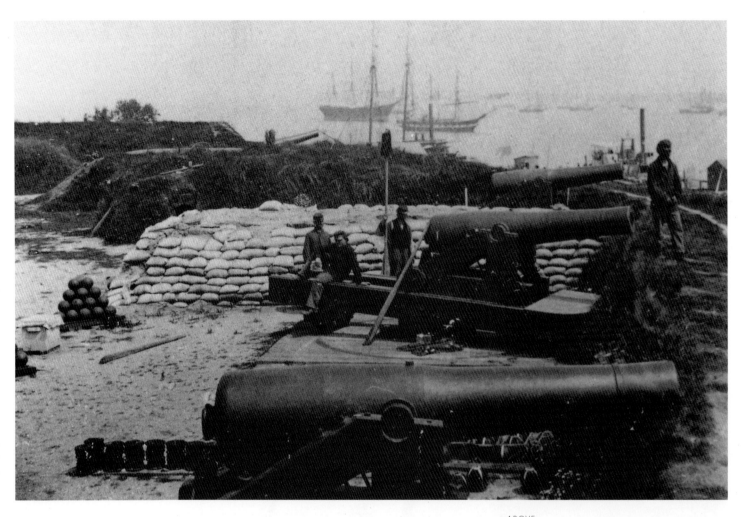

ABOVE
After the Confederates evacuated Yorktown, the Federals quickly occupied and repaired their defenses, being themselves still in enemy territory. This water battery on the York would never fire in anger at a Southern vessel, however, and it would itself be soon evacuated again.

RIGHT
Scenes of destruction of civilian homes and property first became commonplace during the Peninsular Campaign. Here Union soldiers pitch their tents and start their cook fires with only the stark chimneys as a reminder that not long before this was someone's home.

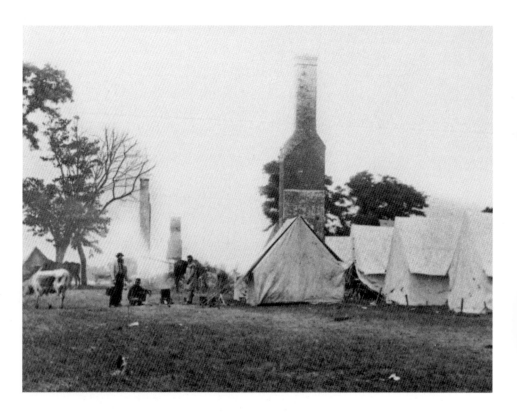

LEFT
The ruins of Gaines's Mill, site of the third of the Seven Days' Battles. The armies left the mill a complete ruin, one of its grinding stones for corn and wheat lying propped against a wall. Confederates had little enough food production as it was, so the destruction of mills only made the lives of its soldiers the harder.

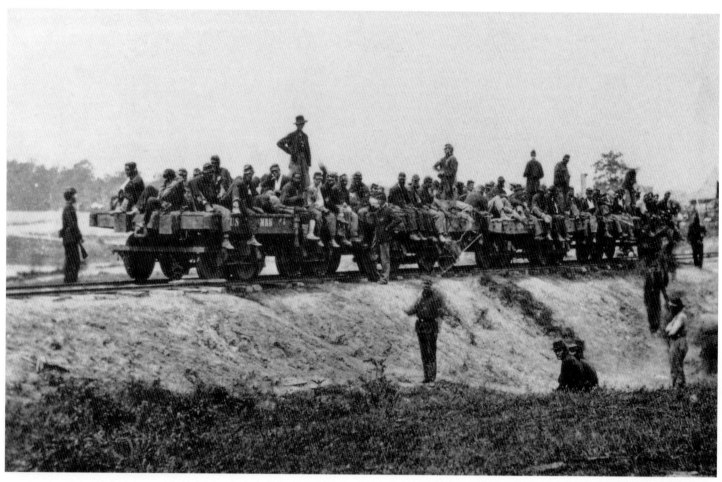

ABOVE
After the action at Gaines's Mill, McClellan sent
most of his movable wounded to the rear on
these flatcars and other rolling stock of the
Richmond & York Railroad, boarding them here
at Savage Station. Some are clearly wrapped in
bandaging, though most appear to be at least
ambulatory.

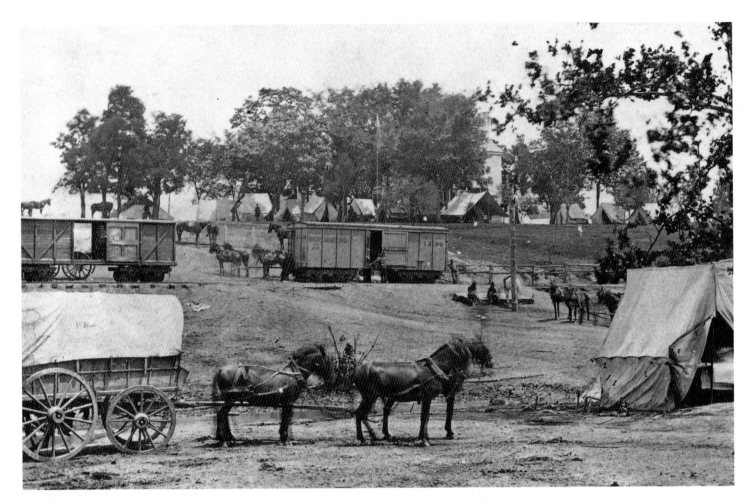

ABOVE

No sooner were Union wounded being evacuated via Savage Station than Lee and McClellan shifted toward the station, and there they fought again in the fourth of the Seven Days' Battles, on June 29, the day after this image was made. Soon enough those boxcars would be full of even more wounded.

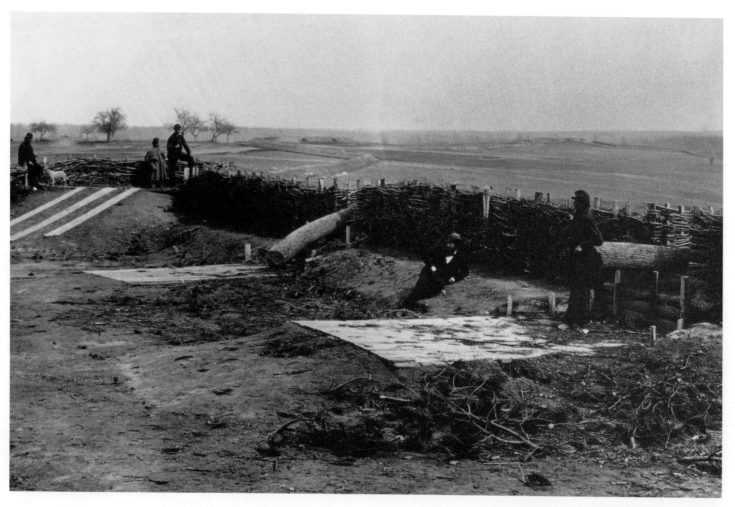

For months the Confederates in their defenses around Centreville had exaggerated their strength and armament with tree trunks sticking out of cannon embrasures, ironically dubbed "Quaker guns." Their extensive earthworks, shown in the distance, were destined never to see action.

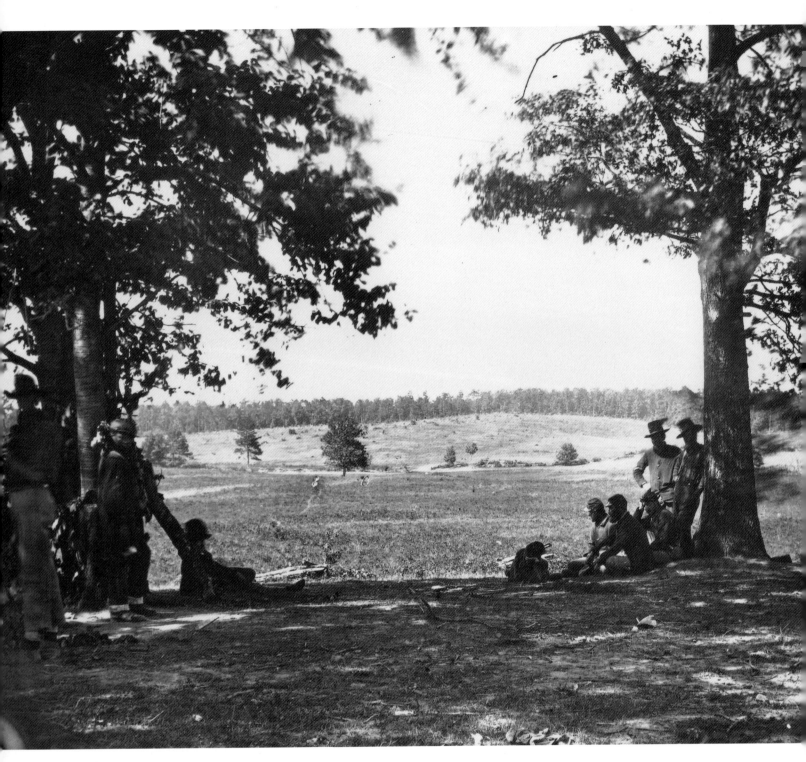

ABOVE
As the scene of fighting shifted from the
Peninsula back to northern Virginia, Federal
forces tried once more to strike south, but after
initial success here at Cedar Mountain on August
9, 1862, elements of Stonewall Jackson's corps
arrived in the nick of time to give the Yankees a
sound beating.

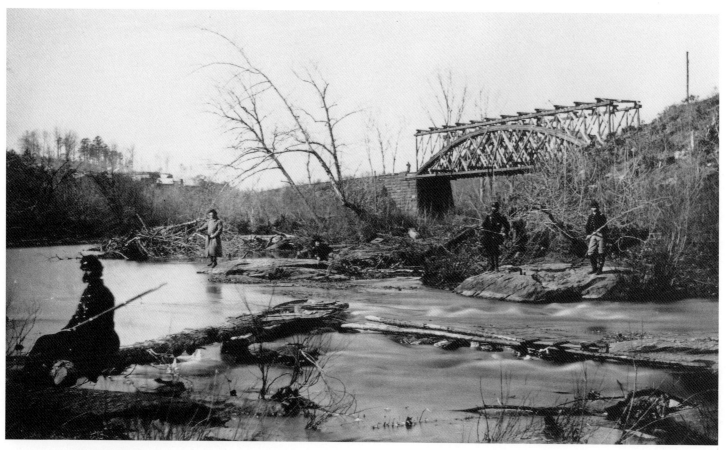

ABOVE

Late in August the armies came again to Bull Run, where the Union would suffer another humiliating defeat along these waters. Here the Orange & Alexandria Railroad, principal lifeline of the Union Army in northern Virginia, crossed the stream at Union Mills.

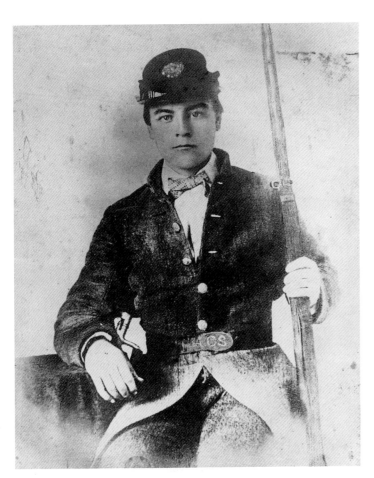

LEFT
William G. Sheppard of the 1st South Carolina Infantry wears the regulation "CS" belt plate that later soldiers rarely ever saw. Service in Virginia with Lee's army in the 1862 campaign was, for many of these boys, their first trip away from the Deep South.

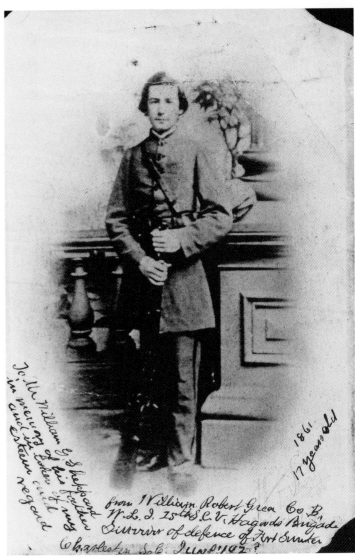

RIGHT
William R. Green of the Washington Light Infantry of Charleston was just 17 when he enlisted. With his unit redesignated the 25th South Carolina Infantry, he fought in Lee's army through the 1862 campaign, and later returned to Charleston to take part in its defense.

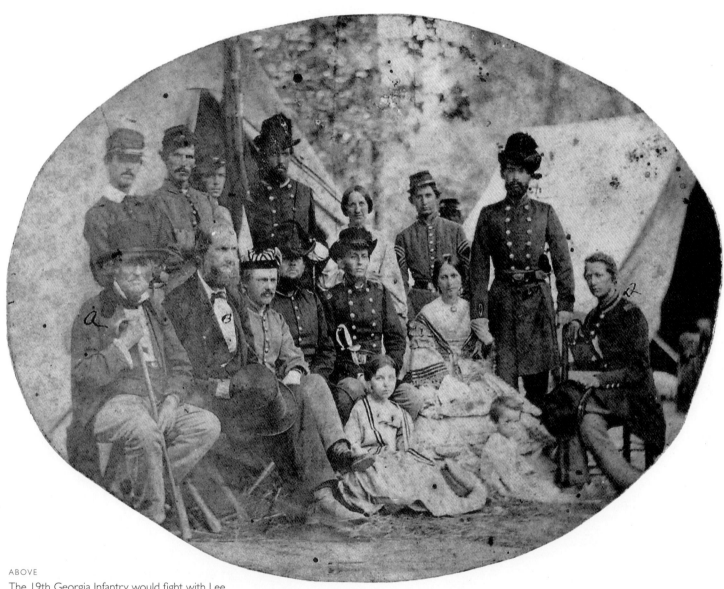

ABOVE
The 19th Georgia Infantry would fight with Lee all through this hard summer, led by Lieutenant Colonel Thomas C. Johnson, standing at right. Seated beside him is his brother, Lieutenant William C. Johnson, who served on his staff; another brother, Sergeant R.A. Johnson, is standing next to the colonel.

FOLLOWING PAGES
The Washington Artillery of New Orleans traveled ever farther to fight in Virginia. Of its five companies, four stayed in the western theater, but one went east and remained with Lee throughout the war, becoming one of the premier artillery units in his army.

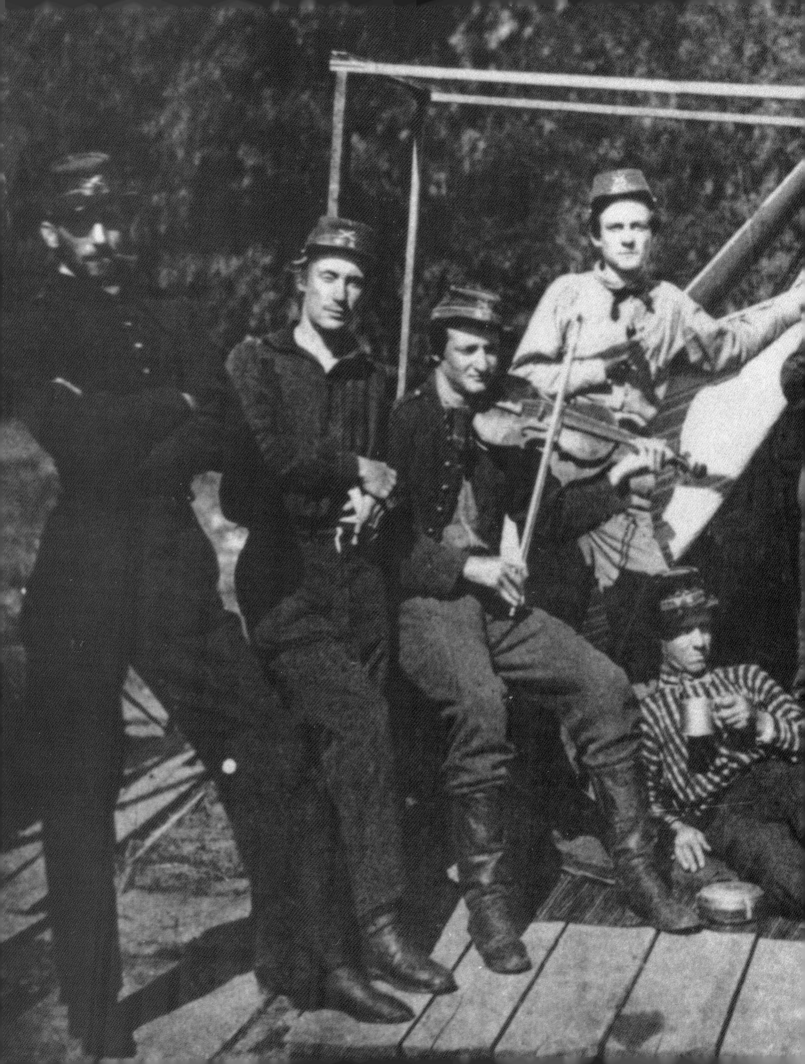

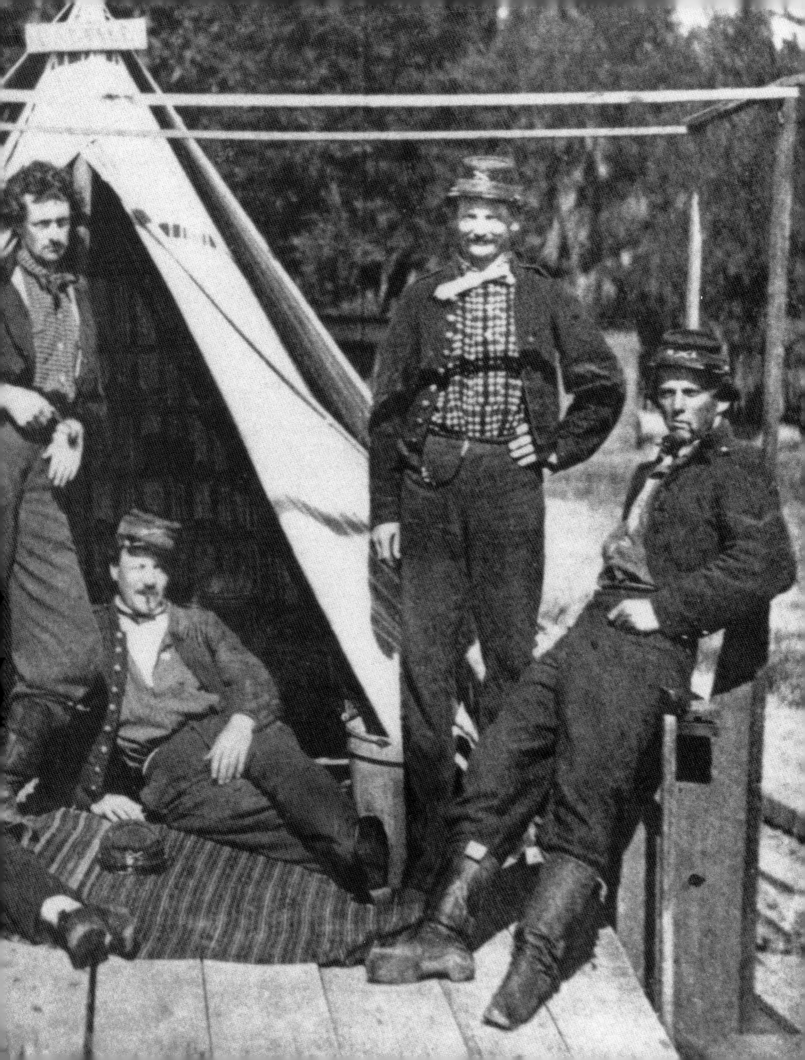

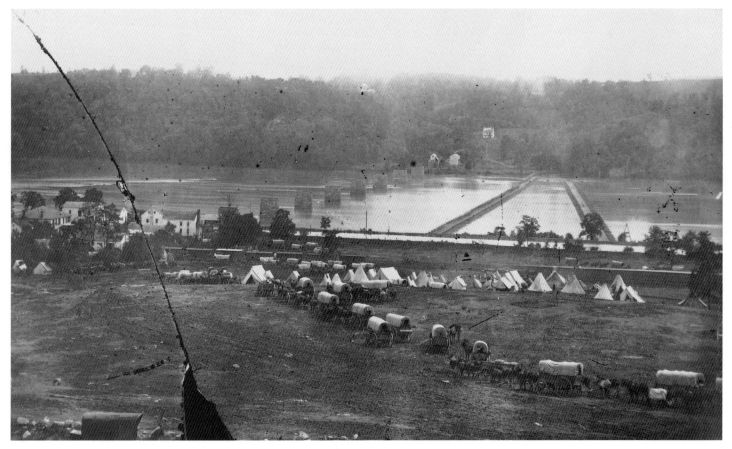

ABOVE
The Potomac River crossing at Berlin, Maryland, in 1863 looked much as it did the year before. The bridge has been destroyed, only its piers remaining. Skirmishing here in September 4, 1862, presaged Lee's crossing of the river on his invasion of the North.

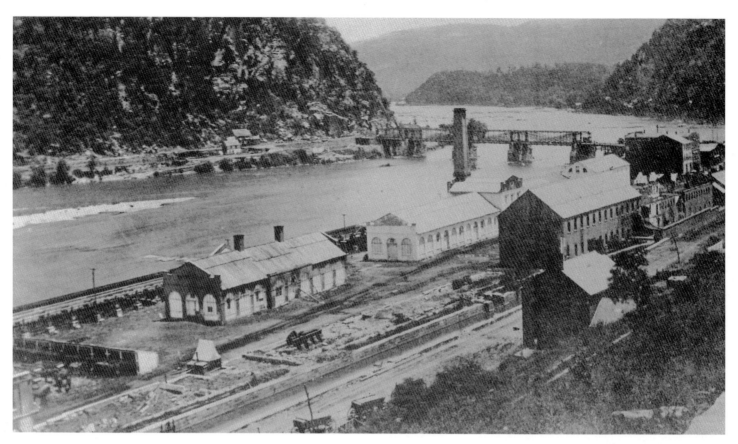

ABOVE

As part of Lee's invasion of Maryland, he sent Stonewall Jackson to capture Harpers Ferry, Virginia, which guarded the Baltimore & Ohio Railroad, and also afforded a line of communications and retreat back to the Shenandoah Valley. Jackson would capture more than 10,000 Yankees and visit destruction on the Federal armory shown here.

RIGHT

Lee and McClellan met in the Battle of Antietam around the little Maryland village of Sharpsburg. Photographer Alexander Gardner captured this view of its deserted main street just two days after the battle. Many of the houses shown are in fact filled with Union and Confederate wounded.

LEFT
Major General A.P. Hill, one of Lee's most combative division commanders, had been left to deal with Harpers Ferry when Jackson and the rest of his corps joined Lee in Maryland. Hill then rushed to the battle, arriving at the critical point, just in time to prevent a disaster.

BELOW
Often mistaken for a photo of actual fighting taking place in the right distance, this Gardner image was made the day after the battle. It looks over ground that just two days before was covered with Union soldiers preparing to go into battle east of Antietam Creek, the stream that gave the engagement its name.

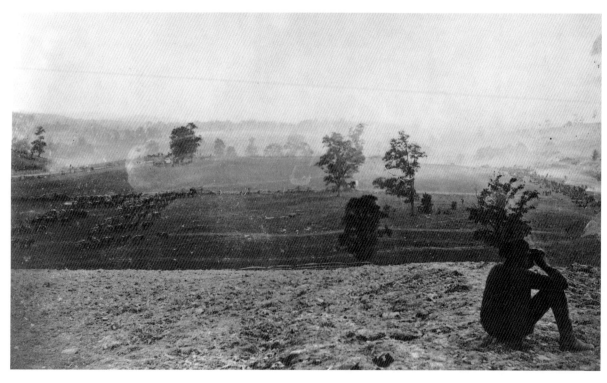

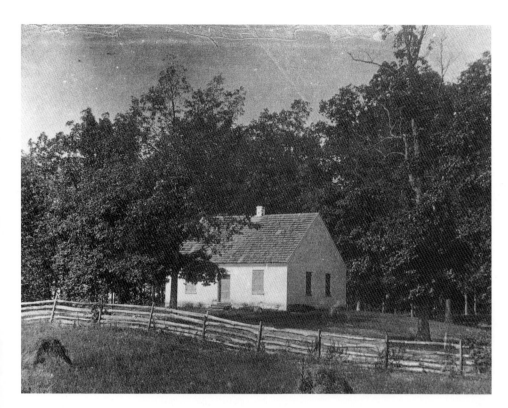

LEFT
One of the most famous landmarks of the Antietam fight was this modest church belonging to the Dunker sect. Immediately after the battle, the field in front of the rail fence was littered with Confederate dead from what proved to be the bloodiest single day of the entire war.

BELOW
So horrible were the casualties in a sunken road in the middle of the battlefield that it became known to posterity as Bloody Lane. Two days after the fight, Gardner made this image of Confederate dead in the lane. These photos of the dead at Antietam would be among the first to bring the horror of war to people at home.

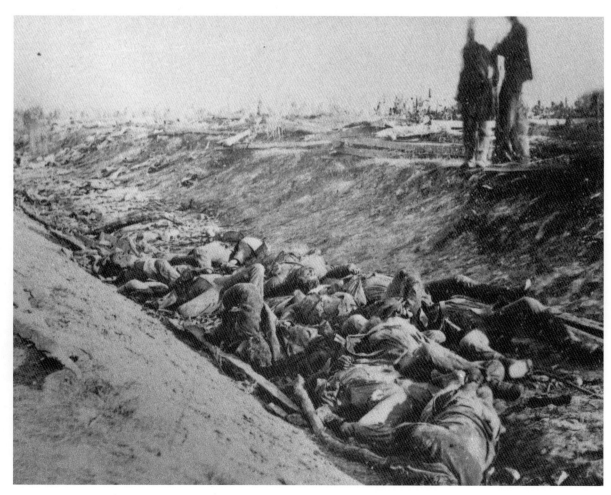

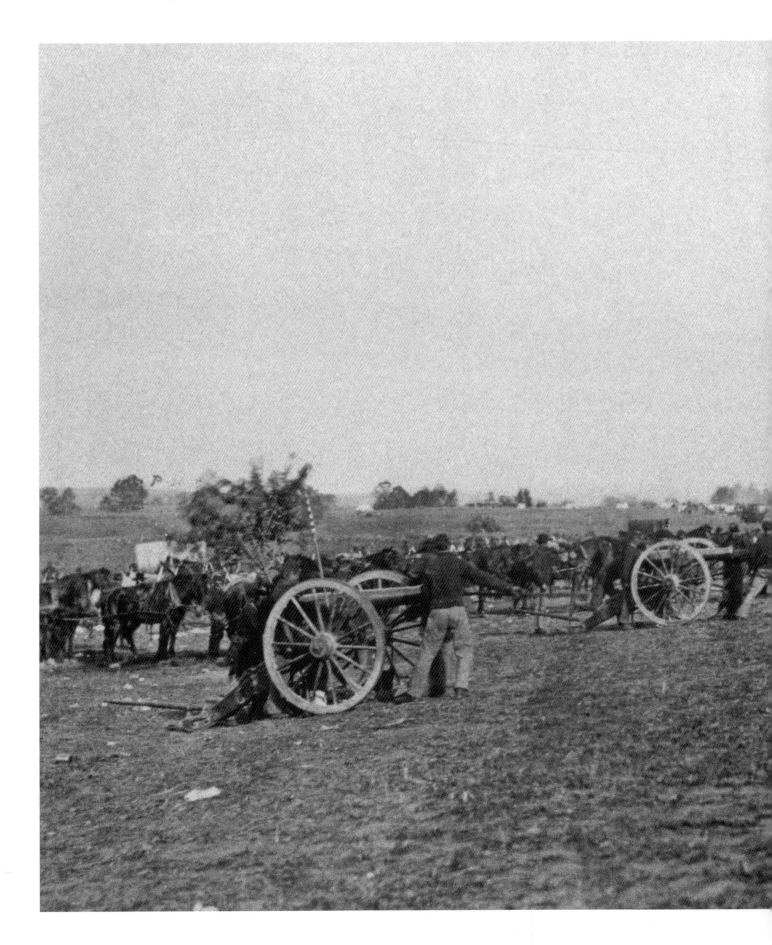

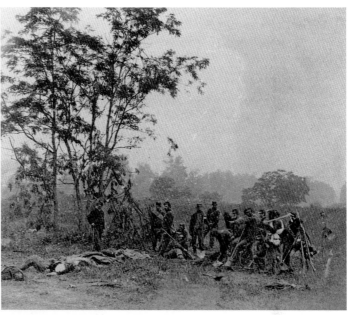

ABOVE

The saddest duty of all after any battle was the burial detail. Gardner caught these Union soldiers with their picks and shovels about to inter their fallen comrades on the north end of the battle line. More than 2,000 men, North and South, died that day—more Americans than were killed on D-Day in 1944.

LEFT

A dramatic scene of Battery D of the 5th United States Artillery, taken by photographer Timothy O'Sullivan. The scene is posed, for in action the men would not be acting in such unison, nor would they be likely to be in full uniform and with their animals so close to the line.

RIGHT
Confederates who fought against all the odds to
hold a crucial bridge across the Antietam, were
finally forced back by superior numbers after
being all but erased from the field. Men like
these Georgians littered the ground in the path
of the retreating Rebels.

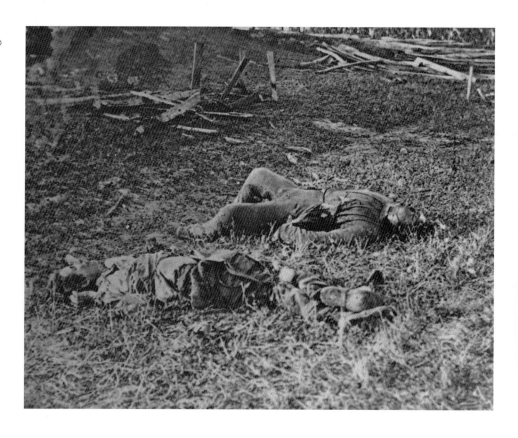

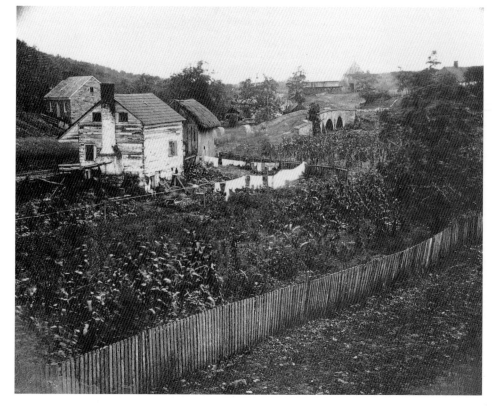

LEFT
Antietam Bridge, often confused with Burnside's
Bridge, crossed the creek at the northern end of
the battlefield, General McClellan's headquarters
lay just beyond the bridge, and there he stayed
throughout the fight rather than coming to the
front to exert more active control.

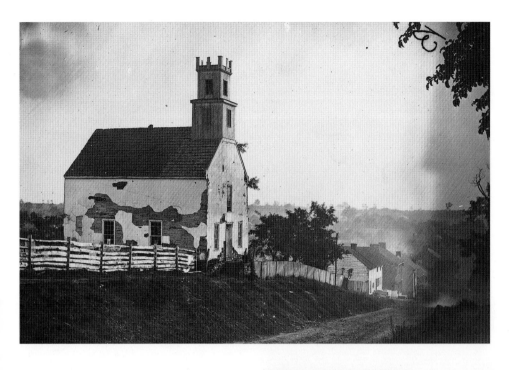

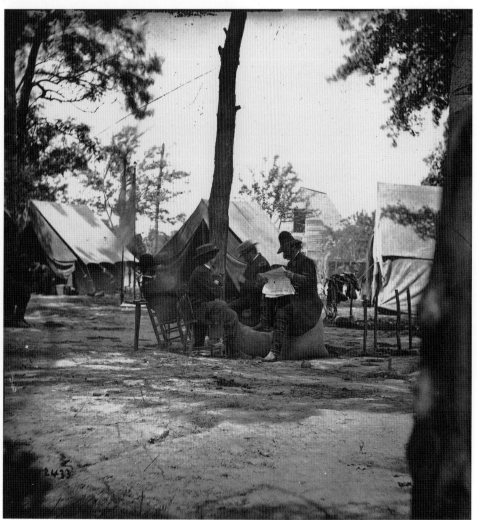

Sharpsburg itself suffered as the armies battled in the fields surrounding the town. St. Paul's Church shows the effects of stray shelling from both Union and Confederate cannon. Little could citizens know that their community would soon become one of the war's first tourist "attractions."

Ambrose Burnside was a capable subordinate, but a poor commander, and had not wanted command of the Army of the Potomac. In this 1864 image, he reads a newspaper at his headquarters, with photographer Mathew Brady sitting across from him.

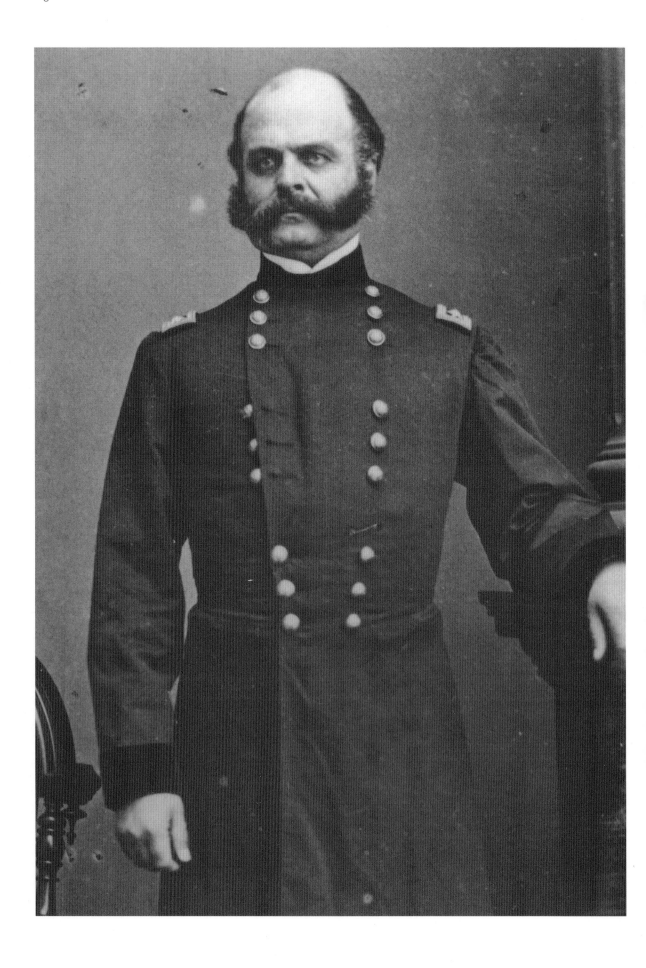

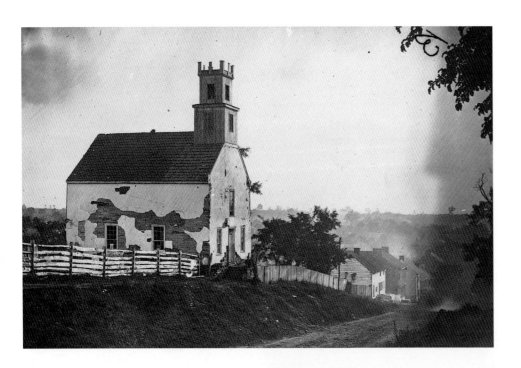

ABOVE
Sharpsburg itself suffered as the armies battled in the fields surrounding the town. St. Paul's Church shows the effects of stray shelling from both Union and Confederate cannon. Little could citizens know that their community would soon become one of the war's first tourist "attractions."

RIGHT
Ambrose Burnside was a capable subordinate, but a poor commander, and had not wanted command of the Army of the Potomac. In this 1864 image, he reads a newspaper at his headquarters, with photographer Mathew Brady sitting across from him.

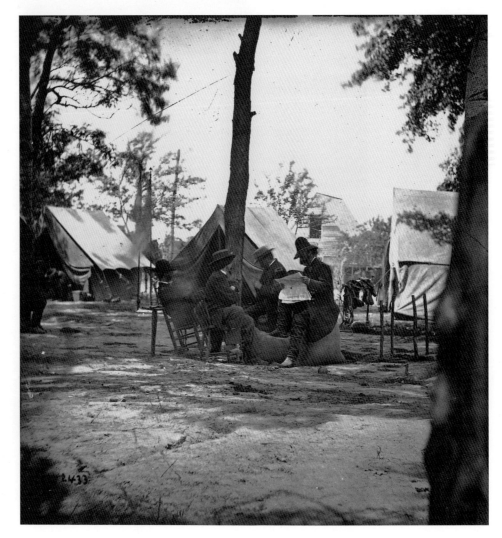

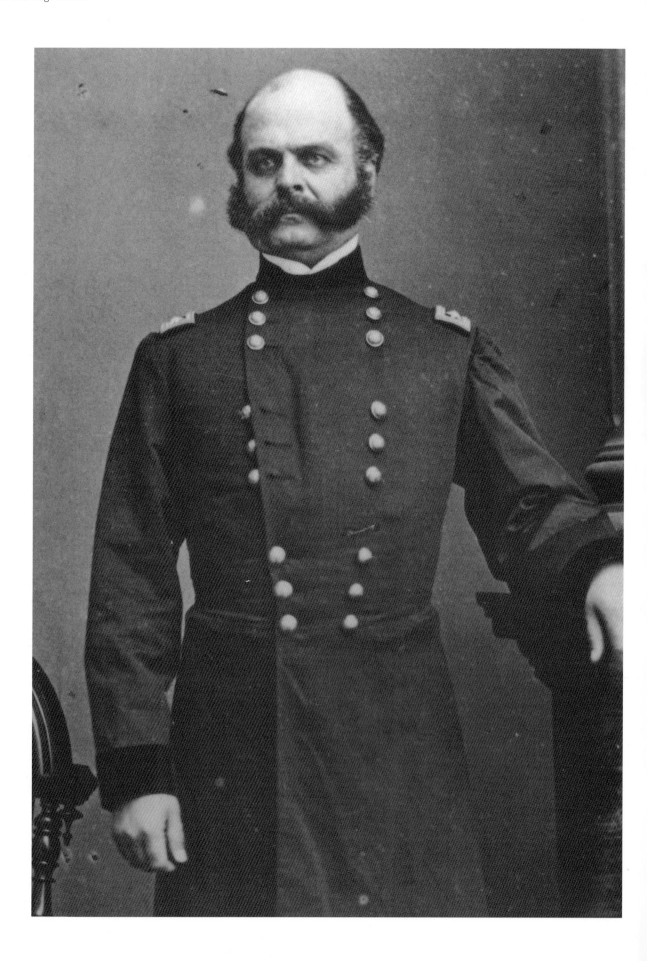

Burnside's grand side-whiskers were such a trademark that this style of facial hair became known as "burnsides," a term so similar to the English expression "sideboards" that it was later twisted into the now universal expression "sideburns." With his defeat at Fredericksburg, this is all that he is known by to posterity.

Pontoon bridges like this one, shown in an 1864 image of the Rappahannock near Fredericksburg, are what Burnside sent his men across in their attempt to take the city. They were open targets from the time they started building the bridges under fire, until they crossed to the other side.

After the Yankees occupied Fredericksburg itself, here in the distance, they had to march out in formation and move up the slopes straight into the guns of Confederates dug in all along Marye's Heights in defensive works like the earthworks in the foreground. It was almost suicidal.

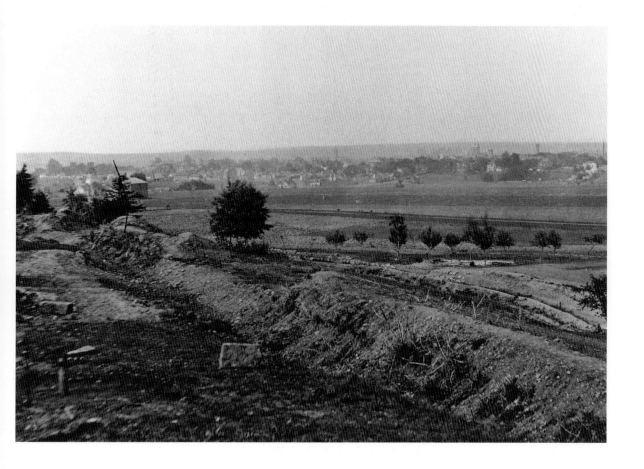

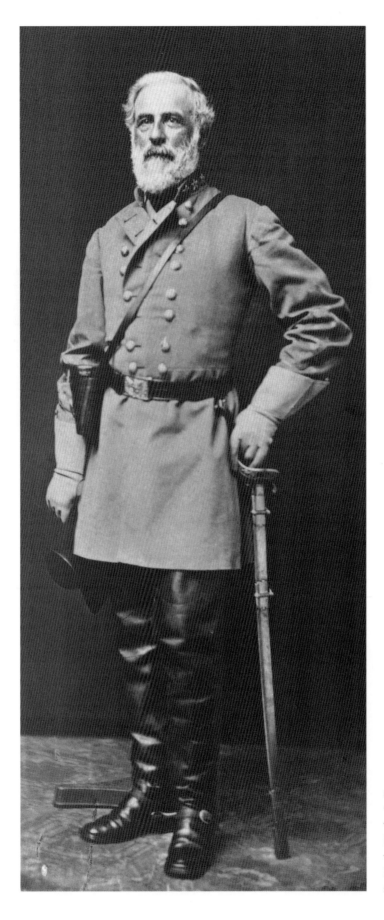

LEFT

General Robert E. Lee in 1863, much as he would have looked at Fredericksburg, in riding boots, with his field glasses at his side. It was after viewing the carnage through those glasses at Fredericksburg that he said it was well war was so terrible, "else we should grow too fond of it."

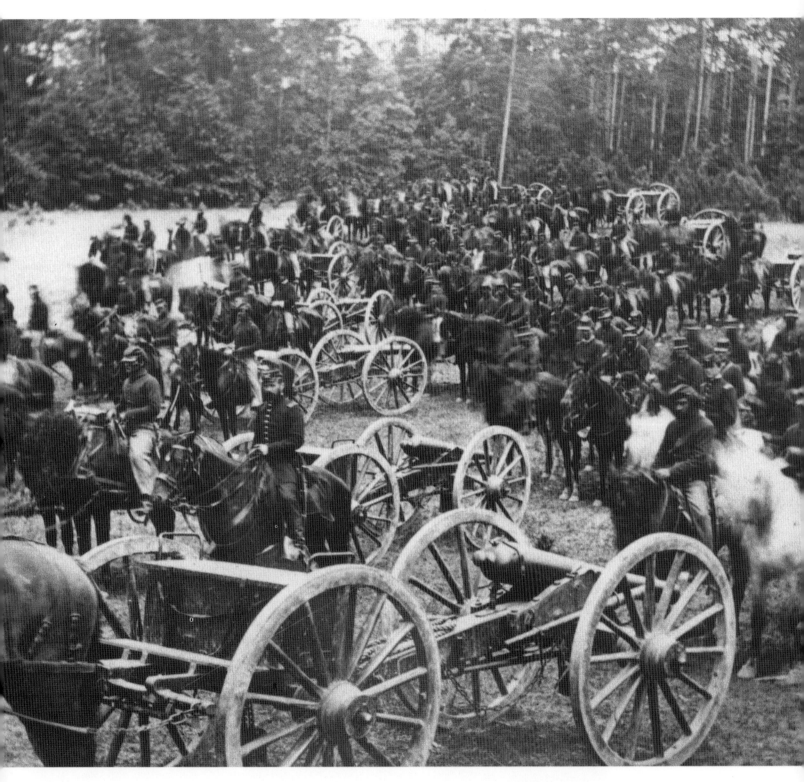

ABOVE
Both Lee and Burnside had mobile field artillery in use during the battle, especially on the left of the Southern line, where division commander General George Meade employed batteries like this with its 3-inch ordnance rifles.

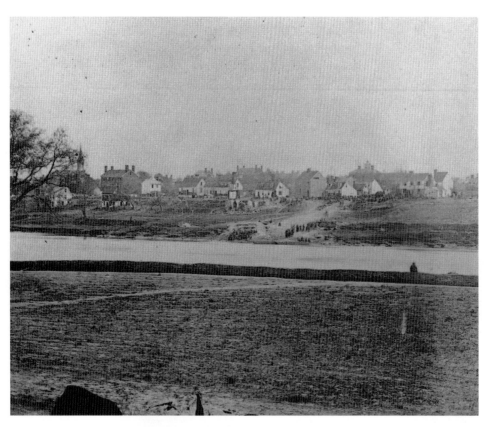

LEFT

The Rappahannock river, and on its opposite bank the town of Fredericksburg. Federal bravery here simply could not overcome bungling and lack of coordination. The men shown at the landing are a Federal flag of truce party coming to bury their dead after the battle.

BELOW

At Fredericksburg, Confederate citizens first learned on a large scale the price that civilians would pay. The Phillips family had a handsome brick home before the battle. Afterward they had nothing but the rubble left by Union artillery fire on the Confederates who were using the house for defense.

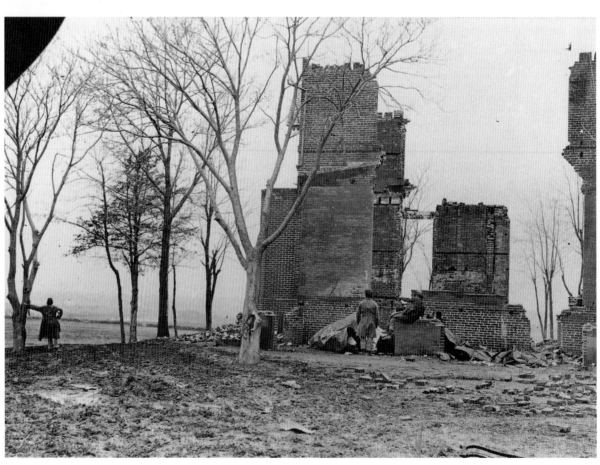

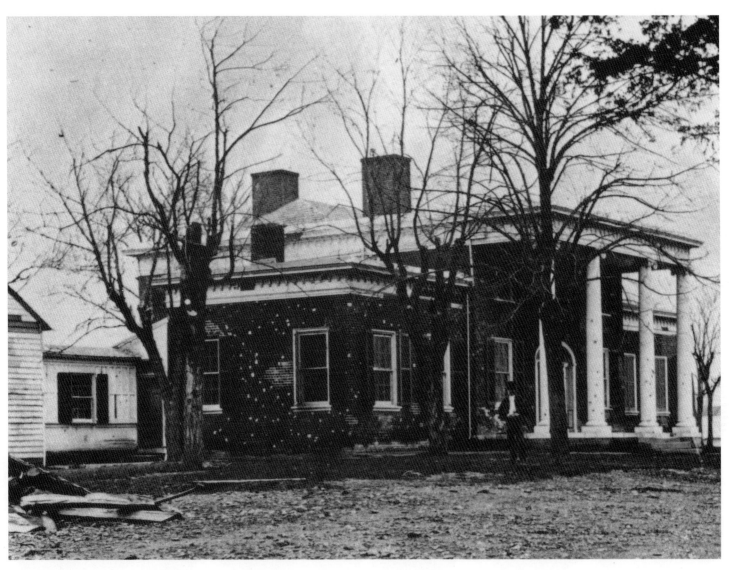

ABOVE
The Marye house atop Marye's Heights was
fortunate enough to survive the battle, but still
Yankee bullets pock-marked its walls and Ionic
columns. It was the slope immediately in front of
the house that became the great killing field of
the battle.

FOLLOWING PAGES
Photographers caught almost nothing of the late
1862 fighting in the western theater, where
General William S. Rosecrans led Union efforts
in Tennessee. Here he sits fourth from the left
with his staff, General (and future president)
James Garfield right of him, and General Philip
Sheridan seated at far right.

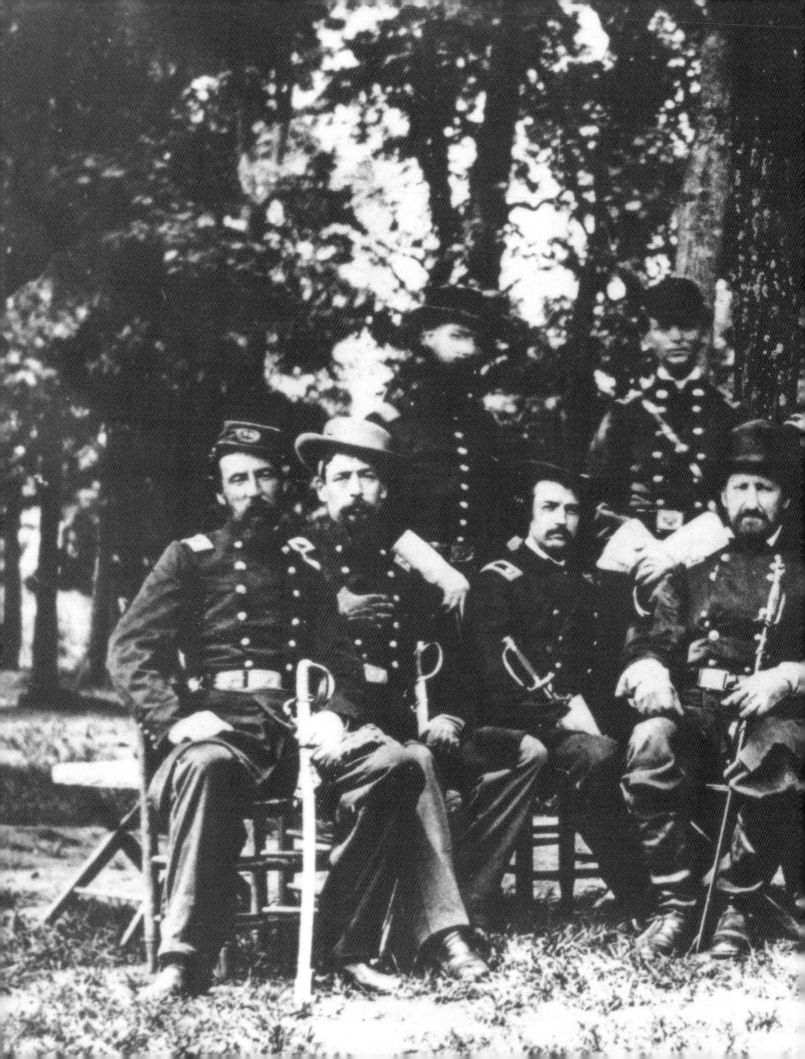

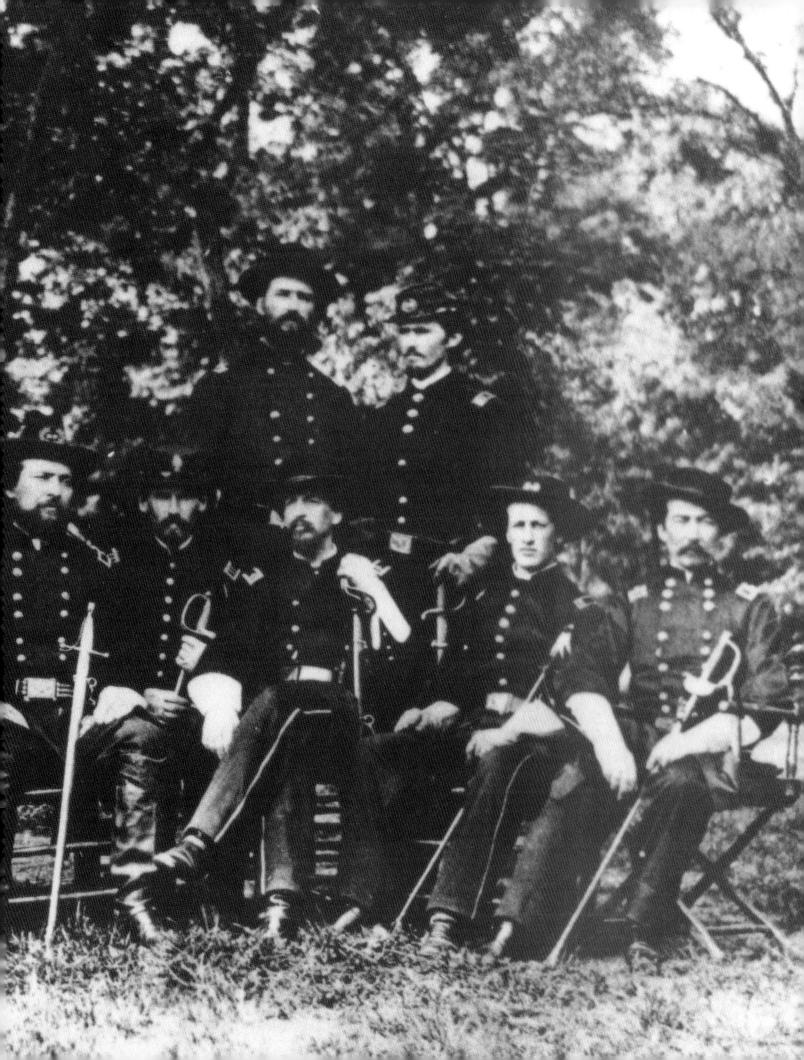

Cavalry

The cavalry was easily the most appealing service on either side in the Civil War, for it so much appealed to mid-Victorian notions of the pageantry and gallantry of war. Both sides would find themselves with too many mounted units before long, a problem exacerbated by difficulties in procuring sound horses, and more so by controlling independent-minded cavalry commanders who themselves were caught up in the lure and romance.

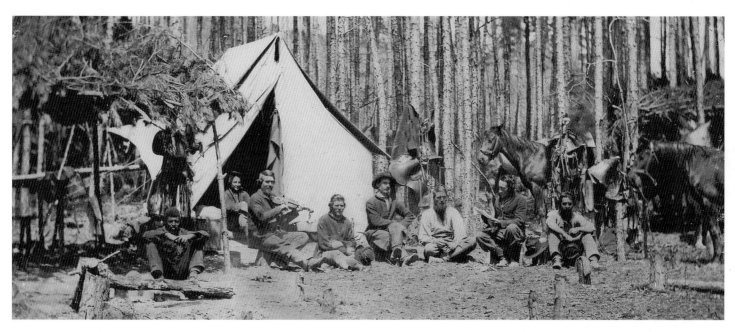

ABOVE
A rare image of Union cavalrymen taken in Georgia in 1864 during Sherman's campaign from Chattanooga to Savannah, shows them resting beside their mounts, one man with a fiddle, and "shebangs" for shade at the left and right, a "contraband" former slave seated at left.

BELOW
A Union cavalry regiment in Louisiana in 1863 parades its mounts for inspection. Each man stands in front of his horse while officers check the grooming and condition of the animals in the foreground, as troopers have saddled and mounted farther down the line.

ABOVE

A typical Union cavalryman, a corporal, poses
fully equipped with regulation saber and revolver,
though the pistol should be in a holster rather
than shoved into his belt for the camera. The
shoulder scales are early war, and would largely
be dispensed with by 1863.

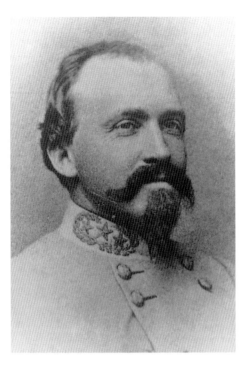

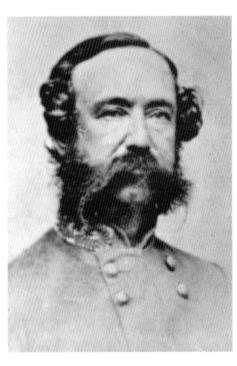

FAR LEFT
One of the most daring and notorious Confederate cavalry commanders was General John Hunt Morgan of Kentucky, whose raids into the Bluegrass made him the object of Yankee enmity and Confederate suspicion. In 1864 in Tennessee, he would be killed in his nightshirt.

LEFT
General Wade Hampton of South Carolina raised a "legion" in 1861, a unit with infantry, cavalry, and artillery rolled into one, but he soon switched to cavalry command, and in 1864, after the death of Jeb Stuart, he rose to command the cavalry corps of the Army of Northern Virginia.

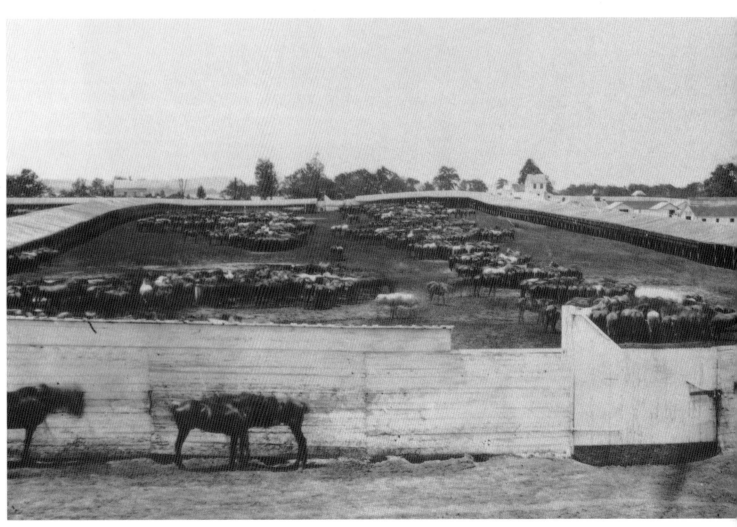

RIGHT
Most controversial among the mounted leaders were the partisans, some regularly enlisted, like Colonel John Singleton Mosby shown here, and some mere free-lances out for plunder. Mosby, the so-called "Gray Ghost," became arguably the most effective partisan of the war.

BELOW
The Union established giant cavalry installations for the procurement, training, and assignment of mounts, like this one at Camp Stoneman at Giesboro Point, Maryland. Tens of thousands of animals passed through here on their way to the regiments.

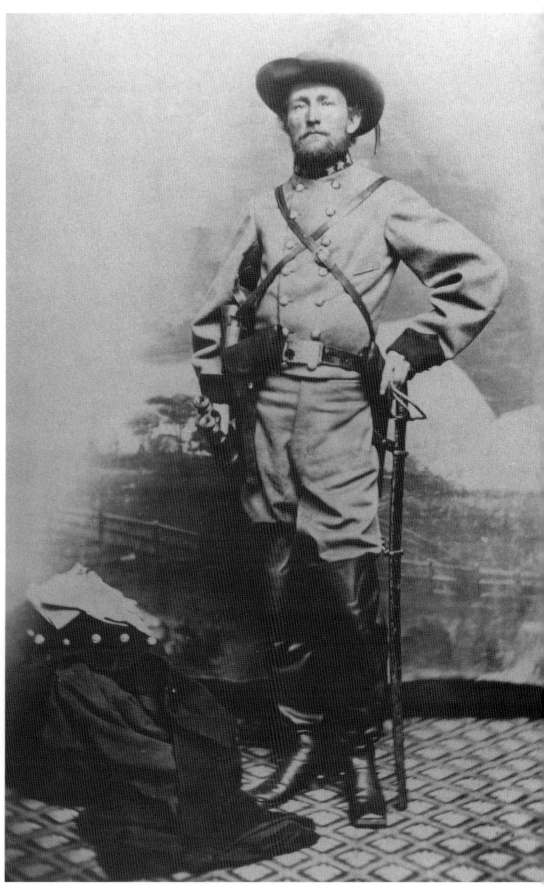

Camp Life: Union

For every day they were actually involved in battle, soldiers spent 20 days or more enduring the boredom of camp life. Thus their daily lives revolved largely around the routines of eating, drill, camp policing, and finding entertainments to fill their idle hours. The soldiers of the Union had the advantage of better and more reliable supplies, making their life more endurable, if not entirely comfortable. These days spent in camp with their comrades were ones they would look back on most fondly in later years.

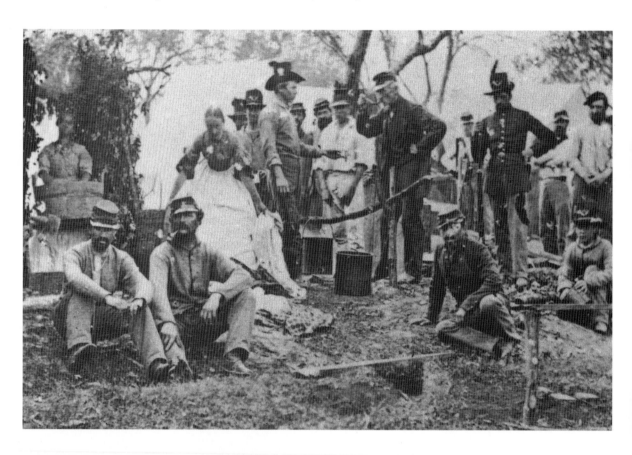

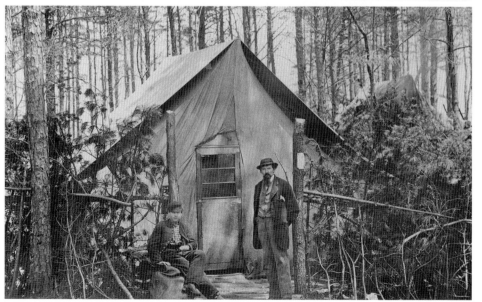

ABOVE

A typical Union camp kitchen in the field, kettles of soup or stew boiling over an open fire, one soldier holding out a plate or bowl of the produce, while another—perhaps an officer— tastes the meal. A common sight in Union camps was a woman, often a wife, helping with the cooking.

LEFT

Cut off as they were from home for months or years, the soldiers craved the mail sent by friends and relatives, and every Union army had its traveling post offices. This is one at the headquarters of the Army of the Potomac near Brandy Station, Virginia, in early 1864.

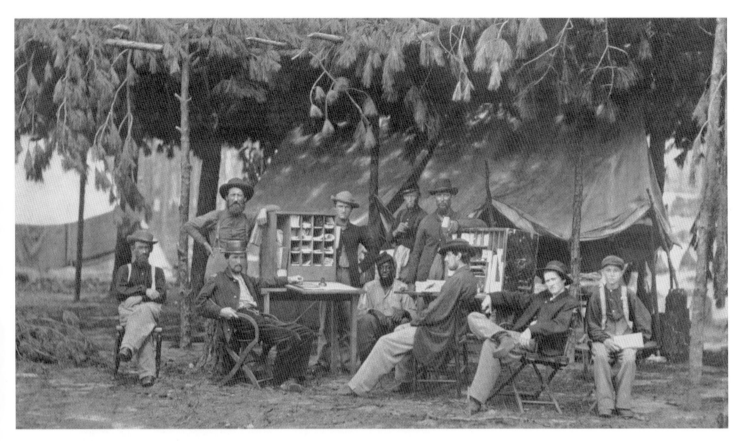

ABOVE

Paperwork made the armies run even then, documents being bundled and tied in a red ribbon called "tape," the origin of today's ubiquitous "red tape." This image shows the headquarters of the IX Corps ambulance unit in Virginia in 1864, with the staff taking shelter from the sun under their "shebang."

BELOW LEFT

The soldiers found every manner of ways to amuse themselves, from forming glee clubs and debating societies, to card games, baseball, and even amateur theatricals. These energetic volunteers in April 1861, with smiling faces, took to acrobatics.

BELOW RIGHT

The officers, of course, lived rather better than the men. This officers' mess in the spring of 1864 has a table and chairs, a tablecloth, plates, cups and cutlery, and even a cruet set and a black orderly with a pitcher to serve them. Officers contributed to a mess fund to purchase meat and vegetables.

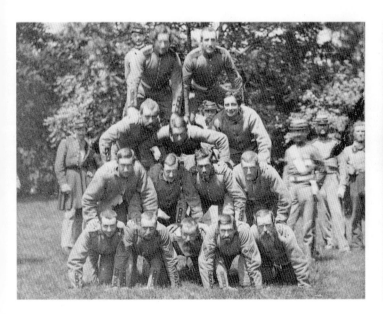

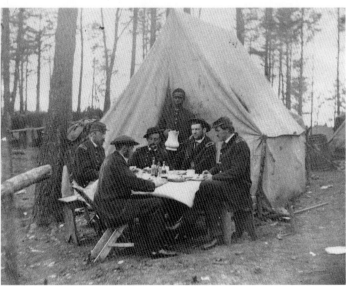

Camp Life: Confederate

Johnny Reb had to make do with much less than his Yankee counterpart, though what he lacked in resources he often made up for with ingenuity. Confederates learned to make coffee from burnt corn, liquor from pine boughs, and a host of other edibles from unlikely sources. For shelter, they made do with whatever they could find. They, too, had their clubs and socials, and one outfit even established its own lending library, though it contained some books in Latin that few could read.

RIGHT
Early in the war these Mississippians at Pensacola enjoyed what by later standards would be luxury—with a tent, chairs, books, and fresh uniforms. They, like all soldiers North and South, strove to take their culture and civilization from home with them to the war.

BELOW
The Confederates, too, liked their music. More than 2,000 songs would be composed during the war, and bands like this one, of the 26th North Carolina Infantry, were immensely popular for raising morale in camp, and providing stirring martial airs before a battle.

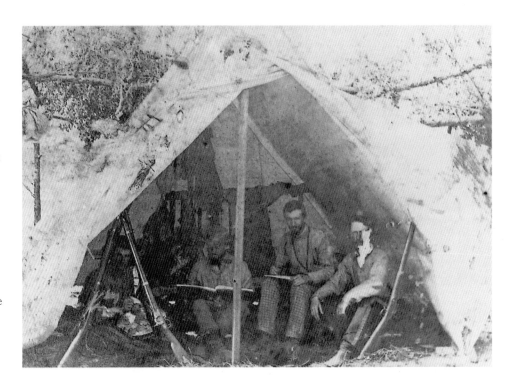

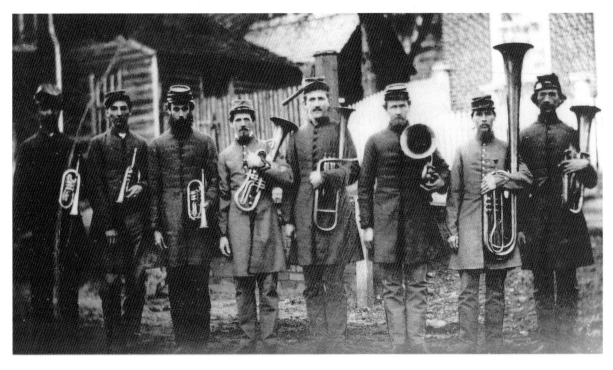

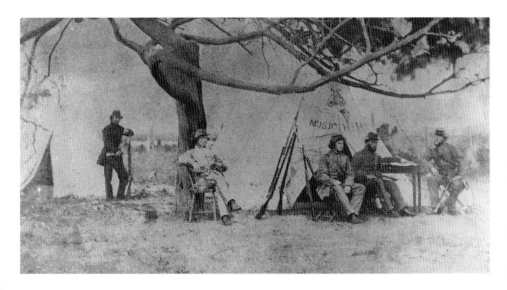

The Washington Light Infantry of Charleston dubbed this tent their "Music Hall," with a bugler standing at left with his rifle, and a fiddler seated at right. Despite the ravages of the war on their clothing and equipment, the Confederates managed to keep many of their instruments with them to the very end.

A typical winter quarters log hut at Camp Quantico in late 1861 or early 1862. These Texans named their huts for their favorite officers—hence their dubbing this one the "Wigfall Mess" after Louis T. Wigfall. In this war, the ax and the shovel were to be in their hands far more often than their rifles.

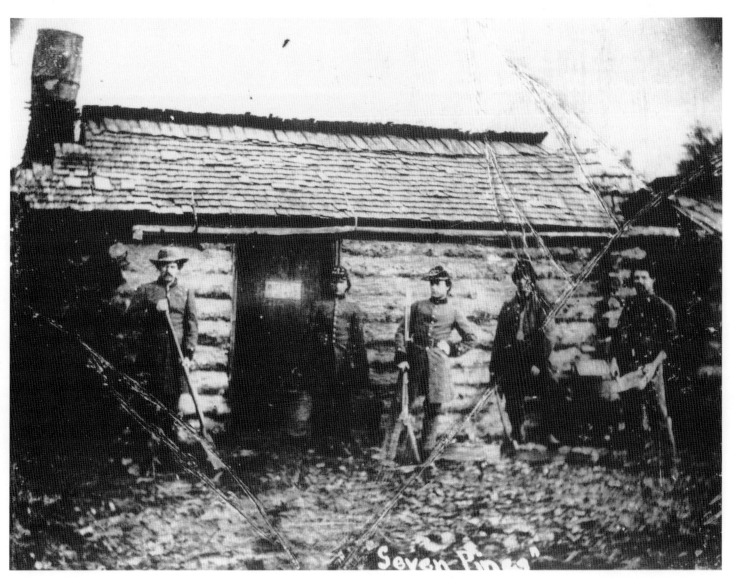

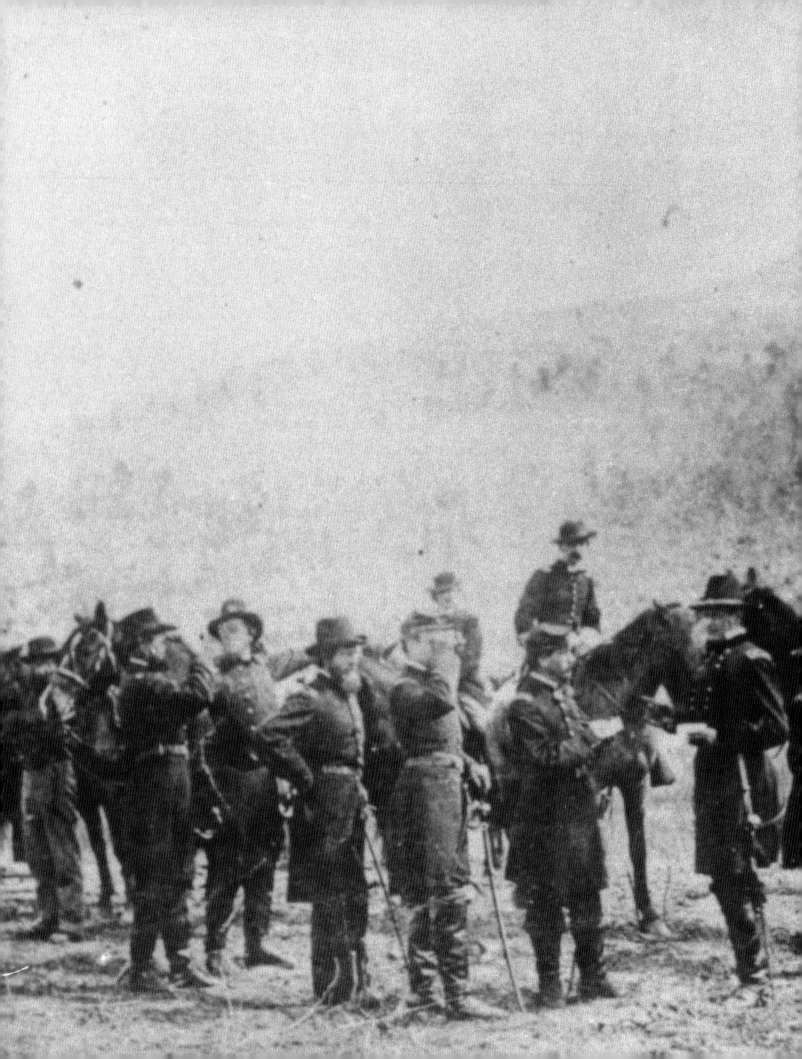

1863

THE YEAR
OF DECISION

Twenty-one months of war left North and South no closer to a resolution of their conflict. The Union was simply too strong to lose, and yet a depressing string of inadequate commanders showed that it was not yet smart enough to win. The South was too fortunate in Robert E. Lee to lose, yet not strong enough to win. Some major change in the status quo was going to be needed to put one or the other on the road to victory.

The year began with guns and politics, as the last of the Battle of Stones River in Tennessee was being fought, and in Washington Lincoln's Emancipation Proclamation became law of the land. But Lincoln's armies would have to win victories before that Proclamation could really free any slaves, and victory seemed as elusive as ever in the East. Indeed, with the resignation of Burnside and the rise of "Fighting Joe" Hooker to command of the Army of the Potomac, and the winter weather's inevitable delay in operations, in addition to the trauma of the severe defeat at Fredericksburg, there would be no action until well into the spring.

BUT OUT IN THE WEST "Unconditional Surrender" Grant waited for nothing. Quickly recovering from the delay caused by the Holly Springs raid Grant, with his bulldog tenacity, simply repaired the damage and started over, his eye never wavering from the goal of Vicksburg. His plan was to get his army onto the eastern bank of the river below Vicksburg, then march north and inland, taking the Mississippi capital at Jackson, and thus cutting off the Vicksburg garrison from all source of supply. Then he would march west and trap the garrison between his army and the river.

To do that, however, he would have to get past the miles of formidable batteries on the bluffs above and below Vicksburg, and that seemed too risky. Instead he tried one indirect approach after another. In February he dug a mile-long canal that would have allowed his transports to bypass the city. Then he tried another canal elsewhere, but that, too, failed. Next he sought a route through miles of swampy bayous over which he might march his army down the west side of the river, but that also came to nothing. Two other schemes, one

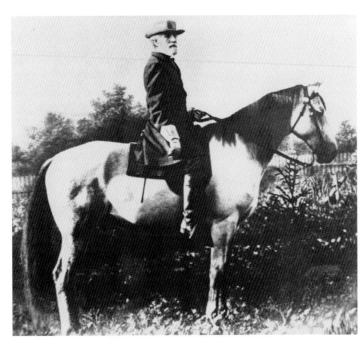

ABOVE General R. E. Lee

involving moving his men 700 circuitous miles to achieve a mere 30-mile advance, also proved impractical, but Grant kept trying.

Finally he found a route by which he could march his men to a point opposite Bruinsburg, Mississippi. Meanwhile, on the night of April 16, Grant's naval associate, Admiral David D. Porter, ran his gunboat fleet past the Vicksburg batteries under cover of darkness. Though the fleet was discovered and heavily bombarded, all but one boat came through safely, and six nights later 11 transports and barges made the same passage. With the gunboats and barges, Grant crossed his army to the east bank on April 30 to begin the march toward Jackson. On May 14 Jackson itself fell, and Grant immediately turned west. Two days later, at Champion Hill, Vicksburg's defender, Lieutenant General John C. Pemberton, came out of his works and attempted to stop Grant but failed. Pemberton went back to Vicksburg, and three days later Grant appeared before his works.

When a heavy assault failed, Grant settled down to a siege that could have only one outcome unless Pemberton were relieved. General Joseph E. Johnston, recovered from the wound he sustained at Seven Pines, tried to assemble an army to come to the rescue, but, as before and after in this war, he proved himself inadequate to the challenge. For 47 days the Confederates in Vicksburg gradually starved until they were eating pets and rats. Finally Pemberton surrendered on the auspicious date of July 4. Five days later the garrison and batteries at Port Hudson also surrendered to a small army commanded by Major General Nathaniel Banks, and at last the Mississippi belonged exclusively to the Union. The Confederacy was cut in two, and Grant and Sherman were now Lincoln's undisputed great captains.

When he accepted Pemberton's surrender, Grant did not yet know that his victory was the second in a double blow from which the Confederacy would never recover. The war continued to go badly in the East after Hooker took command. A dashing and aggressive fighter, he conceived a brilliant plan

to advance to the Rappahannock once more and get his army across upstream before Lee, still at Fredericksburg, knew what he was about. Once across the river, and not forced to face those impregnable positions at Fredericksburg, Hooker hoped to roll down onto Lee's exposed left flank and at the same time cut him off from his line of supply and retreat to Richmond.

The campaign began auspiciously as Hooker stole a march on Lee, and by the end of April the Yankees were across the river and in a densely forested area known locally as the Wilderness, approaching Lee's flank. At the same time Hooker sent a third of his army, under Major General John Sedgwick, to Fredericksburg itself to hold Lee in place. It almost worked, and would have but for three factors. Hooker, on the verge of success, lost his nerve. Lee, even when taken by surprise, was the most dangerous foe any Yankee ever faced. And, in "Stonewall" Jackson, Lee had a subordinate who could and did perform the impossible.

Hooker slowed his advance to a stop in and around the hamlet of Chancellorsville, and Lee seized the initiative. While leaving part of his army behind to cover Fredericksburg, he sent Jackson and more than half of his remaining troops on a wide, sweeping march completely around Hooker's right flank. On May 2 Jackson pushed his men all day, and even though some Federals detected the movement, none appreciated its import until that evening, when Jackson smashed out of the woods into Hooker's right and rear. Jackson kept hammering at them even after nightfall until an accidental volley from his own troops knocked him from his saddle and sent him to the rear severely wounded.

The whole XI Corps of Hooker's army was put to panicked rout, and the Confederates followed up on the success the next morning, placing the Federals completely on the defensive. Meanwhile a planned coordinated attack at Fredericksburg had been stalled for precious hours but finally pushed the Confederates out of their works. They then conducted a skilled withdrawal toward Lee and

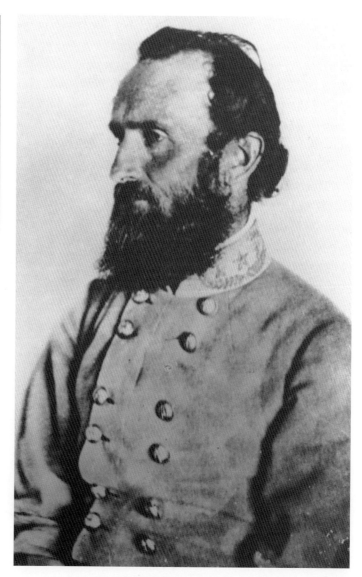

ABOVE General Stonewall Jackson

Chancellorsville, and Lee himself, sensing that the fight had gone out of Hooker, turned with some of the remnant of his army and attacked at Salem Church on May 4. Two days later a thoroughly beaten and demoralized Hooker pulled the rest of his army across the river in retreat.

It had been the most brilliant battle of the war. Outnumbered 135,000 to 60,000, Lee overcame his initial

surprise, split his army in half not once but three times in the face of the foe, and defeated him in detail at every turn. The Confederacy was jubilant, and once more the aura of Lee the invincible was confirmed. But it came at a heavy price, for among the high casualties that Lee suffered was Jackson himself, who would die of complications from his wound on May 10. Lee would never find another subordinate to replace his "Stonewall."

This was the time to take advantage of the enemy being off guard and launch another invasion of the North. It could demoralize public opinion, threaten Washington, gather needed supplies for his own army now that Virginia itself was suffering from the strains of supporting the army, and keep Lee's own battered army fit. And so he proposed to march into the North once more. Lee began crossing the Potomac on June 15, and by the end of the month had marched across Maryland and into Pennsylvania. On June 30 his advance elements were in sight of the Susquehanna River and the capital at Harrisburg. But the Yankees were not napping. Hooker immediately put the Army of the Potomac in motion, following Lee and keeping itself between the Confederates and Washington. Then, on June 28, Lincoln replaced the disgraced commander with Major General George G. Meade, who just two days after taking over found himself facing battle with the most successful general of the war. On June 30 Meade had his corps marching toward an important crossroads at Gettysburg, just as Lee's own advance elements were converging on the same spot.

When they clashed the next day, July 1, 1863, there began the most titanic battle of the war. For three days 85,000 Federals and 65,000 Confederates hammered each other in

ABOVE General J. Longstreet

the Pennsylvania hills around the small community. The first day, as so often before, Lee had it all his own way. He took the town itself and steadily pushed Meade's advance XI Corps back with heavy losses, finally forcing it into defensive positions just south of the town. In the morning of July 2 Lee renewed the attack. He ordered Lieutenant General James Longstreet's corps to attack Meade's left flank while Lieutenant General Richard S. Ewell, Jackson's successor, sent his corps against Meade's right. But Longstreet delayed until the afternoon, while Ewell's attack did not begin until evening. The result was opportunities lost. When he did attack, Ewell achieved little advantage, while Longstreet fought bitter contests in areas later known as the Peach Orchard, the Wheat Field, and Devil's Den. Longstreet gained no advantage, narrowly missing the chance to take the dominant strategic point on the battlefield when he failed to take Little Round Top, a hill commanding most of the Union line. Frustrated, ill, and finding that his army no longer worked the way it had in earlier days, Lee resorted to a massive frontal assault on July 3 in the hope of breaking the center of Meade's line. Known to posterity as Pickett's Charge, it sent more than 12,000 Confederates over almost a mile of largely open ground, into the guns and infantry awaiting them along Cemetery Ridge. They were beaten back, but both sides suffered appalling casualties. Both armies were spent. Lee stayed in position on July 4, but then commenced a withdrawal to Virginia, and Meade was himself too battered to pursue effectively. Between them the armies suffered almost 6,000 killed and more than 37,000 wounded or captured, a total greater than the size of either of the armies involved at the first Bull Run. Lee had at last been decisively beaten. The

mighty Army of Northern Virginia would fight and sting again, but it would never be the same again.

The trauma of Gettysburg was such that Lee and Meade would not fight another substantial engagement for the balance of the year. Instead the action shifted to the West once more. By August General Bragg was protecting Chattanooga against an anticipated Federal offensive by Rosecrans. To aid him, and because Lee's army was relatively inactive, Longstreet's corps was sent west by rail. Meanwhile, when Rosecrans began his advance, Bragg evacuated Chattanooga and set out hoping to attack the enemy unawares. Those efforts failed, but on September 19, along both banks of Chickamauga Creek, the elements of the two armies came together. For two days they battled each other. On the second day Longstreet's columns came onto the field to be ordered into an attack on the Union center just as a wide gap opened in the Union line right in front of him. The Confederates poured through, cut Rosecrans's army in two, and sent the right half streaming back to Chattanooga. The left, under General George H. Thomas, held its ground long enough to cover the withdrawal. It was the most complete victory gained by any Southern army in the war.

Bragg then besieged Rosecrans in Chattanooga, placing his army on the commanding heights of Missionary Ridge and Lookout Mountain, and began to starve the Federals. Rosecrans was relieved of command and Thomas put in his place, and then in October Grant and Sherman were ordered to come to retrieve the situation. In short order Grant opened a new supply line, reinforced and refit the besieged army, and planned a breakout. On November 24 he attacked and took Lookout Mountain, and the next day pushed up Missionary Ridge and drove Bragg off in a rout of his own. Bragg would resign a few days later, the siege of Chattanooga was lifted, and Grant and Sherman were poised to use it as the base for operations in 1864 that would cut the Confederacy into yet smaller pieces.

ABOVE Anxious Yankees awaiting supply steamers on the Tennessee River.

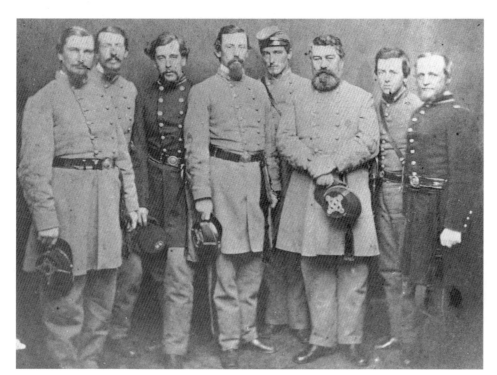

LEFT
Officers of the 16th Virginia, part of the backbone of Robert E. Lee's Army of Northern Virginia as he and they faced the opening of the 1863 campaign. At Chancellorsville, these Virginians would help to bring him the most stunning battlefield victory of the war.

BELOW
Chancellorsville itself was little more than a tavern and the Chancellor house itself, and after the battle, there was scarcely anything left of them, as evidenced in this image made at the end of the war. Thus Virginia civilians paid for the victories that kept the Yankees at bay.

BELOW
The Richmond, Fredericksburg & Potomac Railroad tracks ran through Guiney's Station, and it was here that Stonewall Jackson was brought after his wounding. Inside this modest house surgeons amputated his arm, and in this house, on May 15, 1863, he died of pneumonia.

RIGHT
An early 1863 photograph of General Thomas J. "Stonewall" Jackson, surely the last portrait made of him before his death. The fires of both genius and fanaticism burned in his eyes. Many of his men would love him only after his death, yet in posterity all would recognize his greatness.

FOLLOWING PAGES
While Lee battled Hooker at Chancellorsville, a bitter fight went on over the old battleground at Fredericksburg. Less than half an hour after the fighting ended, a photographer captured the grim visage of war's cost on these Confederate dead behind the wall along Marye's Heights.

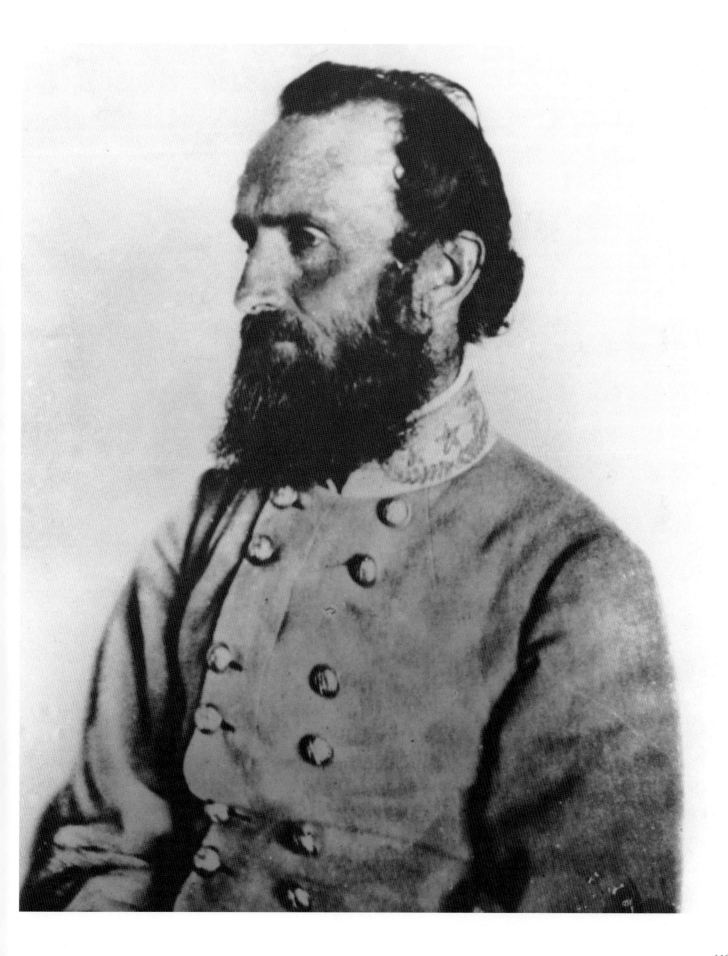

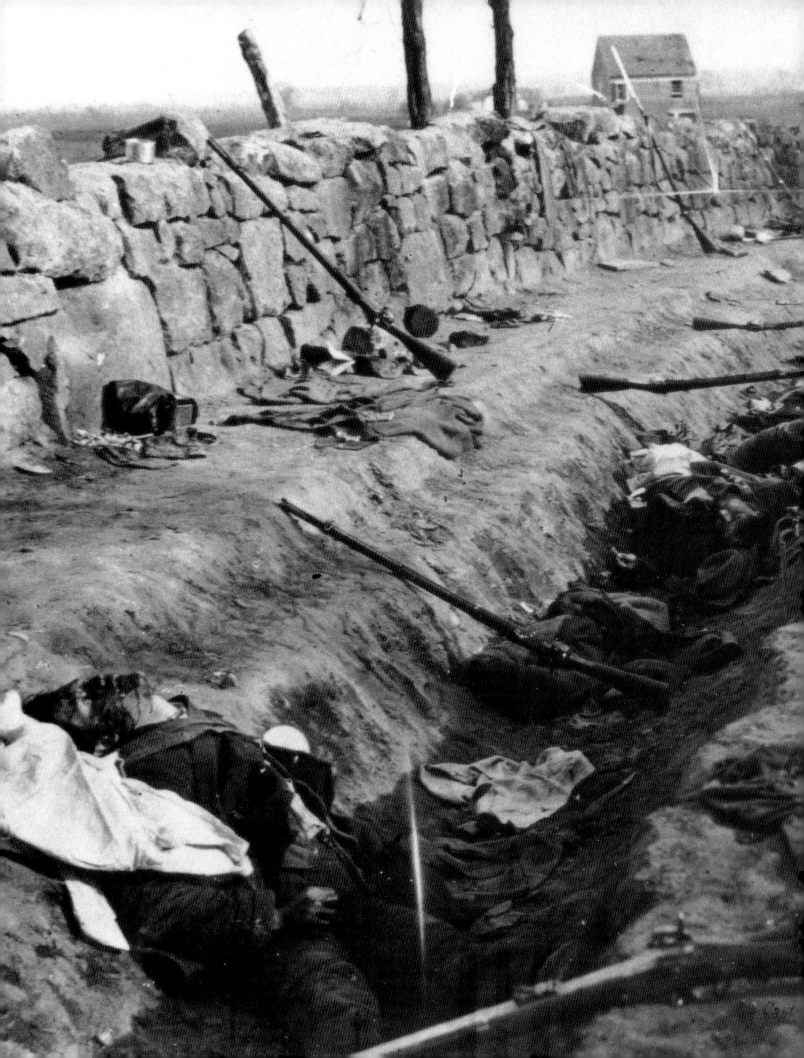

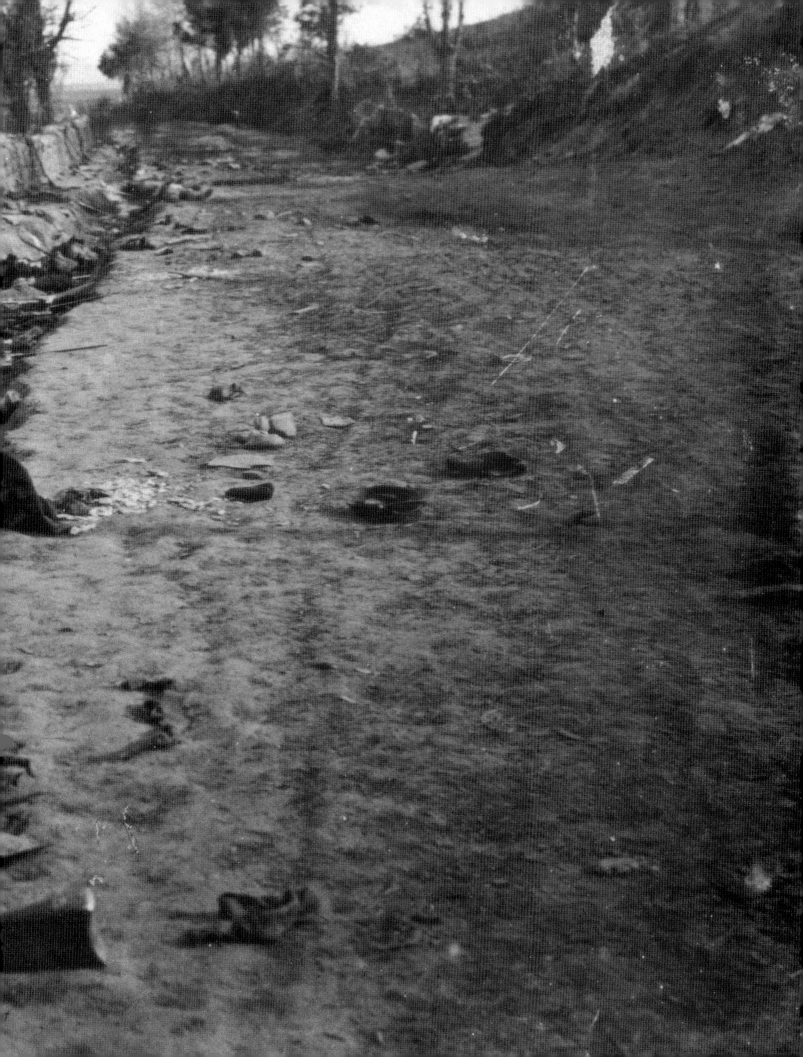

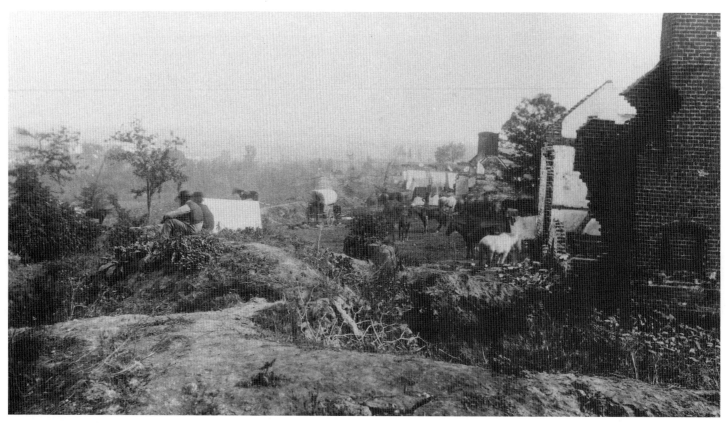

ABOVE
Confederate earthworks on Marye's Heights as
they appeared immediately after the battle in
May 1863. Though forced back, the Rebels
defending here played a vital part in protecting
the outnumbered Lee's flank and rear as he
fought for his life in Chancellorsville.

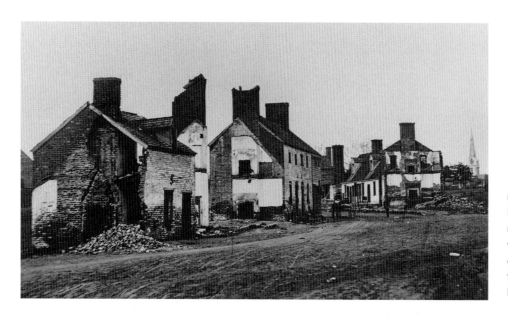

LEFT
More of the civilian cost of war is evident in the
ruins along a street in Fredericksburg. After the
war, many Virginia citizens would attempt to gain
compensation for their losses in the war, but if
they could not prove that they had remained
loyal, Washington turned a deaf ear.

After the fighting around Fredericksburg during
the Chancellorsville battle, Union General
Herman Haupt, standing at left, surveyed some
of the damage from Union shelling on
Confederate artillery. In this war, more than a
million horses and mules would die in action.

BELOW

General Robert E. Lee on "Traveler," his favorite
mount. It was said in the army that Traveler had
an instinct to head to wherever the fighting was
the fiercest. He and Lee would remain together
until the general's death, and Traveler would be
buried close to him when his time came.

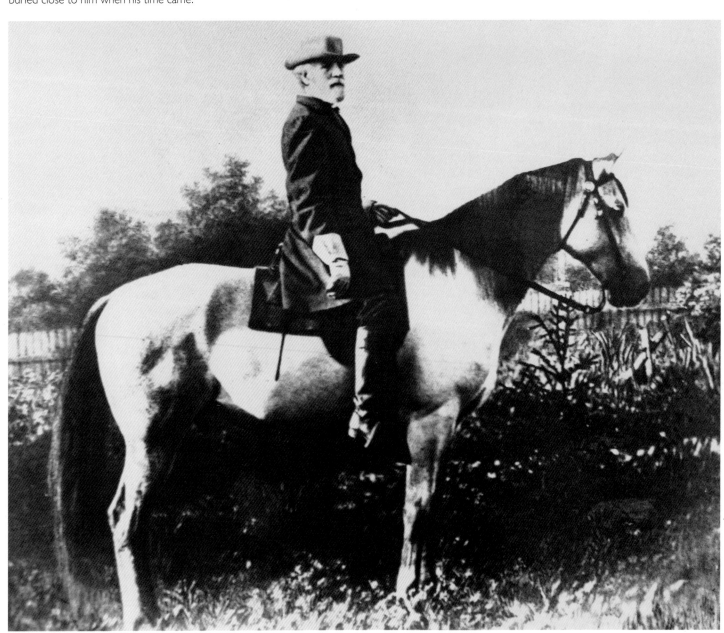

BELOW
Traveler would take Lee to his fiercest fight of
the war, and his greatest defeat, when they rode
into Pennsylvania in June 1863 and came to
Gettysburg. It was a sleepy little town about to
become the center of attention of more than
160,000 soldiers in the costliest battle of the war.

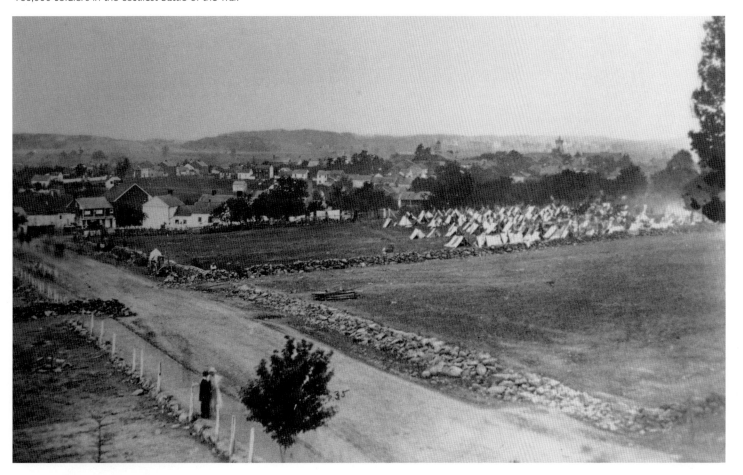

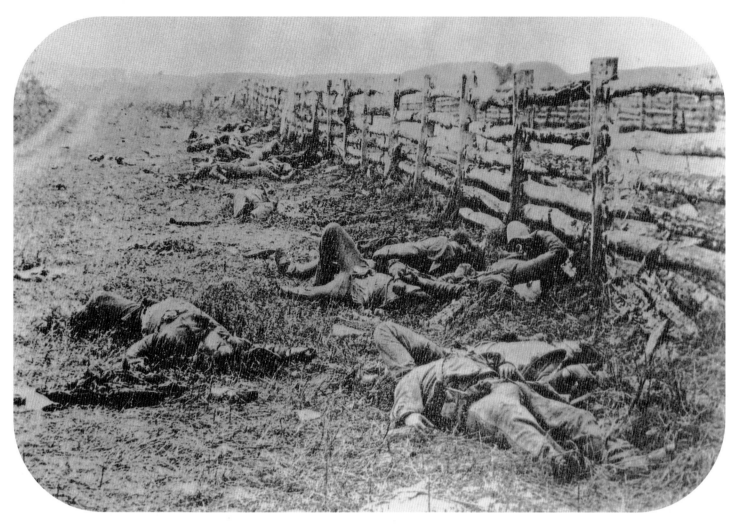

ABOVE
Over the ensuing three days, more than 6,000 men would be killed. The dead lined every fence and wall that had been used for defense, like these along a farmer's rail fence, and filled every barnyard and field. The scale of the killing left both armies exhausted.

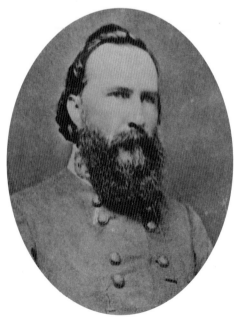

RIGHT
Lieutenant General James Longstreet of South Carolina commanded Lee's First Corps, and would ever-after be the center of controversy over his actions on July 2, 1863, at Gettysburg, when he may have dragged his feet before launching a flanking movement of which he did not approve.

Two weeks after the battle began, a Brady camera caught this view of Little Round Top on the left, and Big Round Top in the distance. The former was key to holding the southern end of the Federal line, and the fight for its possession on July 2 was one of the decisive contests of the battle.

Culp's Hill at the northern terminus of the Yankee line was almost as critical as the Round Tops, and each side fought hard over it, but Meade's bluecoats would not be driven off. Wesley Culp, who went south to join the Confederacy, would be killed in fighting close to his Pennsylvania home.

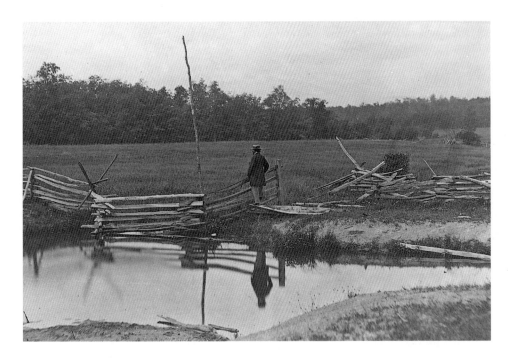

LEFT
Mathew Brady poses in front of McPherson's woods northwest of Gettysburg, near where the fighting began, and where Union General John Reynolds, commander of the I Corps, fell in action just 40 miles from his home in Lancaster, Pennsylvania.

RIGHT
The gate house of Evergreen Cemetery in Gettysburg soon became a landmark of the battle, as fighting actually encroached on the graveyard itself. When the fighting swept through town on July 1, soldiers took cover behind the tombstones, many of which were shattered by gun and cannon fire.

RIGHT

RIGHT

General Meade made his headquarters just behind the Federal lines on Cemetery Ridge, in this little cabin. It was here on the night of July 2 that he decided to stay and fight another day. Four days later, Gardner's camera caught the scene, with dead horses still littering the road.

BELOW

Abraham Trostle had a farm near the Emmitsburg road, and across his fields, and right past his house, the fierce fighting of the second day swarmed. Dead men and horses lie where they fell almost on his doorstep. The cleanup of dead animals alone would take weeks after the battle.

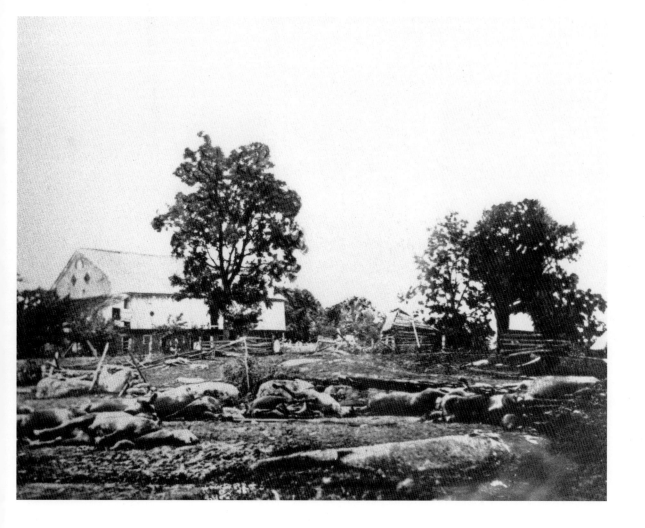

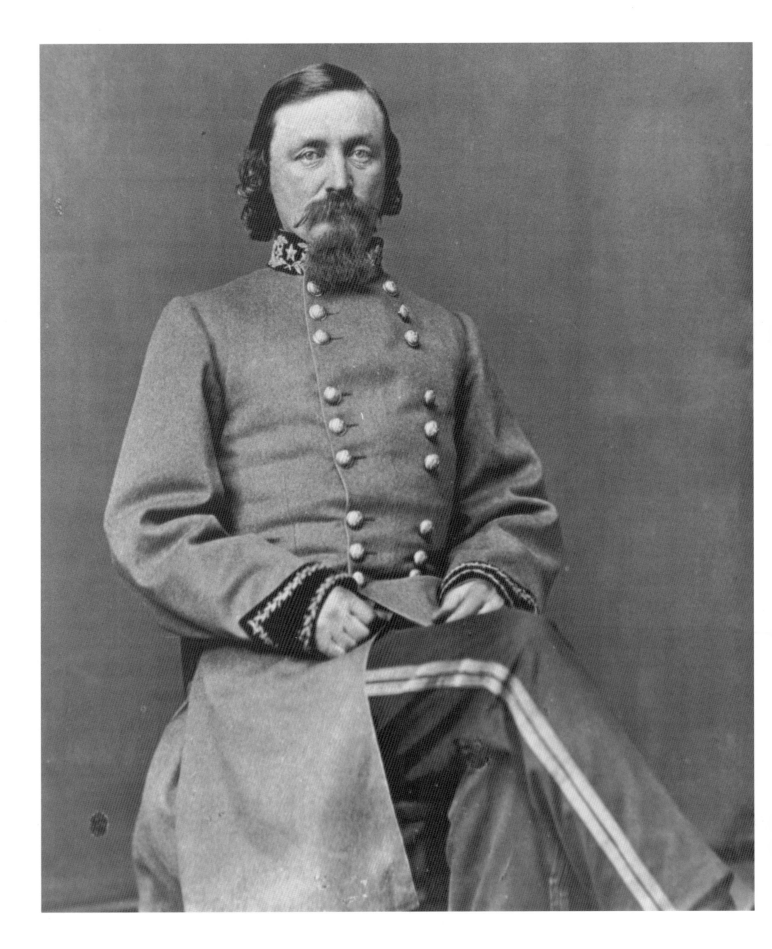

LEFT

No Confederate general emerged with more renown from Gettysburg than Virginian George E. Pickett, and all for a misnomer. On July 3 Lee's desperate last grand assault was commanded by Longstreet, and Pickett commanded only one of the divisions involved, yet it would thereafter be "Pickett's Charge" to posterity.

RIGHT

His irreverent men would call him "a damned goggle-eyed old snapping turtle," yet Union Army commander George Gordon Meade was the first one to give the Army of the Potomac an unequivocal victory over Robert E. Lee. He was solid, dependable, and thoroughly professional.

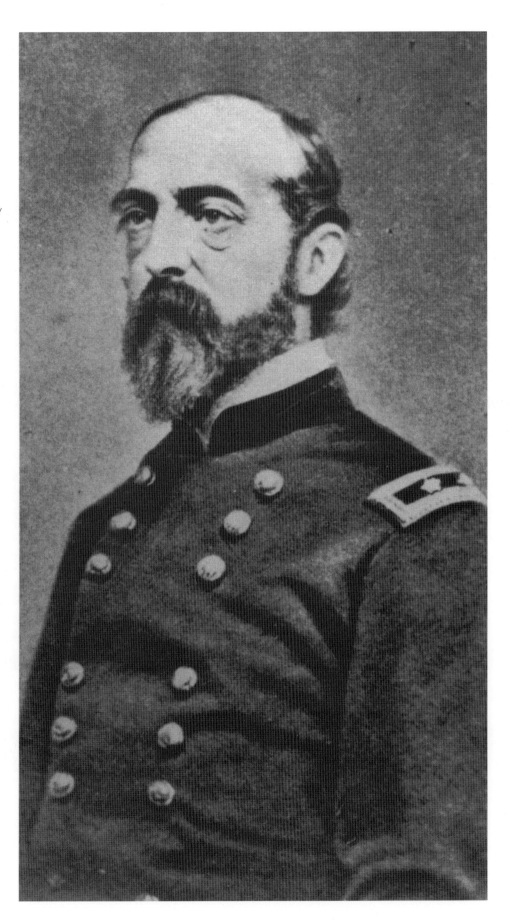

ABOVE
The war is over for these lean Confederates,
captured at Gettysburg and here photographed
awaiting transport to their future home in a
prison camp in the North. They are surrounded
by all their worldly possessions, and the variety
represents a stark contrast with those well-
caparisoned Johnny Rebs of 1861.

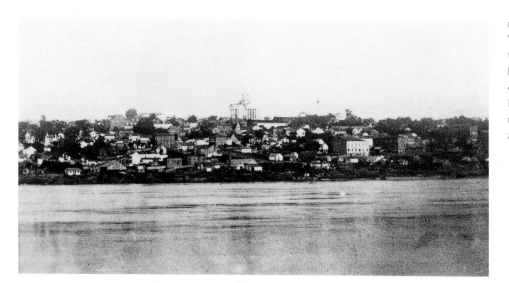

While Lee and Meade battled over Pennsylvania fields, a far more decisive siege was being waged by U.S. Grant for possession of the fortress city of Vicksburg high above the Mississippi. Dominated by its court house in this photograph made in 1863, its batteries controlled passage up and down river.

After Grant accepted Vicksburg's capitulation on July 4, 1863, Union soldiers swarmed over the town that had for so long been their goal. The cameras followed them everywhere as they set up their camps in the one-time yards of leading citizens, including the owner of "The Castle," one of the more unusual houses.

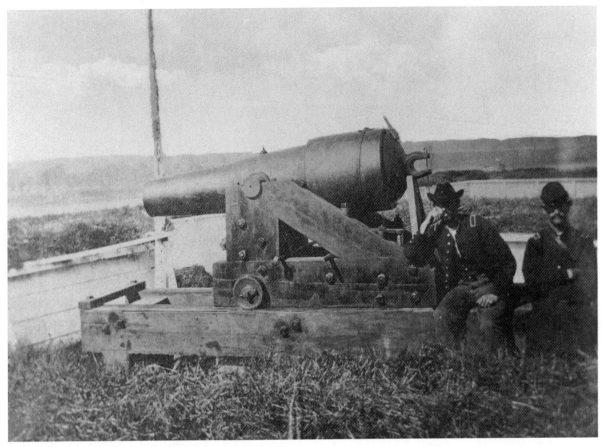

ABOVE

One cannon in the Rebel defenses would become notorious. This 7.44-inch English Blakely was better known as "Whistling Dick" to the Yankees, thanks to the peculiar noise that its projectiles made when they whizzed through the air toward them. The bluecoats would adopt the gun as their own after Vicksburg's fall.

RIGHT

The cupola of Vicksburg's Warren County Court House afforded the best view anywhere around. Confederate officers had watched previous river fights from it, but for Grant's Yankee army it became an ever-present target. Union soldiers pose in its yard, and the Stars and Stripes now flies from the cupola.

BELOW
One of Grant's favorite corps commanders was General James Birdseye McPherson, seated second from the right with his staff, in front of the Balfour House, his headquarters. He continued to rise, by 1864 commanding the Army of Tennessee, but was the only Union Army commander killed in action.

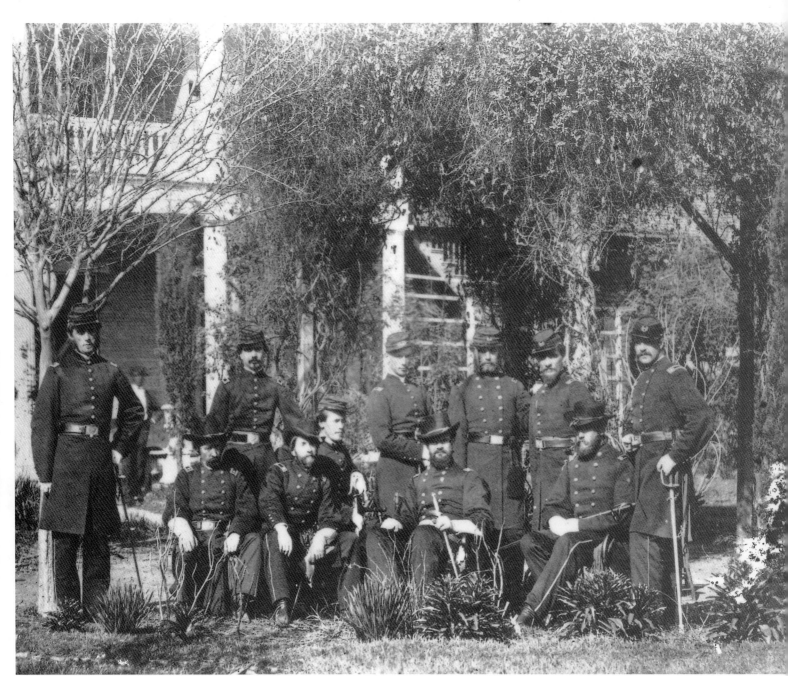

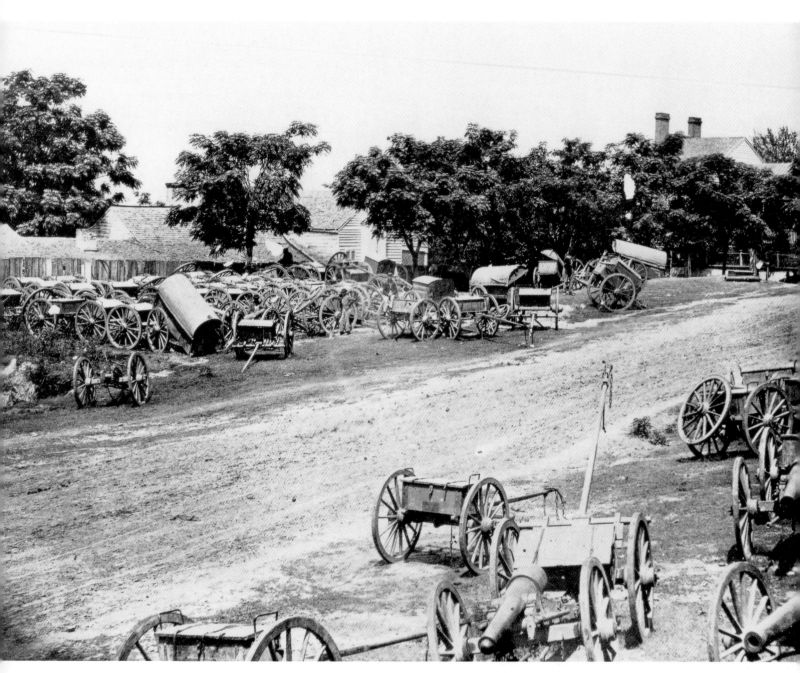

ABOVE
Just one of the parks of captured Confederate
artillery taken in the surrender. Ordnance like
this was hard for the South to come by, and it
could only be replaced slowly, and at great
expense and difficulty. The men surrendered at
Vicksburg, of course, were simply irreplaceable.

RIGHT
Right after the surrender, two Baton Rouge photographers made this image of Confederate earthworks, showing the earth-filled "gabions," or wicker baskets, used in their construction, and the "coonskin tower" observation post built of logs to keep an eye on advancing Yankees.

BELOW
Later that year Rosecrans's Army of the Cumberland made its move to take Chattanooga in order to control railroad communications. Confederates destroyed bridges like this one over the Tennessee River in order to slow the Yankee advance, but Union engineers would prove adept at quickly rebuilding them, as they are here.

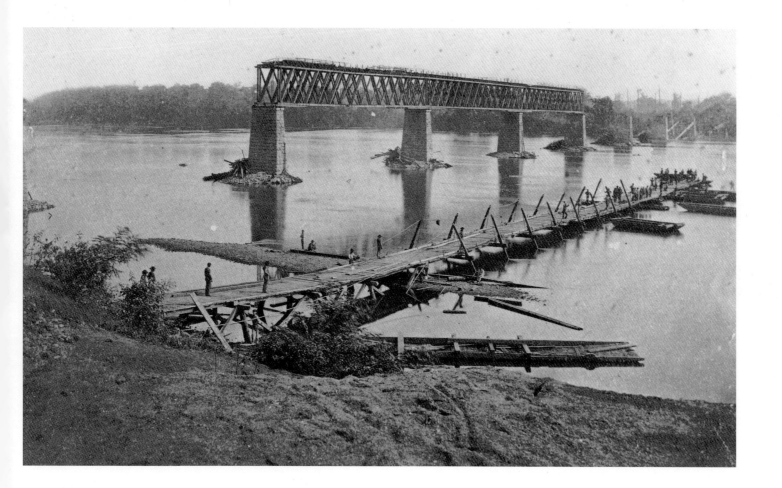

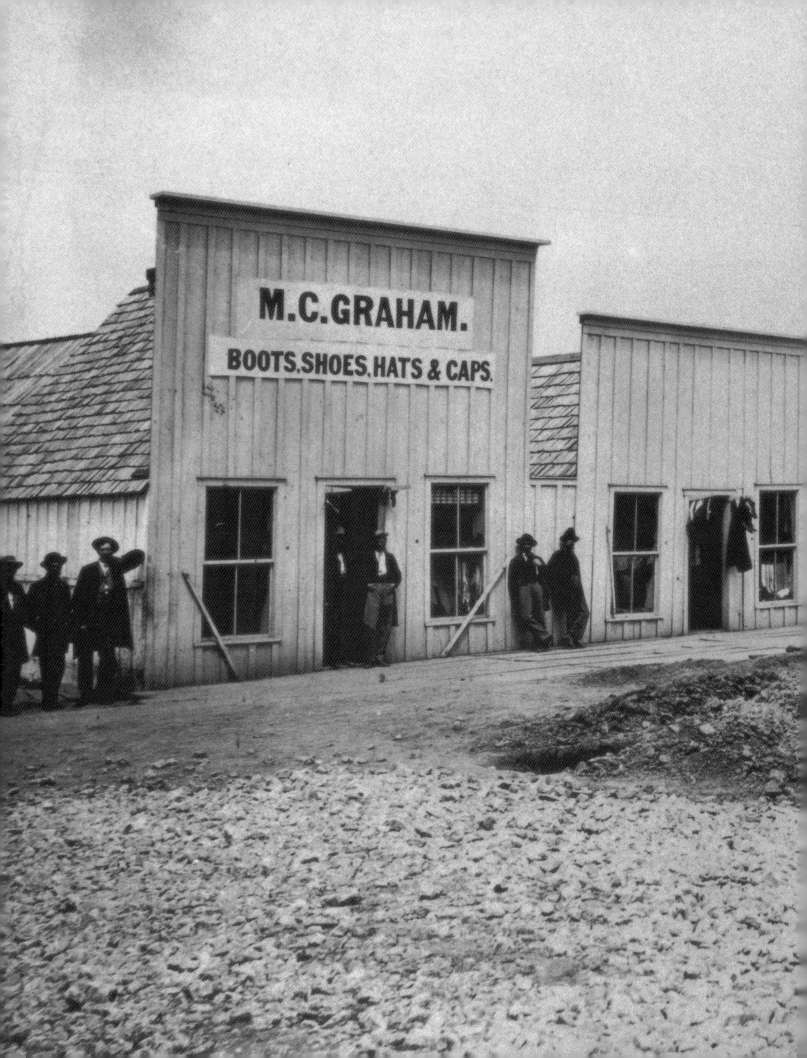

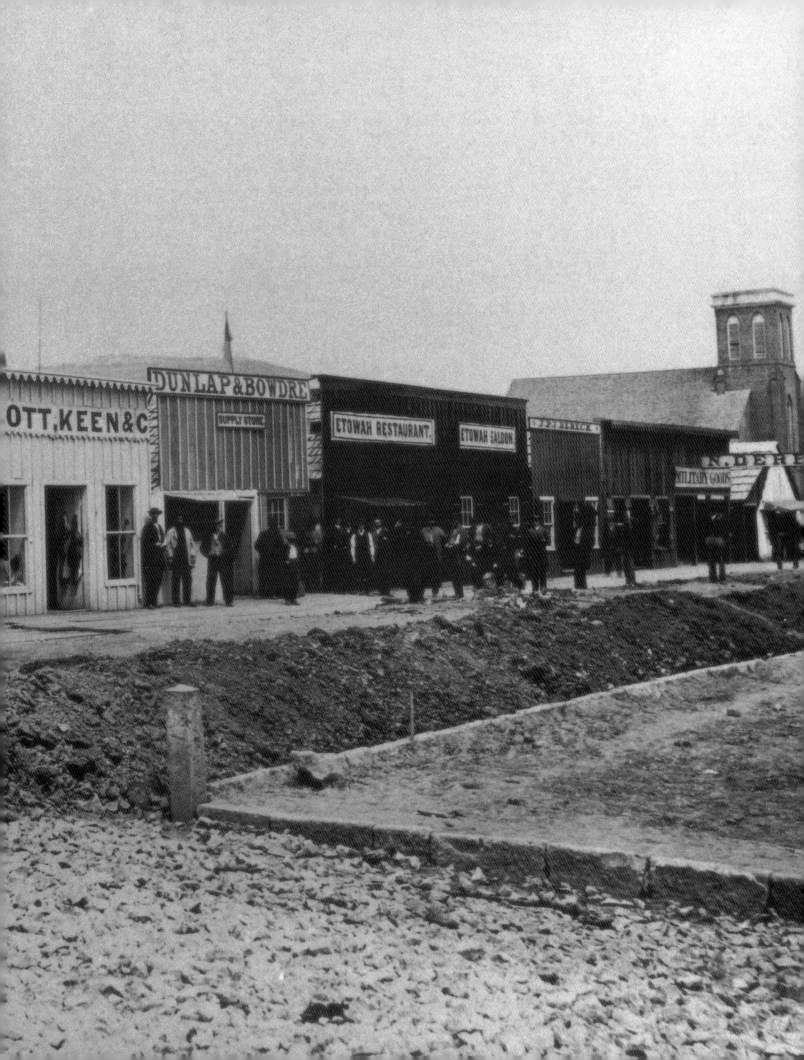

PREVIOUS PAGES
Eventually trapped in Chattanooga, Rosecrans's army at first faced starvation as they were besieged by Bragg, but finally supplies got through, and then the sutlers erected their "robbers' row" to provide whatever would separate soldiers from their monthly pay.

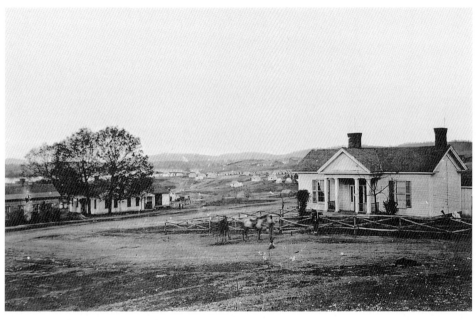

ABOVE
When Grant arrived to retrieve the situation, he brought his favorite lieutenant, William T. Sherman, with him. Sherman made his headquarters in this house and immediately set about retraining and rebuilding the dispirited Army of the Cumberland.

BELOW
Grant began by breaking the blockade on supplies. Utilizing steamboats and strategic captures of isolated points on the Tennessee River, he opened what the soldiers called the "cracker line," referring to the hardtack and other victuals that these hardy little steamers brought in spite of shoals and shallows.

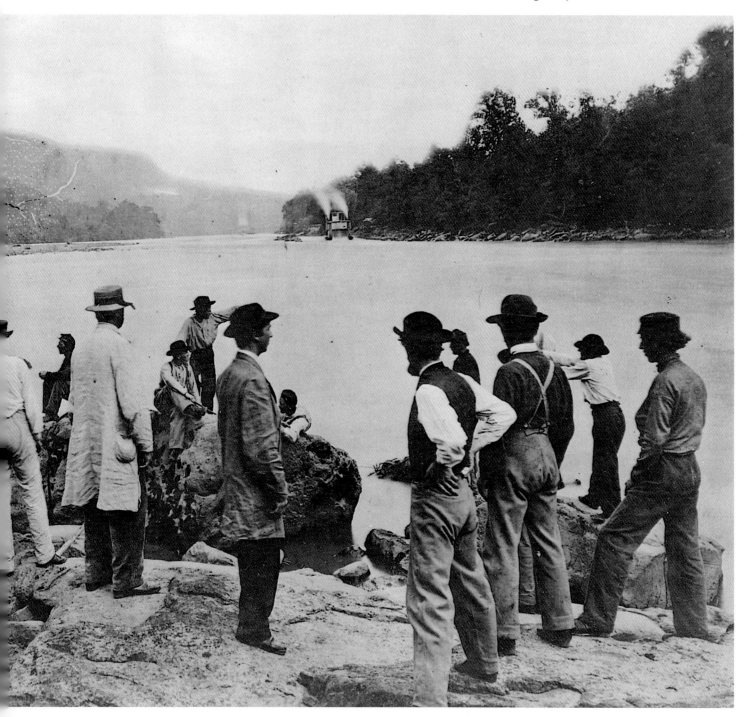

RIGHT
Then it was time to break out. On November 23 Grant sent part of his army forward to take Orchard Knob in the center distance, a staging area for the assault to come on Bragg's Confederates on the heights of Missionary Ridge and Lookout Mountain.

ABOVE
On November 25 came the main attack on Missionary Ridge itself, seen in the distance. What started as a tentative probe ended in an all-out assault as Yankee soldiers clambered up the steep slopes and overran enemy positions along the ridge. No one had expected so easy a victory, or so complete a Confederate rout.

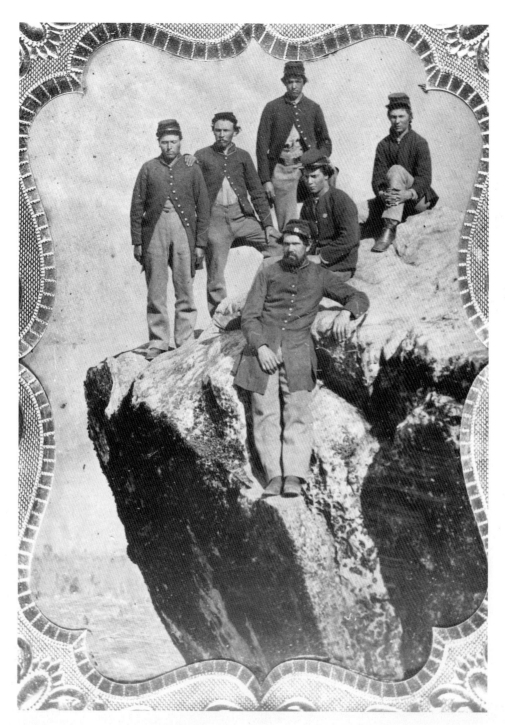

ABOVE

After the victory, Union soldiers flocked to the heights of Lookout Mountain, which became a favorite tourist spot of Federal soldiers for the rest of the war. Royan M. Linn, a photographer, set up a studio on the summit and made a living as "Linn of Lookout," photographing all those who came.

LEFT
With Chattanooga in hand, Grant and his forces consolidated their hold on southeast Tennessee and north Georgia, as here at a pass in Raccoon Mountain near Whiteside, Georgia. Yankees built block houses like this to protect their vital rail lines for the supply buildup prior to marching on Atlanta.

BELOW
In Chattanooga as the winter came on, Sherman trained his growing army, drilling men like these engaged in skirmish practice with sharpshooters out in advance of the main line. There would be hard work ahead of them when spring came in 1864 and the next campaign could commence.

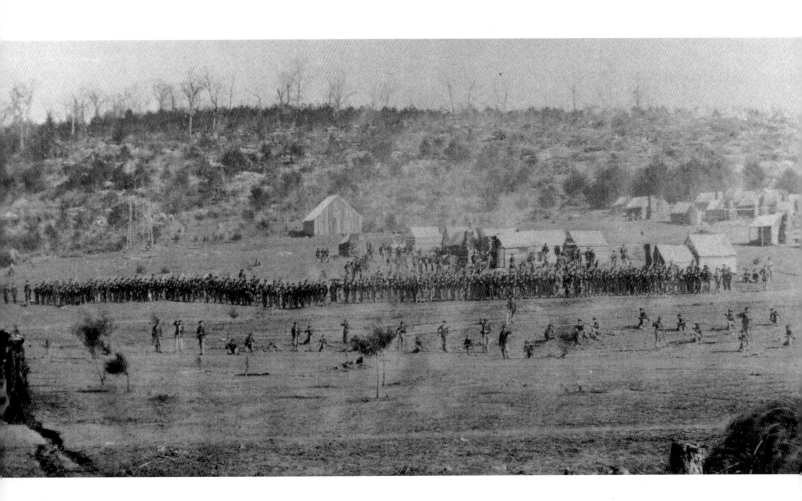

ABOVE

Meanwhile there was time for the noted artist James Walker to come to Chattanooga and take his paints and brushes up Lookout Mountain to do a prototype for one of his famous battle canvasses. Newspaper sketch artist Theodore Davis records the scene sitting at right.

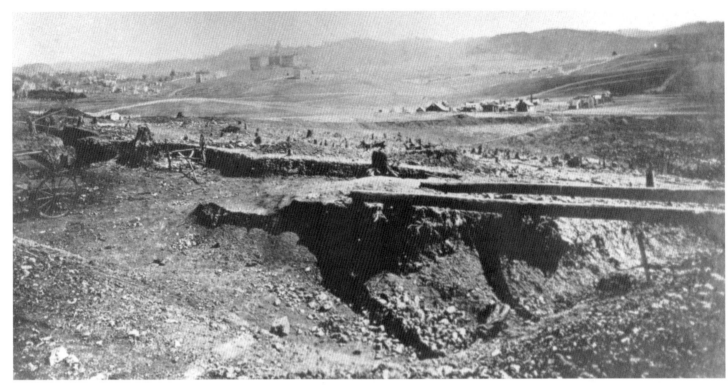

ABOVE
While Grant was lifting the siege of
Chattanooga, Longstreet led several thousand
men of his corps northward to lay siege to
Knoxville, then garrisoned by Burnside. Behind
ditches like this, the Yankees had skillfully
barricaded themselves, and Longstreet would
achieve nothing.

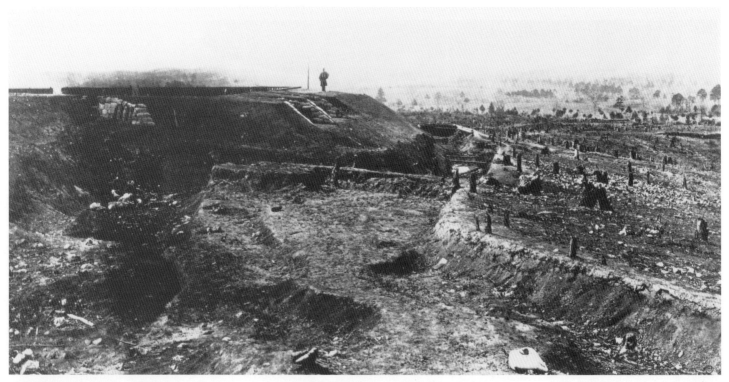

BELOW

The bitterest fighting at Knoxville came here at Fort Sanders, where the Confederates wasted scores of lives in fruitless assaults across the open ground to the right, against the formidable earthworks at left. When it was over, Longstreet withdrew, and the Union hold on east Tennessee was secure.

Union Ironclads

The idea of an armored warship was not new to the Civil War. The British and French had experimented with them in peacetime a few years earlier, and several hundred years earlier the Koreans had done something similar with their famous "turtle boats." But technology and warfare were ideally synchronized to make the Civil War the first contest actually to see such monsters engaged in battle on a wide scale, revolutionizing naval warfare forever.

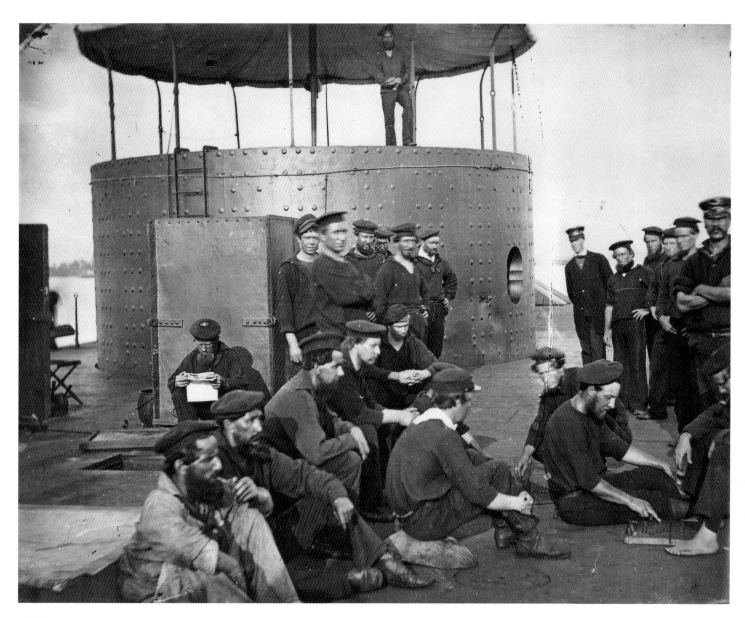

ABOVE
The Union's first ironclad, and the prototype for the most successful class of warships of the era, was the USS *Monitor*, photographed here in the summer of 1862 by James Gibson on the James River. It met and stymied the CSS *Virginia* (formerly the *Merrimack*) on March 9 and changed everything.

LEFT

Soon scores of monitors were coming off the ways, like the mammoth *Dictator*, shown here at her launch. The monitors, some with two and even three turrets, would see service all along the Atlantic seaboard and rivers, and one would even be sent to faraway San Francisco Bay.

BELOW

Even before the first monitor's launch, other ironclads, like the USS *Cairo*, were being designed and built for the river service in the western theater. Called the "city class" or Eads gunboats, after their designer James Eads, they became workhorses in supporting Grant's efforts to conquer the Mississippi and its tributaries.

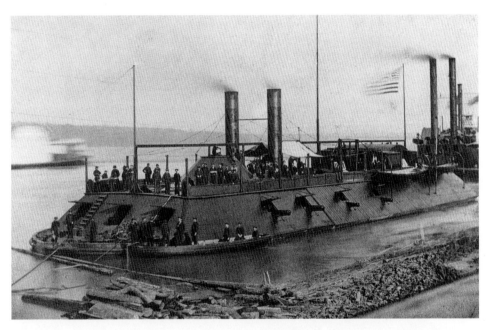

BELOW

There were behemoths out there on the Mississippi, none bigger than the gigantic USS *Lafayette*, a beast with cannon behind its curving armored superstructure on all sides, an armored pilot house amidships, and iron encasing its paddlewheels. Passing the Confederate batteries at Vicksburg gave it no trouble whatever.

BELOW RIGHT

The St. Louis was the first of the Eads gunboats to be launched, a prototype for all that followed. It would see service for the rest of the war, though, ironically, its name would later be changed to Baron De Kalb, a very un-city-like name for the first "city class" gunboat.

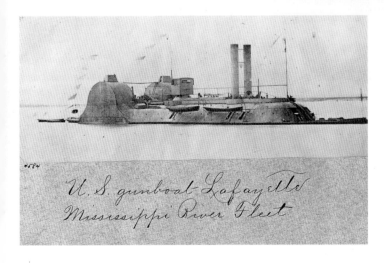

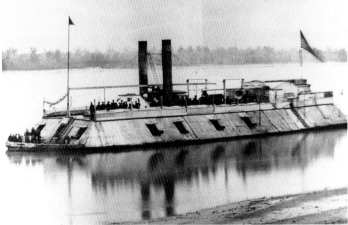

Confederate Ironclads

While both North and South were considering ironclad design at the same time, it was the Confederates who launched theirs into action first, with their conversion of the USS *Merrimack* into the CSS *Virginia*. Sadly, no photographs of the *Virginia* survive, and she was destroyed in May 1862 to prevent her capture. However, almost every subsequent Confederate ironclad followed her basic slope-sided iron casemate design, though with modifications that made them more seaworthy. They would prove to be great equalizers in the river and harbor fighting.

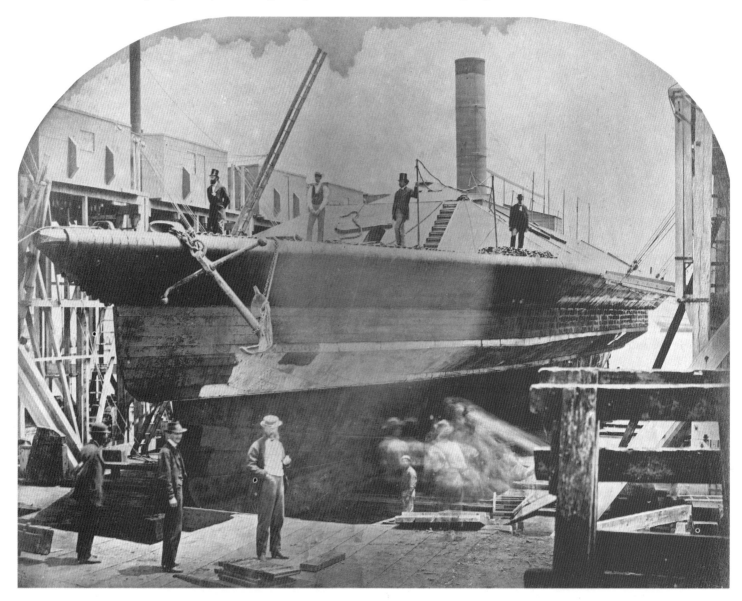

ABOVE
A formidable Confederate ironclad was the CSS *Atlanta*, so much so that after her capture the Yankees had her refitted in a navy yard seen here, to be put into service as one of their own. They did not even change her name, entering her on the naval list as the USS *Atlanta*.

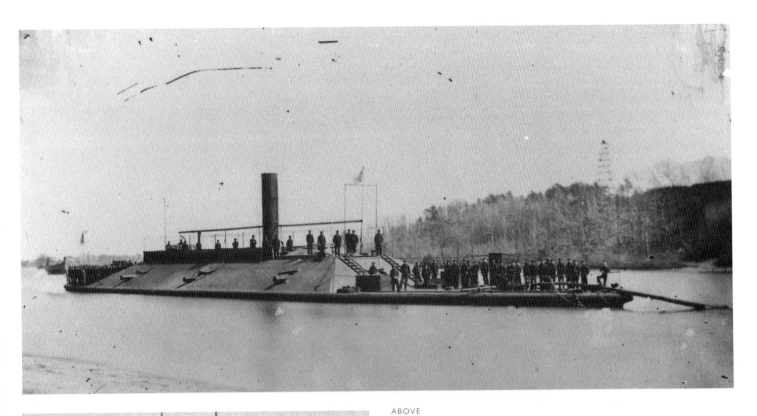

ABOVE

The USS *Atlanta* would spend the balance of the war patrolling the James and other rivers, often with long booms out in front, as in this image, to detect underwater mines or "torpedoes" before they could contact the ship's hull.

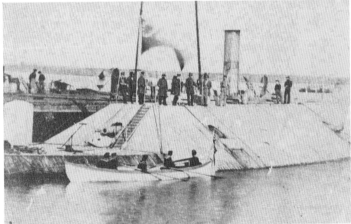

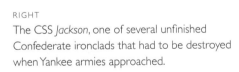

LEFT

The Charleston "ladies' ironclad" *Chicora*, so called because it was built with money contributed by women.

RIGHT

The CSS *Jackson*, one of several unfinished Confederate ironclads that had to be destroyed when Yankee armies approached.

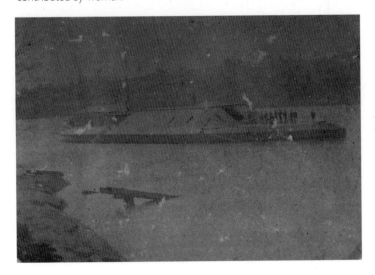

Union Navy

When the war began, the United States Navy had scarcely thirty ships, many of them antiquated, and many more on distant foreign stations. By the end of the war, Washington would have built the largest and most modern naval fleet in the world. Beginning still in vestiges of the age of sail, the Union charged into the age of iron and steam. Its domination of the Confederate coastline and conquest of the navigable rivers went a long way toward producing ultimate victory.

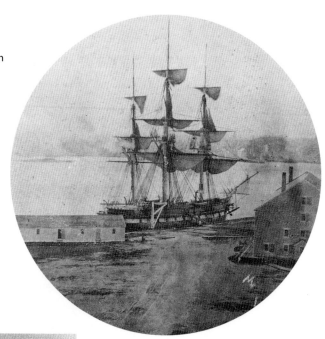

RIGHT

The USS *Cumberland*, shown here in 1860 at the Portsmouth Navy Yard in New Hampshire, represented the older United States Navy. She was sent to the bottom in flames by the Confederate ironclad *Virginia* on March 8, 1862, the first victim of the advent of iron.

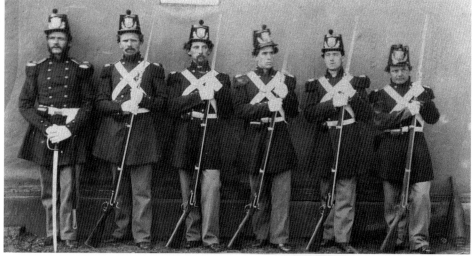

ABOVE

Attached to the Navy was the small contingent of United States Marines, virtually soldiers aboard ship without duties except for landing parties. They would see very little action in the war, as few ship-to-ship assaults were made, and even fewer landings under fire.

RIGHT

Soldiers on land had to be at least 18 to enlist in the Union Army, but long naval tradition allowed much younger boys, some no older than 12, to enter the Navy as cabin boys and "powder monkeys." Despite his youth, this lad aboard the USS *New Hampshire* has the jaunty air of a seasoned hand.

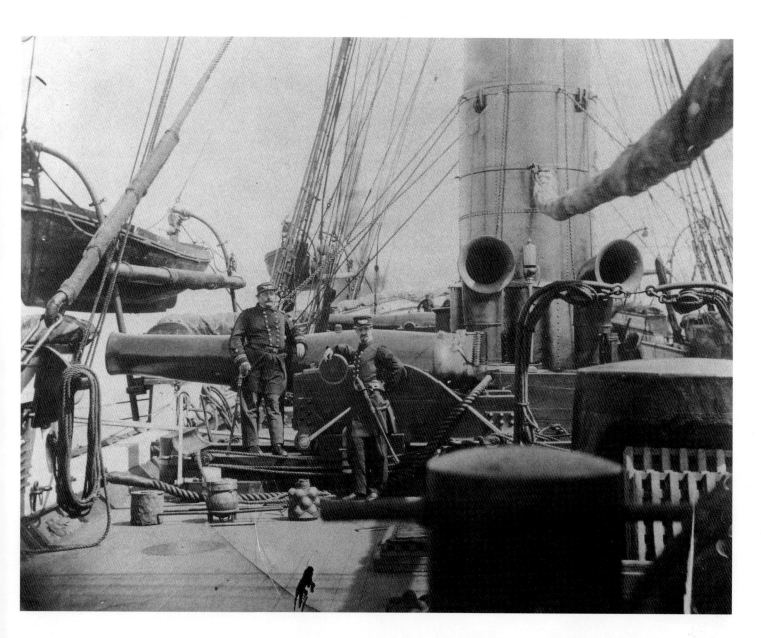

ABOVE

Officers on the deck of the USS *Kearsage*, whose chief task was to hunt and stop the daring Confederate commerce raiders that preyed on Union merchant shipping.

RIGHT

The *Kearsage*, right, trapped the notorious CSS *Alabama* in 1864 and sent her to the bottom.

OVERLEAF

A typical shipboard scene in the Union Navy. Some seamen play checkers, while others play a banjo and drum, and the rest pose, read letters, or doze. The presence of a few blacks is a reminder that the Union Navy was integrated long before the rest of the military.

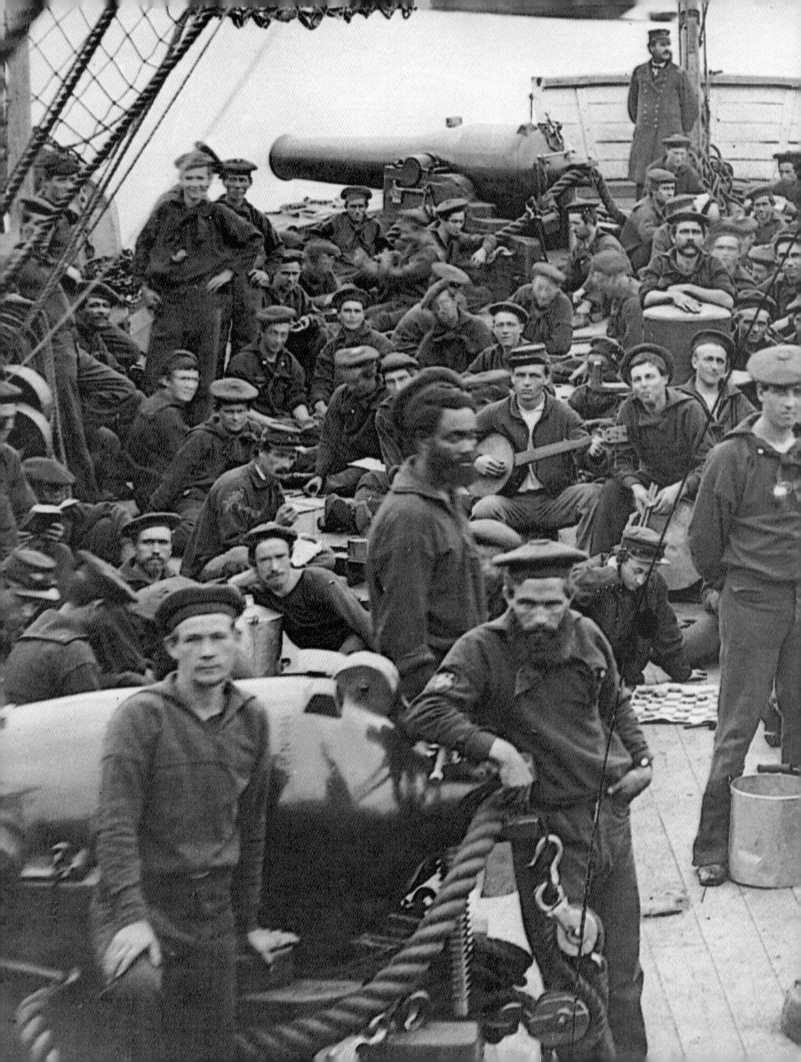

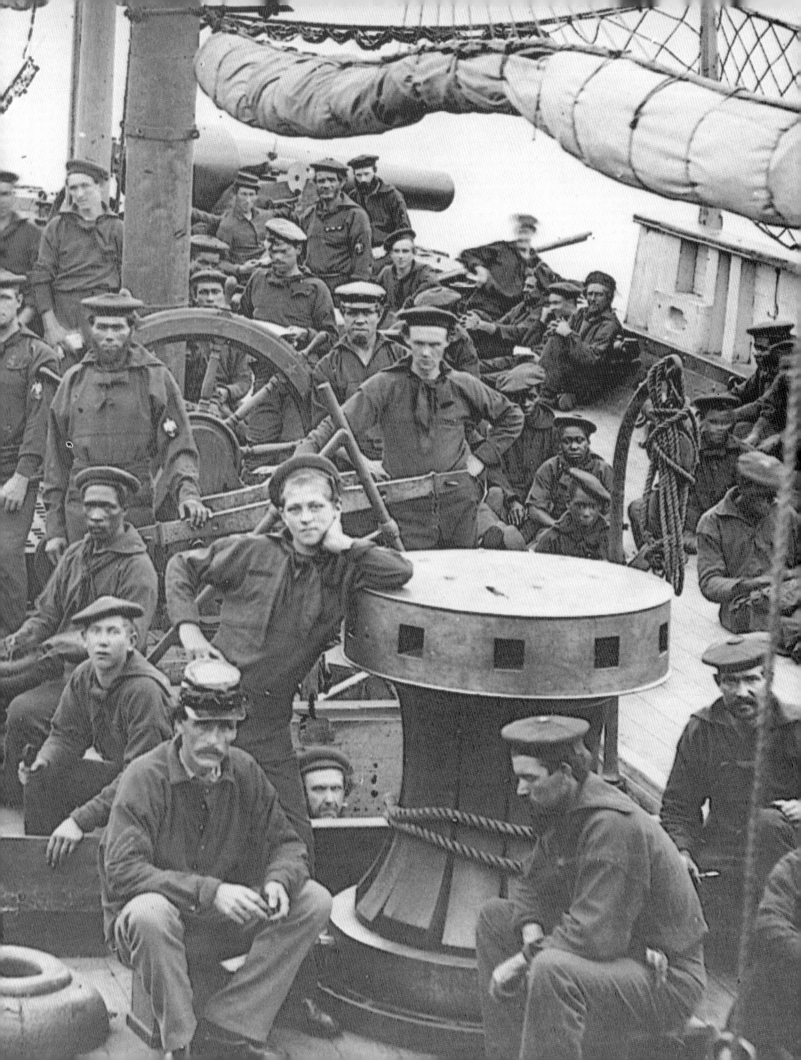

Confederate Navy

With no shipbuilding facilities of its own, the Confederacy began its navy by capturing Union vessels and buying others abroad. It never tried to challenge the Union on the oceans, but did attempt to use its ironclads to lift the blockade of its ports, or to employ other "infernal machines" to even the odds. Its greatest success came with its commerce raiders, which greatly damaged Union commercial shipping.

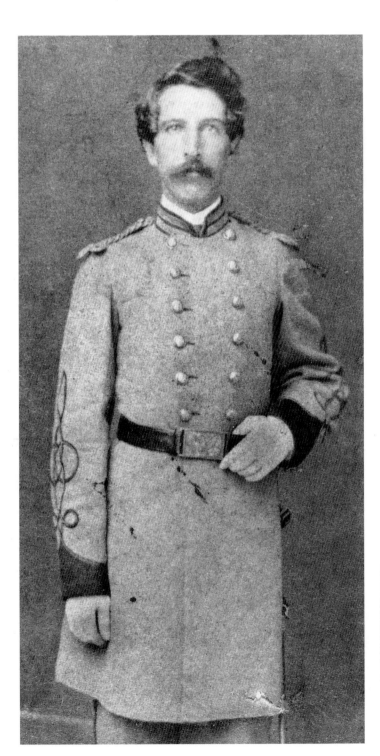

LEFT

There were Confederate Marines, too, like this one, but they took little part in the war. Some ships had a few Marines aboard, as did the *Virginia* in her brief career, but there was no more need for them than there was for United States Marines, and the corps never exceeded a few hundred men.

BELOW

The Confederates exercised considerable ingenuity in the underwater mines—then called "torpedoes"—that they used to protect rivers and harbors. Little more than iron or wooden kegs of powder with unreliable detonators, they still sank several Union ships, including the *Cairo* and a Yankee monitor.

RIGHT

Most feared of all Rebel vessels were the commerce raiders, fitted out not to fight armed warships, but to prey on unarmed merchantmen. The CSS *Tallahassee*, commanded by President Jefferson Davis's nephew John Taylor Wood, was one of the more successful.

ABOVE.

Less well known was the CSS *Rappahannock*, shown here in Calais, France. Her own commander called her "rotten," and she would never see action as the French refused to let her leave port for fear of causing diplomatic difficulties with the United States.

RIGHT

The great hope of the Confederate Navy was the CSS *Stonewall*, a radical new design built abroad. Beneath her bow was an iron ram which could hole a Yankee vessel below the water line, while huge 300-pounder cannon could perforate almost any bulwark. Yet her own crew thought her flimsy, and the war ended before she reached Confederate waters.

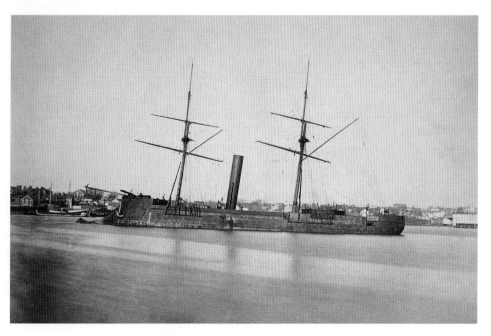

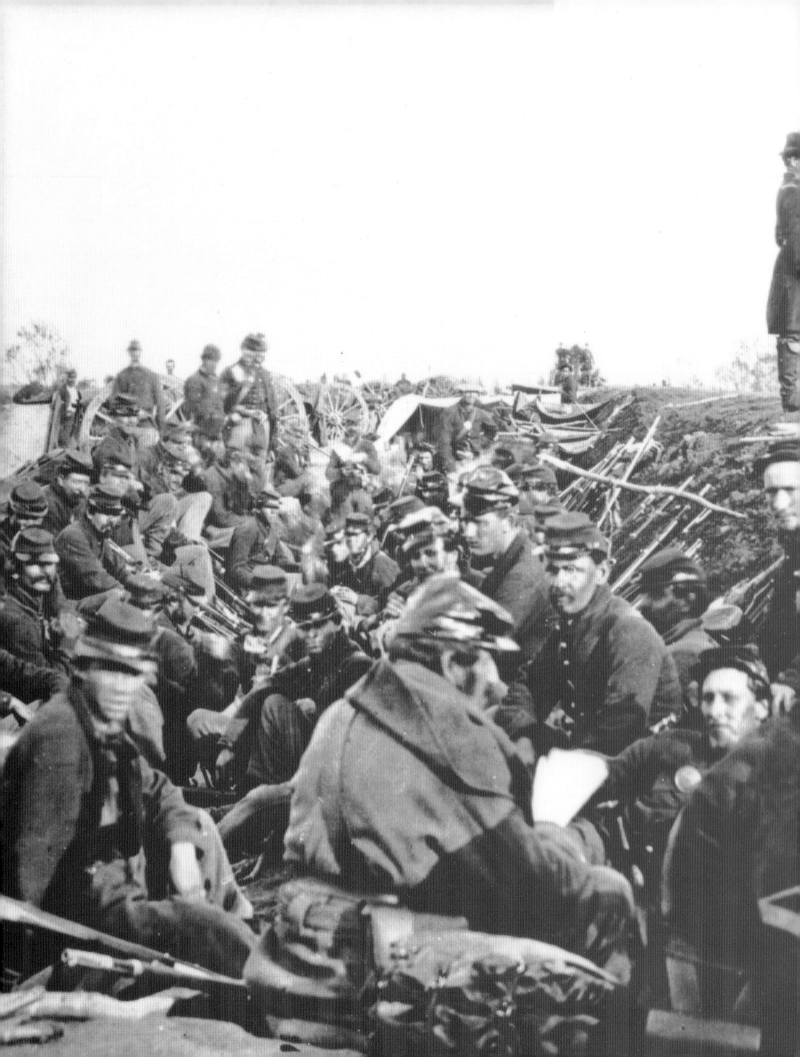

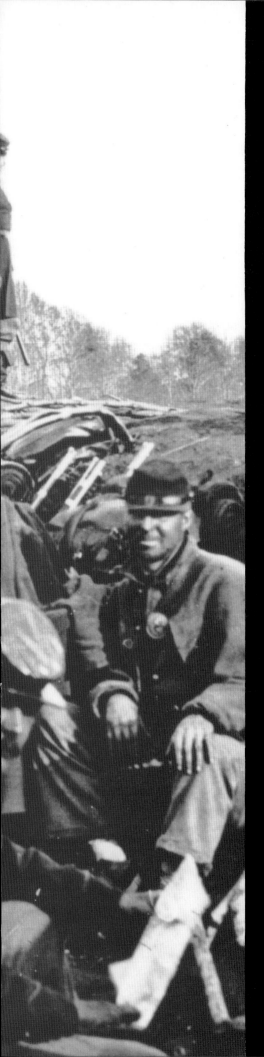

1864

THE
HARDEST YEAR
OF THE WAR

The Mississippi River was gone, the largely irrelevant territory west of the Mississippi River was hopelessly isolated from the rest of the Confederacy, two small armies had been surrendered, Bragg was routed, and Lee severely and irreparably damaged. Southern prospects never looked dimmer, but Southern determination remained undimmed. If the Confederacy could outlast Yankee resolution to continue, it could still win its independence.

If 1862 and 1863 had been the years of Lee, then 1864 would be the year of Grant and Sherman, for they would dominate the war from now on. Sensing that he had found the man to bring him ultimate victory, Lee promoted Grant to lieutenant general and gave him overall command of all Union armies, leaving it to him to plot a coordinated strategy to end the war. Grant, in turn, reluctantly decided to make his headquarters with the troubled Army of the Potomac, while leaving Sherman to oversee their old commands in the western theater.

Meanwhile the strategy to follow was clear enough. The Confederacy was badly wounded. The blockade was slowly working. Now was the time to take full advantage of the Union's numerical superiority. Grant wanted to press the enemy at every point. He would move with the Army of the Potomac to meet Lee. Sherman would advance toward Atlanta against Johnston, who had succeeded Bragg, and then move as circumstances dictated. Banks would campaign up Louisiana's Red River to occupy Confederate forces in Texas, Arkansas, and west Louisiana in the Confederates' so-called Trans-Mississippi Department. Major General Franz Sigel would lead a small army into the Shenandoah to deny its important crops to Lee, while Major General Benjamin Butler would lead his small Army of the James against Richmond from the southeast. They did not all have to succeed. Indeed, the movements of Banks, Sigel, and Butler were almost immaterial, but by pressing the Confederacy at all points they would drain its strength, and make it easier for the principal armies under Grant and Sherman to accomplish the real goal.

Banks was the first to get started, launching his small army up the Red late in March, accompanied by a fleet of gunboats under Porter. Though they took Alexandria, Louisiana, without difficulty, thereafter it was a folly almost from the start. Porter barely got his fleet above the rapids at the city, owing to low water, and then delays and Banks's ineptitude made the situation worse. When Banks approached Lieutenant General Richard Taylor's small army at Sabine Cross Roads near Mansfield, Louisiana, Taylor routed him. Banks struck back successfully at Pleasant Hill a few days later, but then

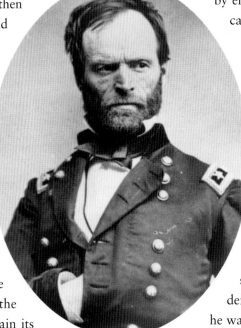

ABOVE
General W. T. Sherman

retreated anyhow, with Trans-Mississippi commander General Edmund Kirby Smith in pursuit. Thereafter the Confederates harassed Banks until he called off the campaign, only to find that the water in the Red would not allow Porter's fleet to pass back over the rapids to get away. An impromptu dam had to be constructed to raise the water level enough for most of the fleet to slide over to safety, only to be pursued by enemy shore troops all the way. The whole campaign was a shambles that ruined Banks.

Meanwhile Sherman had begun his own march, and he would be the only one of the prongs of Grant's plan to achieve complete success. The timid and indecisive Johnston was no match for Sherman, who steadily pushed him back south through north Georgia almost without a fight. Only at Kennesaw Mountain, a few miles north of Atlanta, did Johnston offer a momentary check to the Yankees, but then he continued his withdrawal, showing that he had no real plan for defending Atlanta. Finally, on July 17, when he was in the very environs of the city itself and still would communicate no plans to President Davis, Johnston was relieved and replaced by General John B. Hood, a determined if impetuous fighter. Hood launched an immediate attack three days later at Peach Tree Creek that failed to stop Sherman, then fell back into Atlanta's earthworks. Two days later Hood tried again, unsuccessfully, to halt the enemy envelopment, and within five days Sherman had the city under siege. Gradually he spread out, encircling the city, until August 31, when, finding himself with his last route of escape threatened, Hood launched an unsuccessful battle at Jonesborough. Failing, he had no choice but to evacuate. "Atlanta is ours, and fairly won," Sherman exulted to Lincoln.

It was a victory that gave the North a much-needed boost of morale, and likely helped in Lincoln's reelection that fall. The only real remaining hope for Confederate independence lay in Lincoln being defeated by his Democratic opponent, who just happened to be General McClellan, whose platform—which he himself largely repudiated—called for ending the war with peace negotiations that might have included letting the South go. The defeat of "Little Mac" signaled to the South that the people of the North were resolved to see the war through as long as it took, and that there would be no peace short of victory.

Elsewhere affairs had not gone well for the Union. Butler, a career politician who had no business even holding an army command, began moving his army up the James River on May 4 toward Richmond, but got no farther than Drewry's Bluff, where Confederates commanded by Beauregard cost him almost a third of his little army in casualties. Butler retreated to Bermuda Hundred, on the James, where he would remain ineffectually for months to come.

Meanwhile another Yankee campaign started out more promisingly. Sigel was a prominent German refugee from the revolutions of 1848 who had enormous influence with the

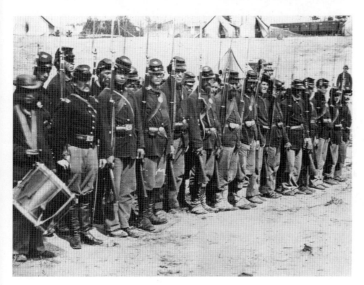

ABOVE Young Yankees in 1864 ready to finish the war.

large German population in the North who supported the Union. Though an inept and more often incompetent general, still his popularity made it politic to keep him in a command. Late in April he began his march into the Shenandoah, and at first moved almost unimpeded. By May 14 he was approaching New Market, with its important gap in the Massanutten Mountain leading to eastern Virginia and Lee's army. Take that gap and Sigel would have a back door open to Lee's rear as he faced Grant. All that was available to stop Sigel was a tiny army put together by Major General John C. Breckinridge, who had been one of the Democratic candidates running against Lincoln in 1860. Frantically moving northward from his base in southwest Virginia, Breckinridge pushed some of his units even faster and farther than had Jackson in 1862. By May 14 he had also augmented his 3,000-man army with the 227 cadets of Lexington's Virginia Military Institute, some of them no more than 15 years old.

Though outnumbered two to one by Sigel, Breckinridge took the initiative early on May 15 and attacked the Yankees just south of New Market, and then steadily pushed them back all day, at one point putting the cadets into the center of his line at a critical moment. By evening Sigel had been driven from the field in some confusion, and only the failure of a subordinate prevented Breckinridge from bagging the whole Union command. That done and the Shenandoah saved, Breckinridge immediately turned east and himself went to reinforce the beleaguered Lee.

And it was Grant and Lee that the eyes of everyone in the East watched. Grant knew that Lee was too skilled, even with his army battered by the fighting of 1863, to beat easily. True to his nature, Grant hoped to use maneuver instead of pitched battle to accomplish his aims, but as soon as he and Lee first clashed in the Wilderness on May 4 it became evident that Lee would match him stratagem for stratagem. For two days they fought inconclusively in the Wilderness, then for almost two weeks around Spotsylvania, then again for four days along the North Anna River, then finally for three days at the beginning

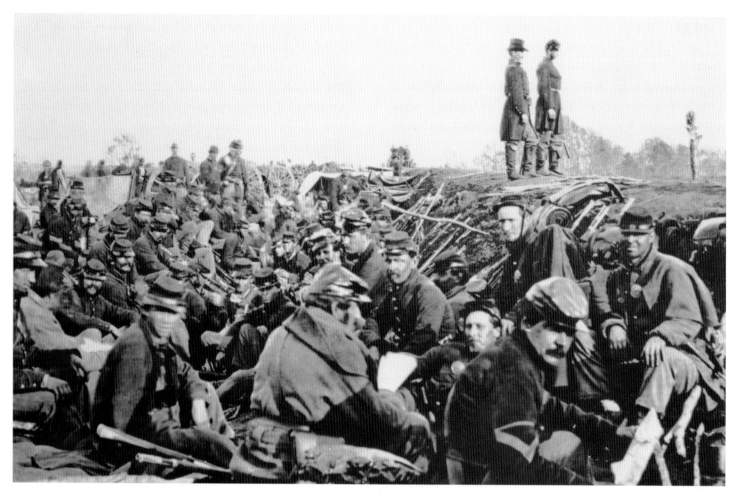

ABOVE Federal soldiers resting in the cool of the spring of 1864.

of June at Cold Harbor. Lee was steadily falling back toward Richmond, so Grant was gaining, but at the cost of heavy casualties. At Cold Harbor the Union commander resorted to a costly frontal assault that stunned his army, costing thousands of killed and wounded in barely an hour.

Now Grant turned to ingenuity again. Incredibly, he managed to move almost his entire army around Lee's right flank without Lee detecting the movement, and put it across the James River on a pontoon bridge that was a military marvel. With that head start, Grant had almost a clear road to the vital transportation and supply center at Petersburg, the key

to Richmond itself. But his army was too exhausted, and when, on June 15, he began to launch assaults on Beauregard's little band of defenders, the Yankees simply did not have stamina to seize what ought to have been an easy victory. Soon Lee arrived on the scene and the opportunity was gone. Once more, as at Vicksburg, Grant had no choice but to began a siege.

But even a siege worked to Grant's purpose. It kept Lee at bay, where he could no longer be a threat, and over time the Union might must eventually prevail. Gradually the siege lines extended until they ran more than 30 miles around Petersburg and much of Richmond. As at Vicksburg, Grant occasionally

tried something to break the stalemate, as on July 30 in an assault launched after he let Pennsylvania miners dig a tunnel under the space between the lines and pack an excavated cavern with tons of gunpowder that they detonated under Confederate works. It blew an enormous hole in the Southern lines, but the follow-up attack was botched by Grant's subordinates. Thereafter Grant contented himself with building up his army, gradually extending his siege lines strangling Richmond, and watching for an opportunity to force Lee out into the open that seemed never to come.

Meanwhile at least Grant could do damage elsewhere as he sent the army's cavalry under Major General Philip H. Sheridan back to do in the Shenandoah what Sigel had failed to do. In June Lee had detached a corps commanded by Lieutenant General Jubal A. Early on a diversionary raid using the valley as a route into Maryland. By July 11 Early actually reached the outer defenses of Washington, throwing a fright into the Yankee capital before he was forced to pull back. Now Sheridan went after Early, and in a series of battles in September and October he soundly defeated the Confederate and took undisputed control of the Shenandoah, which he systematically denuded of the resources so badly needed by Lee.

However, good news for the North came from Mobile, Alabama, where Admiral David G. Farragut steamed a gunboat fleet past forts and through underwater mines—then called torpedoes—to capture a vitally important Confederate port. Meanwhile, at sea, the Confederate effort at hindering Union merchant commerce with raiders suffered a severe blow when the dread CSS *Alabama* was sent to the bottom off the French coast. But most of the good news came from Sherman. He and Grant had no firm plans as to what he should do after taking Atlanta. Now Sherman proposed that he evacuate the city and drive for the Atlantic coast and Savannah, splitting Georgia and demoralizing the enemy.

Hood led his army in another direction, on a campaign into Tennessee hoping to decoy Sherman away, but it did not work. Instead Sherman just sent Thomas after Hood with a

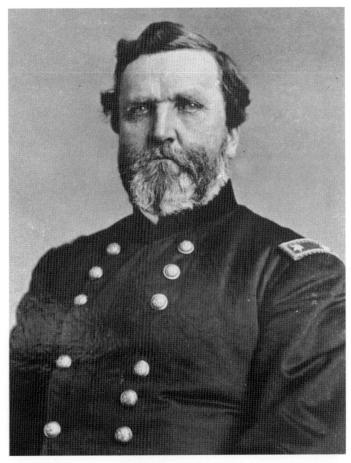

ABOVE General George Thomas

portion of his forces, while Sherman led the rest on a triumphal campaign that found little opposition in its path. In early December Hood almost destroyed his army attacking Thomas at Nashville, Tennessee, and then withdrew the tattered remnants, himself soon to resign. Sherman occupied Savannah on December 21 after its outnumbered defenders evacuated. The next day he sent Lincoln another telegram presenting him with Savannah "as a Christmas gift." The Confederacy was hopelessly fragmented, one of its two major armies practically disintegrated, its resources exhausted, its infrastructure shattered irreparably. It remained now only to take Lee out of the war, and it would all be over.

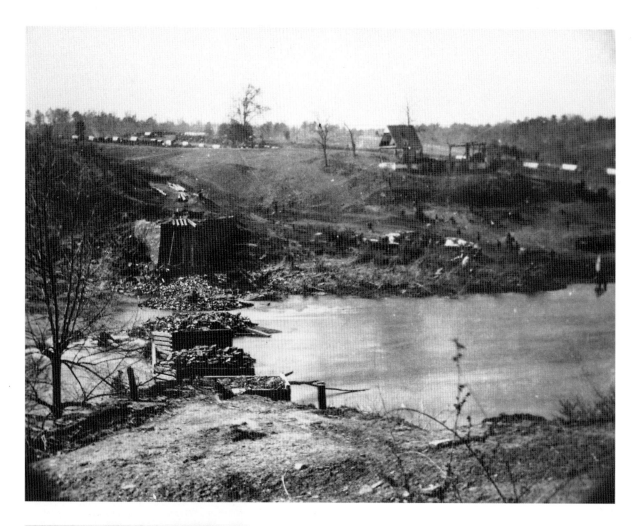

ABOVE

The ruins of the bridge at Germanna Ford on the Rapidan River, one of the crossings by which Grant began the Wilderness Campaign on May 5. Incredibly, he got much of his army across before Lee could react, inaugurating a duel between them that would last for months.

LEFT

The Orange Turnpike intersects with the Germanna Plank Road here not far from the Wilderness tavern, and then continues off into the distance. It was down this road that part of the Union Army marched on its way to the Wilderness fighting.

LEFT
When the Yankees came to the Spotsylvania area, they found the ground just as densely wooded and impenetrable as the Wilderness had been, and besides the woods and underbrush themselves, there were the enemy log breastworks and rifle pits like these to contend with.

RIGHT
Spotsylvania Court House was a small community of little more than a hotel and this court house itself, but after the fighting ended in the Wilderness, it found itself in the path of the advancing armies. It would witness some of the heaviest fighting of the campaign.

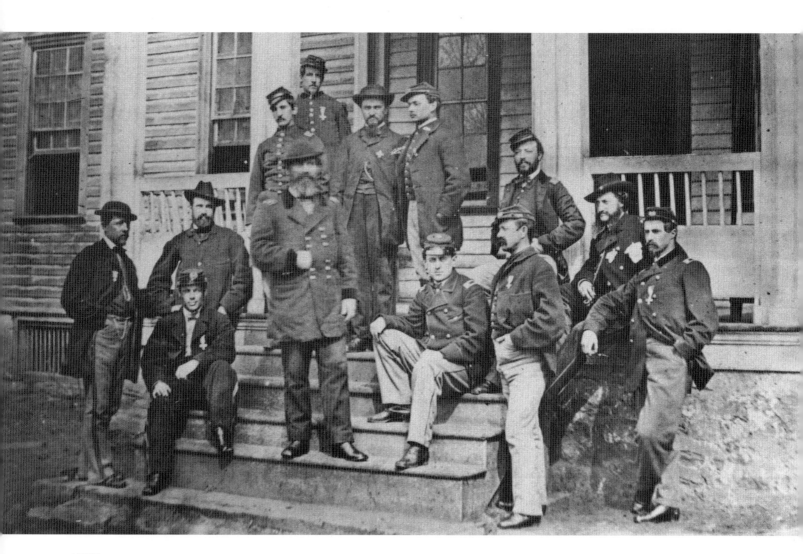

ABOVE
Union Major General John Sedgwick and his staff
pose at his headquarters near Brandy Station
before the campaign began. Sedgwick himself
stands at center in Napoleonic pose, with his
hand thrust inside his blouse.

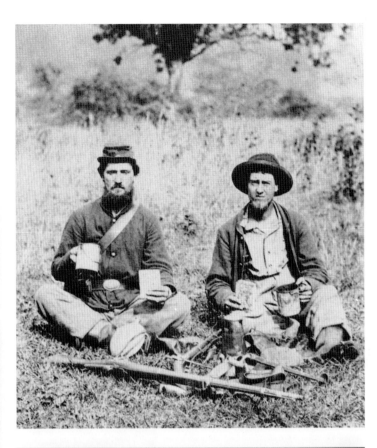

RIGHT

Two Yankee privates take a pause during the 1864 campaign in Virginia to pose for a photographer. In their hands are very substantial tin cups for their coffee, and the hardtack "army bread" that was a staple of the soldier's ration. It was so hard they sometimes had to soak it in their coffee before chewing.

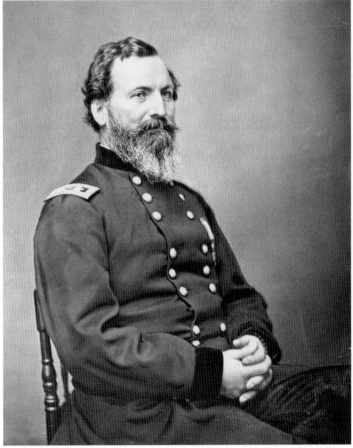

LEFT

Sedgwick commanded the VI Corps and was universally popular with men and officers alike. At Spotsylvania he made one of the most inaptly chosen remarks of the war when he said the enemy "couldn't hit an elephant at this distance." A moment later one of them hit him in the head.

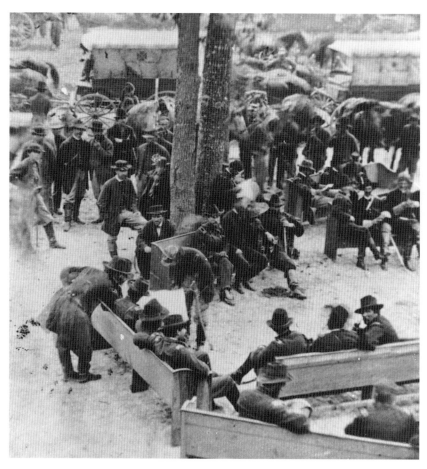 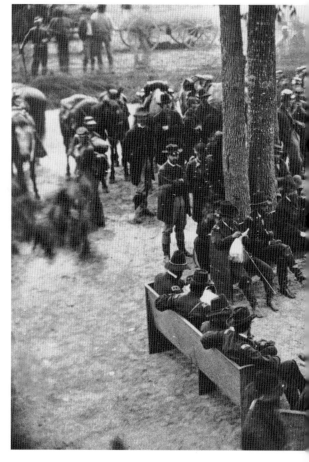

ABOVE

A real coup for the photographer was a historic moment like this war conference at Massaponax Church on May 21, as Grant and his army was marching toward the North Anna River. On pews hauled out of the church, he and his generals confer, Grant leaning over a pew at left to talk with Meade, then seated immediately beneath the trees.

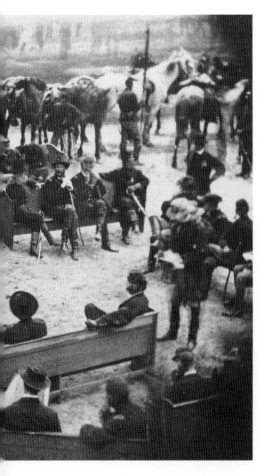

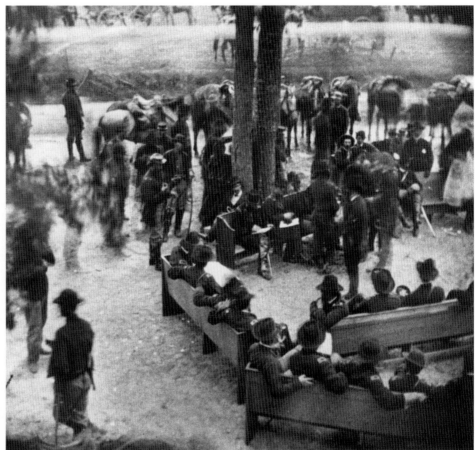

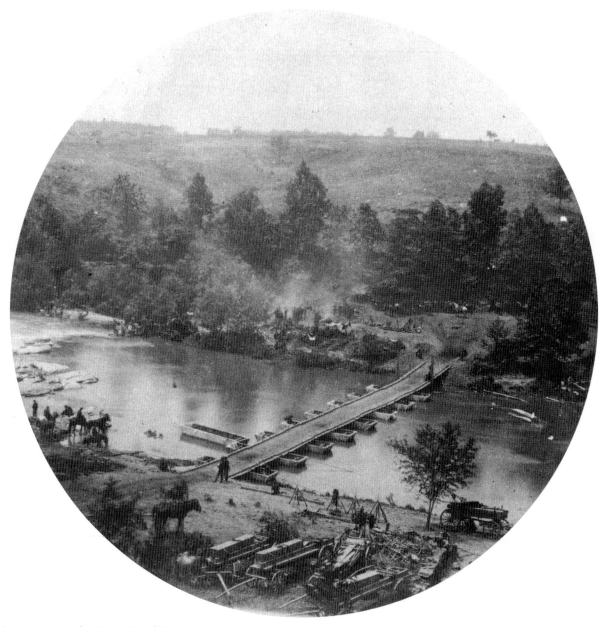

A sight destined to become familiar in May 1864 and afterward, Union engineers bridging Virginia rivers, in this case the V Corps crossing the North Anna River at Jericho Mill as Grant's army moved south after the fighting in the Wilderness and Spotsylvania.

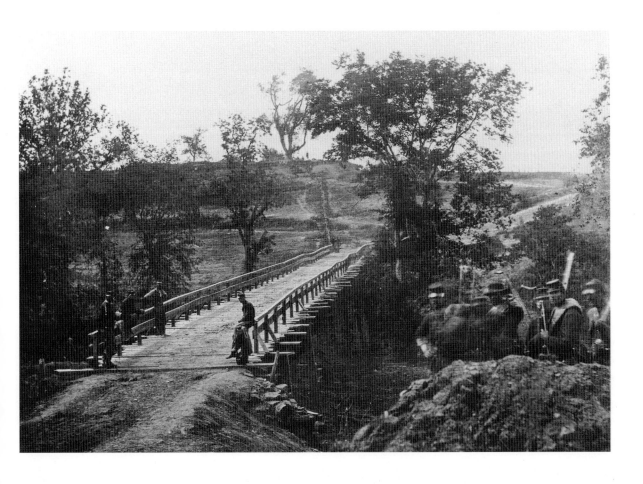

ABOVE

Here at the Chesterfield bridge over the North Anna, General Winfield Scott Hancock and his II Corps attacked Confederate defenders in the earthwork on the ridge in the distance, and then crossed the river on May 23. These multiple crossings moved Grant's army faster, and pressed Lee at every point.

RIGHT

Another view of the Chesterfield bridge, taken from within the former Confederate earthworks, shows cavalry of Hancock's corps actually crossing the North Anna toward the main camps of his corps in the distance, marked by the smoke of cook fires.

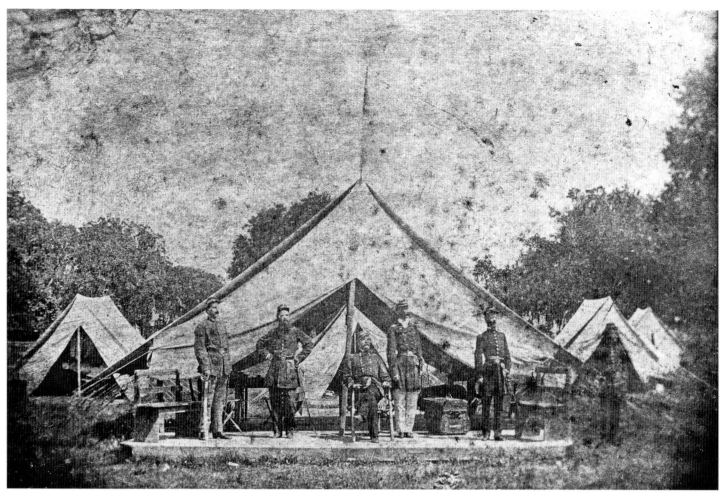

ABOVE

Confederate soldiers with Lee in the 1864 campaign hardly looked as resplendent as these officers of the Washington Artillery of New Orleans, with their commander Colonel James B. Walton seated at center, but the officers almost always managed to look better than the men.

RIGHT

Timothy O'Sullivan's view of Union soldiers burying their dead during the campaign. They may be wearing masks to guard against the smell and possible infection. It was the dreadful casualties that wore Grant's army down so that it could scarcely function by mid-June.

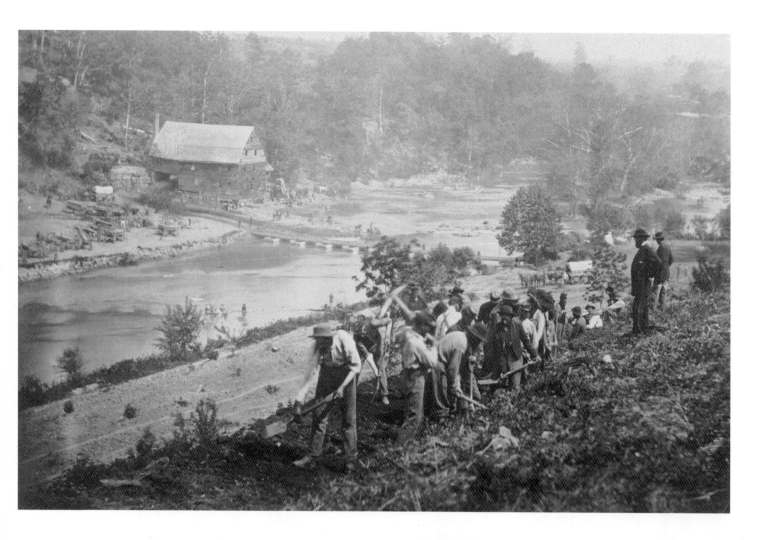

After the fighting had passed farther south, Grant's engineers solidified his communications, as here at Jericho Mill on the North Anna, where the 50th New York Engineers is in the act of cutting a new road along the south bank of the river after laying the pontoon bridge in the distance.

In the wake of the armies, the photographers also took time out to search for photogenic subjects, like this 10-pound shell which struck a tree near the 7th Rhode Island Infantry during the Spotsylvania fighting, and embedded itself, fortunately without exploding.

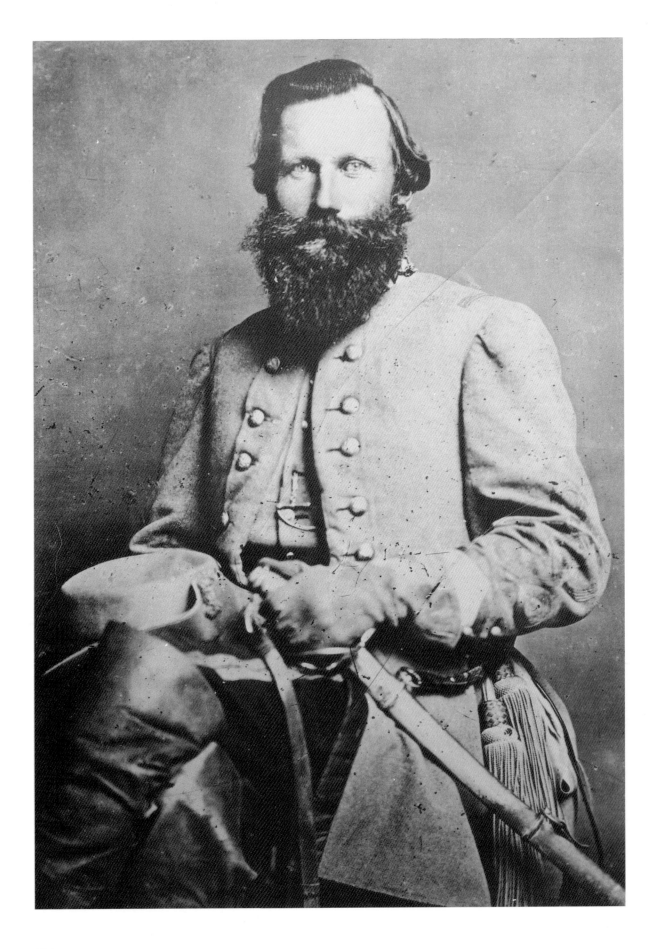

LEFT
On the fringes of the armies Union and Confederate cavalry sparred, and now at last Yankee horsemen fought completely on a par with the Southern horse, who took a terrible blow at Yellow Tavern on May 11 when charismatic corps commander Major General Jeb Stuart was mortally wounded.

RIGHT
By early June Grant and Lee met again in bloody contest at Cold Harbor. There on June 3 Grant made what he admitted himself was his worst mistake of the war, launching a massive frontal assault over this ground against well-placed Confederate forces. It was a bloody shambles.

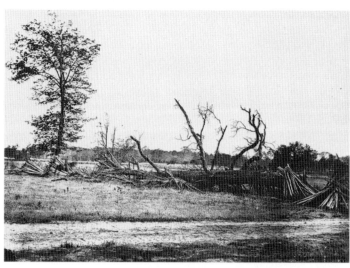

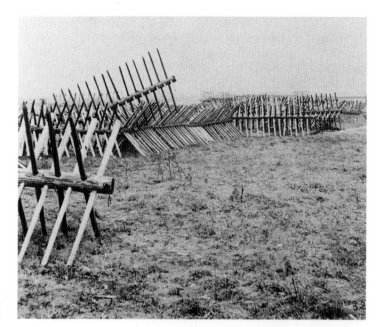

LEFT
Two weeks after Cold Harbor, Lee had been forced into the trenches and forts surrounding Petersburg and Richmond, and the longest siege of the war began. The Rebels used stakes driven through logs like these, *chevaux-de-frise*, to line their defenses and break up any attack.

RIGHT
Just one of the innumerable trenches that surrounded Petersburg, made miserable by rain for their Confederate occupants. In the distance is the entrance to a bomb proof where the Southerners could take refuge from the almost constant Yankee shelling. Photo taken April 3, 1865, just after Petersburg's evacuation.

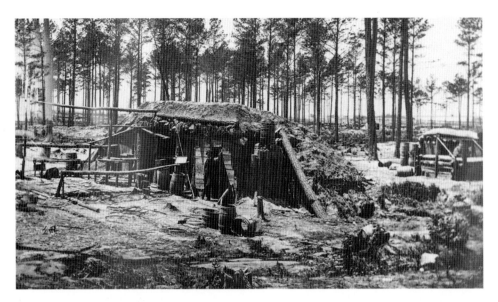

LEFT

The Union soldiers, too, built their bomb proofs, like this one, which has been turned into a combination defense and winter quarters. Soldiers learned to hoard anything that might be useful, explaining the empty barrels and boxes lying around, some of which could become building materials.

BELOW

General U.S. Grant, and his favorite horse "Cincinnati," in the field in 1864. Known throughout the army as a superb horseman, he was often to be seen riding along the lines, unassumingly chatting with officers and soldiers alike. And in his hand, the ever-present cigar.

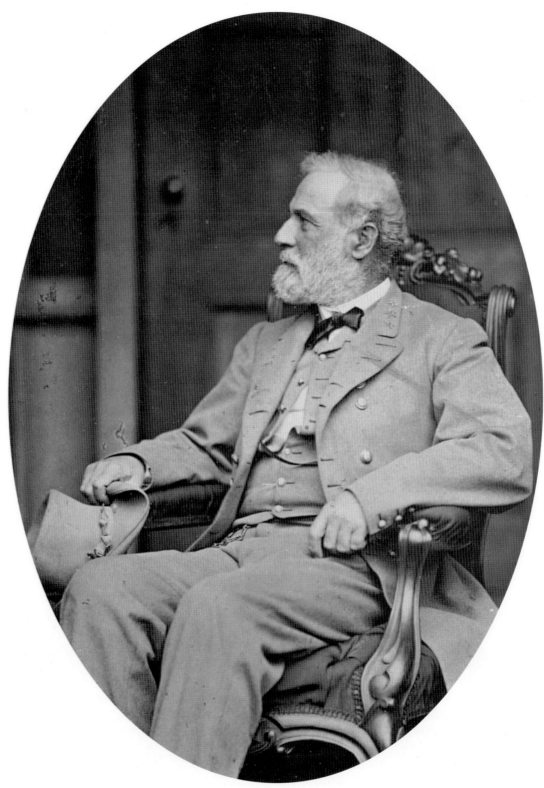

ABOVE
The war was aging Robert E. Lee, as is evident in this portrait taken within months of the Petersburg siege, and just days after the close of the fighting. He bore the responsibility not only of commanding his army, but also of leading the hopes of most of the Confederacy—a crushing burden, as he well knew.

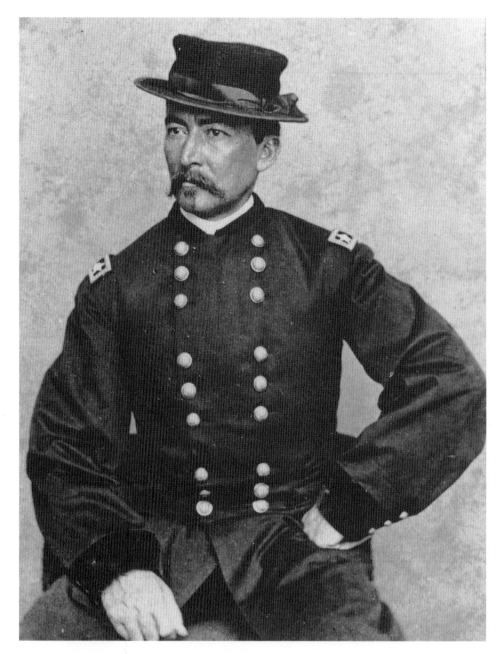

ABOVE

As part of his overall strategy, Grant sent Philip
H. Sheridan, whom he had brought west with
him, to command the Army of the Potomac's
cavalry and use it to clean out the Shenandoah
Valley that supplied much of Lee's army and the
rest of the Confederacy.

ABOVE

To oppose Sheridan, Lee detached Lieutenant
General Jubal A. Early with much of Stonewall
Jackson's old corps. Early tried to hold the
Shenandoah, but in a series of battles in
September and October Sheridan all but routed
him, opening the valley to Yankee devastation.

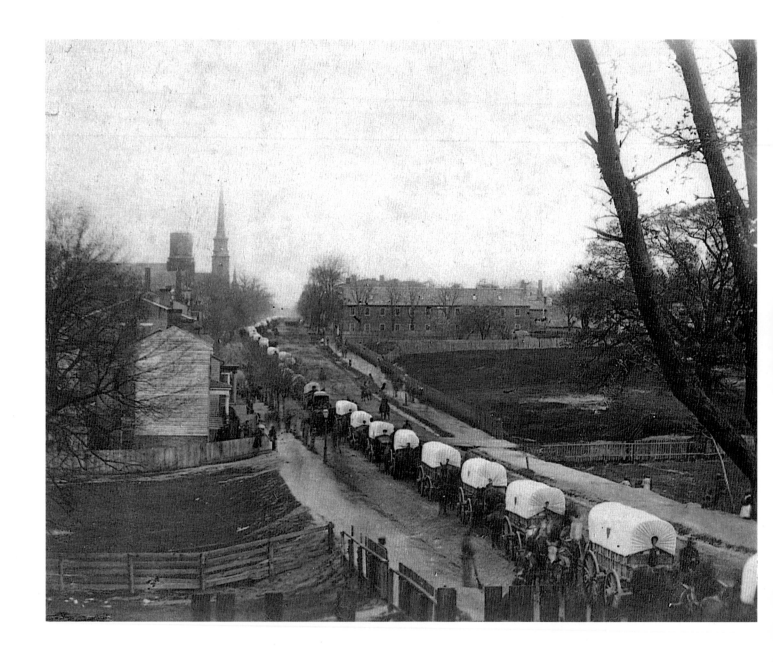

ABOVE

When Petersburg finally fell in April 1865, Union wagon trains poured into the city to supply Grant's army as he set off to pursue Lee to Appomattox. Like Richmond and Vicksburg and Atlanta, Petersburg had suffered substantial ruin, and much of it would never recover.

RIGHT

Most successful of all of Grant's many thrusts into the Confederacy was the drive toward Atlanta planned and executed by Major General William T. Sherman. He was an unusual man, brilliant, multilingual, full of nervous energy and often unable to sleep, but he could make war hell.

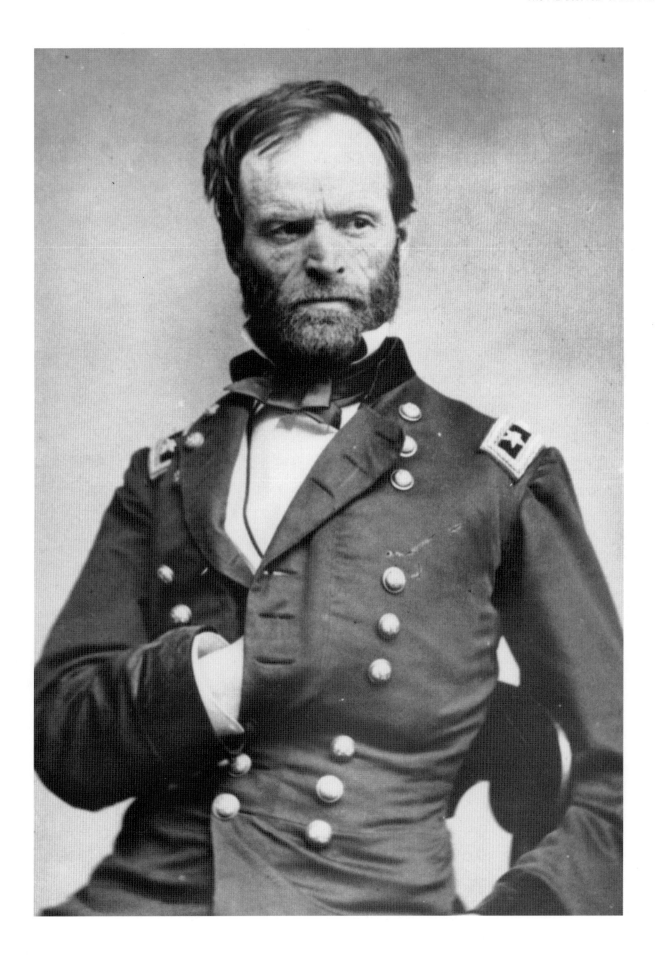

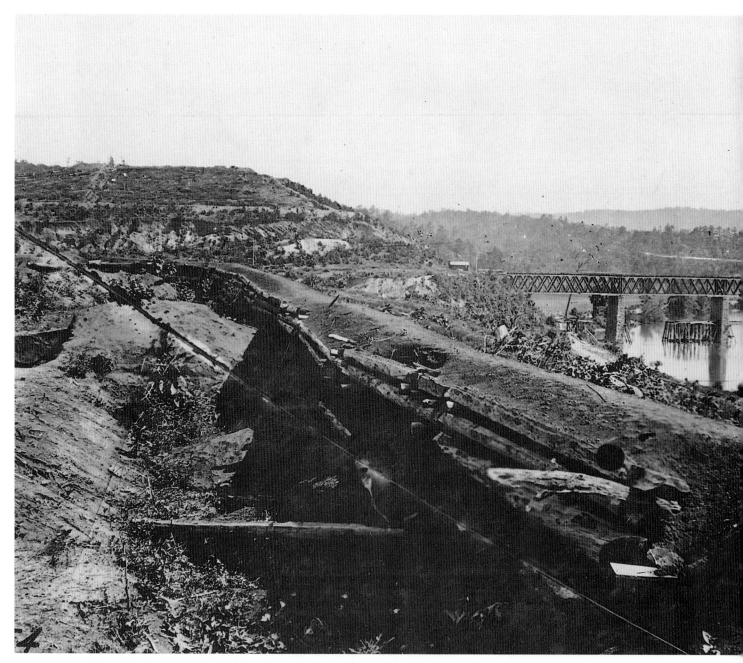

ABOVE
Once he got started, Sherman did not relent.
After fights at Resaca and Kingston, Johnston fell
back across the Etowah River without sufficient
time to do a thorough job of destroying it.
George N. Barnard followed Sherman and put
his camera in old Confederate defenses to
capture the scene.

BELOW
Another Barnard view from inside Johnston's Etowah defenses looks to the south toward Allatoona Pass in the distance. Johnston had it heavily fortified, but Sherman would simply march around it and force Johnston to evacuate the pass without a fight—a tactic that Sherman would carry out again and again.

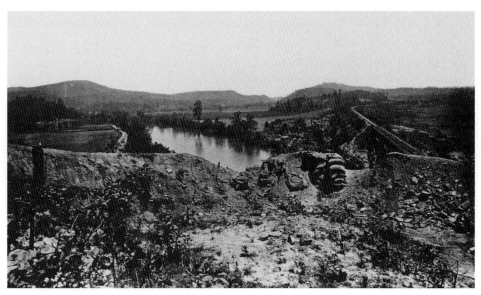

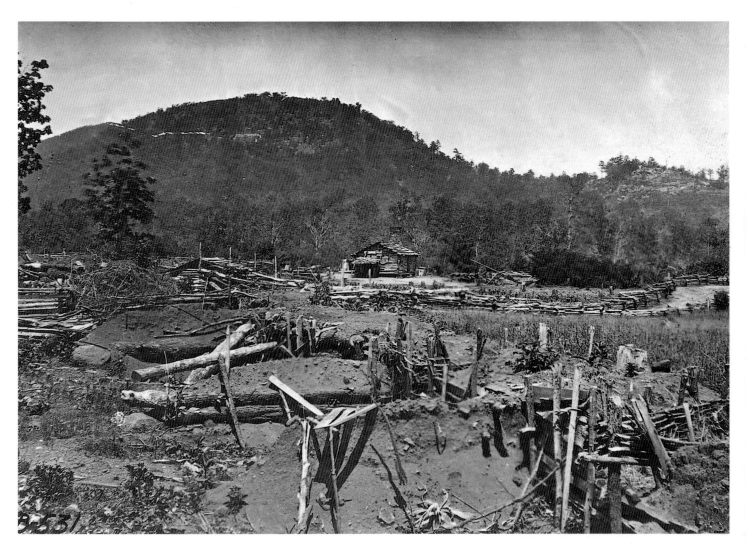

Finally Johnston would hold his ground on the
heights of Kennesaw Mountain, and Sherman
would break his habit and attack, with costly
results. It would be the only defeat that Johnston
would hand him in this campaign, but in the end
the Confederates still withdrew.

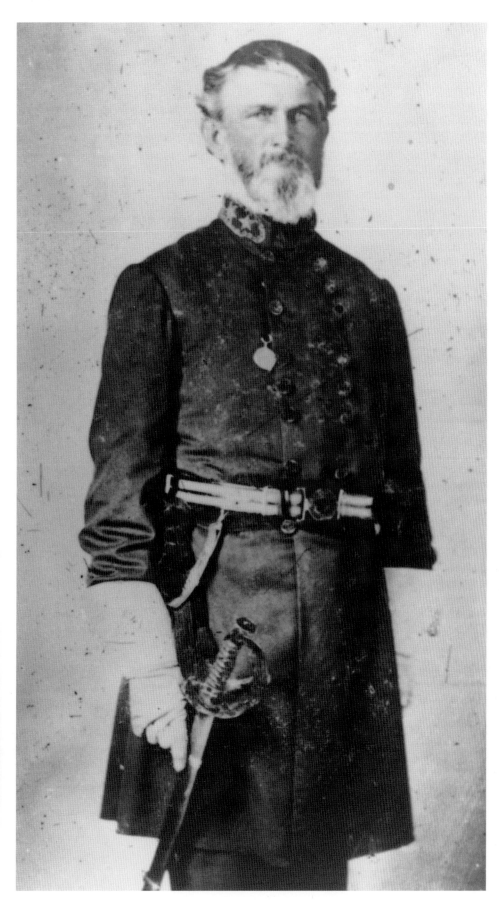

LEFT
A heavy blow—or a blessing in disguise, depending on one's point of view—came at Pine Mountain on June 14, 1864, when a Yankee cannon shell struck Lieutenant General Leonidas Polk square in the chest. He had fomented political intrigue and unrest in the army since 1861.

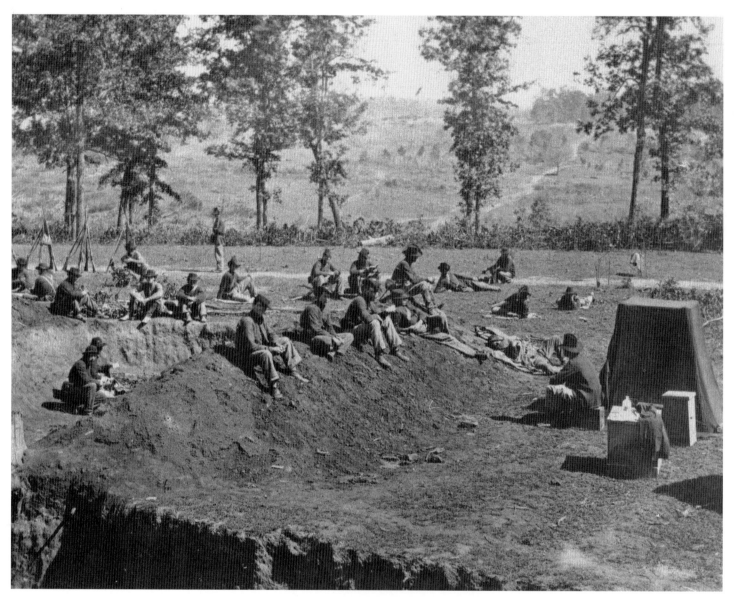

ABOVE

Finally Sherman pushed Johnston back into the
defenses of Atlanta itself, and then began a siege
of sorts as the Yankees extended lines of works
of their own, with bomb proofs like this one. At
right sits the portable dark room of the
photographer Barnard, while the men read and
pretend indifference to his lens.

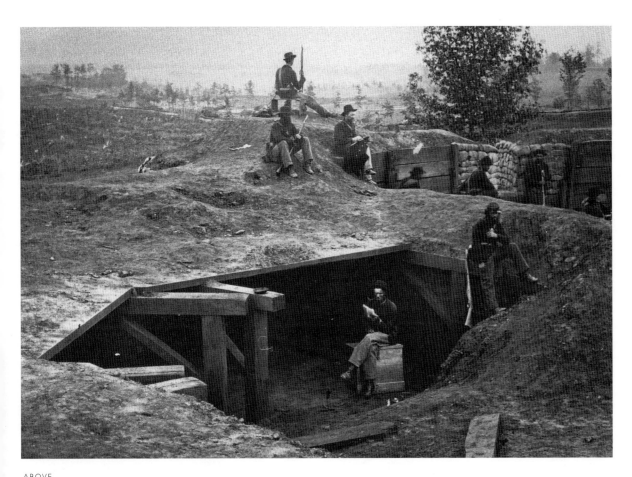

ABOVE

Just one of the host of bomb-proof shelters erected by Sherman's troops, in part to give them shade from the hot summer sun of Georgia. On the distant horizon, Confederate defenses protect defenders who know that soon they will be cut off from retreat and forced to give up Atlanta.

RIGHT

Johnston's Confederates protected Atlanta well, ringing it with a series of earthworks, sandbag gun emplacements, stake walls, and miles of chevaux-de-frise. It would be extremely foolhardy to attack against such defenses under fire, and Sherman wisely decided not to take the chance.

FOLLOWING PAGES

In the end Sherman took Atlanta by maneuver, cutting its defenders off from their line of supply and retreat. The Confederates destroyed much when they left, but Sherman would destroy more, like the roundhouse of the Western & Atlantic Railroad, when he started on his March to the Sea.

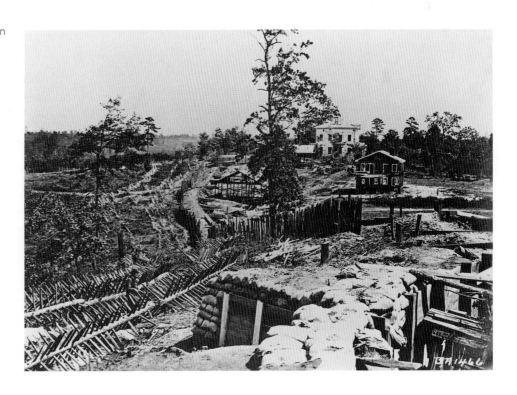

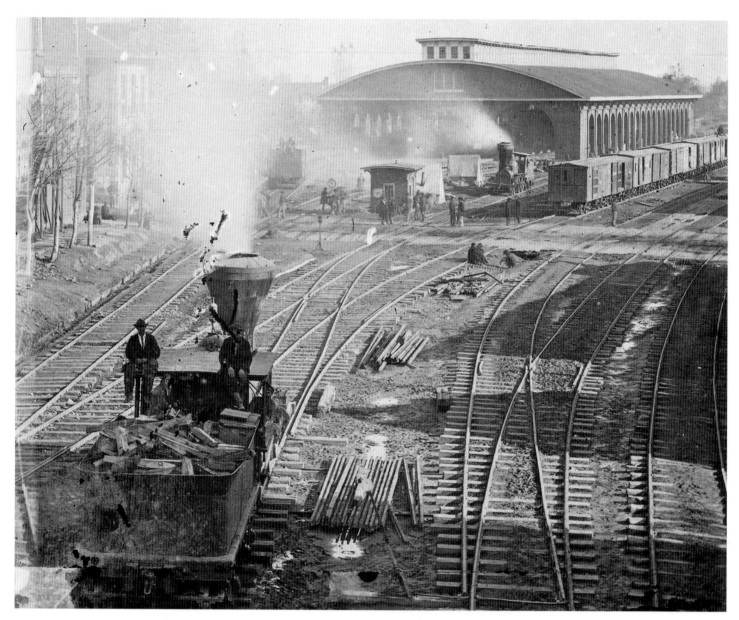

The famous car shed of the Western & Atlantic
was what made Atlanta so important, for it was a
railroad junction and nerve center for
Confederate communications in Georgia and the
southeast. Sherman would leave it, too, in ruins
when he departed.

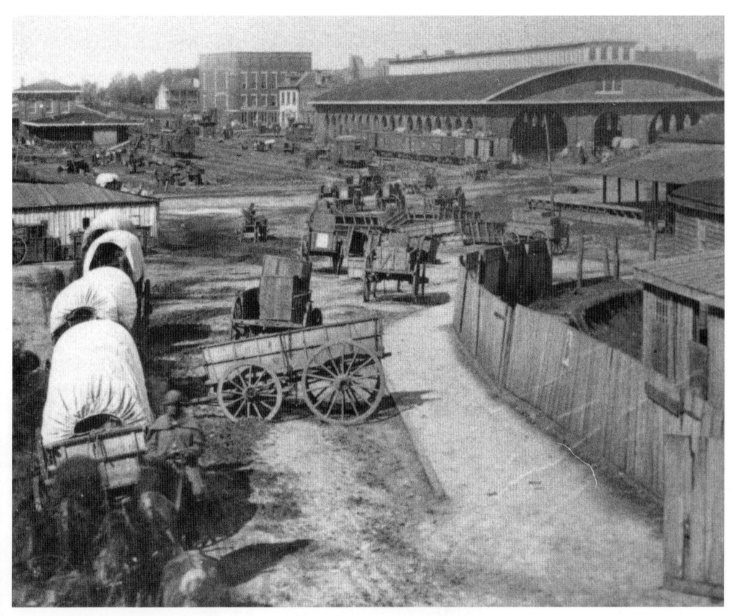

ABOVE

Just a few of the thousands of wagons that
would go with Sherman on his March to the Sea.
Sherman carried provisions with him and cut
himself off from a line of supply through Atlanta,
another reason to leave behind nothing that
would be of any use to Confederates when he
marched on.

LEFT
Behind them the battling armies left a landscape littered with scenes of their fighting, like these Confederate works of logs and earth on the outskirts of Atlanta, the remains of which would last for generations, just as would the resentment over Sherman's act of destruction.

BELOW
And behind them the armies, both of which
had used the torch, left a ruined Atlanta. Amid
the rubble of buildings destroyed by artillery
fire, or by military order, civilians struggled to
continue their lives until the war passed on
and left them alone.

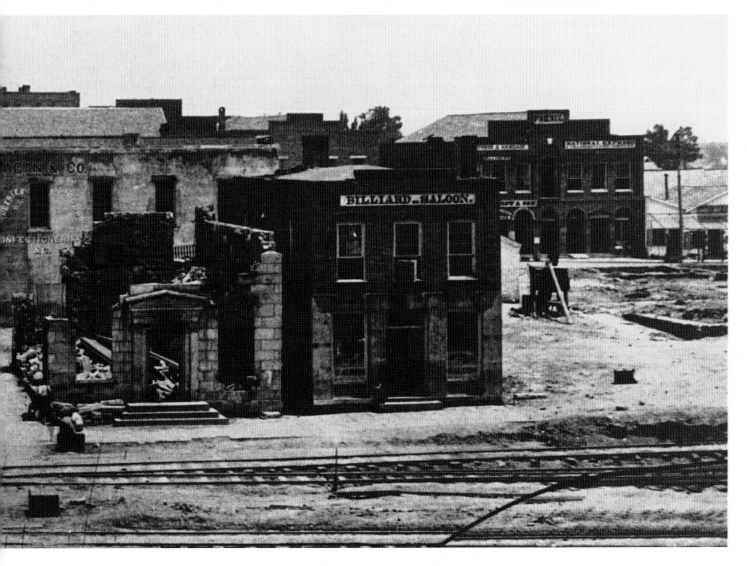

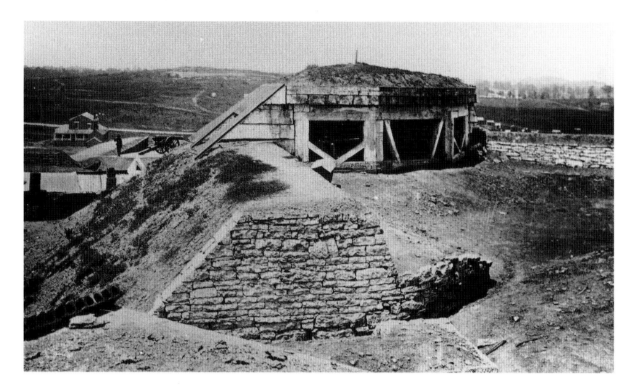

ABOVE

General Hood, who gave up Atlanta, would attempt to regain his loss by invading Tennessee late in the year, but a resolute army and the defenses of Nashville would stop him. Here a casemate on the perimeter of the lines at Fort Negley houses artillery that would punish Hood.

RIGHT

Civilians inside Nashville stand watching the battle off in the distance out of camera range as Thomas sends his army out to pummel the battered and defeated Army of Tennessee under Hood. It would end with the near-destruction of the Confederates.

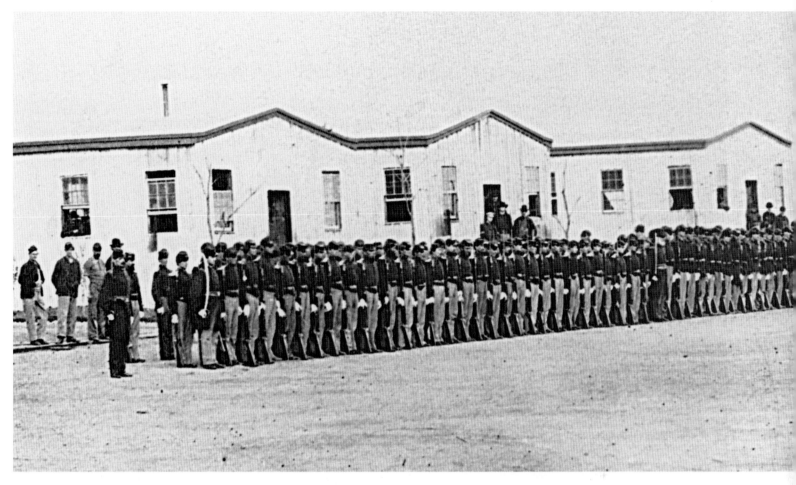

ABOVE
A fresh-looking Union regiment poses for the camera in Nashville sometime around the time of the battle in December 1864. Against men so well equipped and trained, Hood's poor ragged veterans had little chance, especially after their awful blooding at Franklin.

OVERLEAF LEFT
Sad-eyed General John Bell Hood of Texas had been a determined and resourceful division commander under Lee. But the loss of a leg and the crippling of an arm in action may have clouded his judgment, and his attack on Nashville was an act of pure desperation for which many in his army would never forgive him.

OVERLEAF RIGHT
The determined visage of Major General George H. Thomas betokened a man not brilliant or dynamic, in fact somewhat slow and plodding, but when he decided to hold his ground, he did it. He earned the sobriquet "Rock of Chickamauga" in 1863, and at Nashville he would administer to Hood one of the most complete battlefield defeats of the war.

195

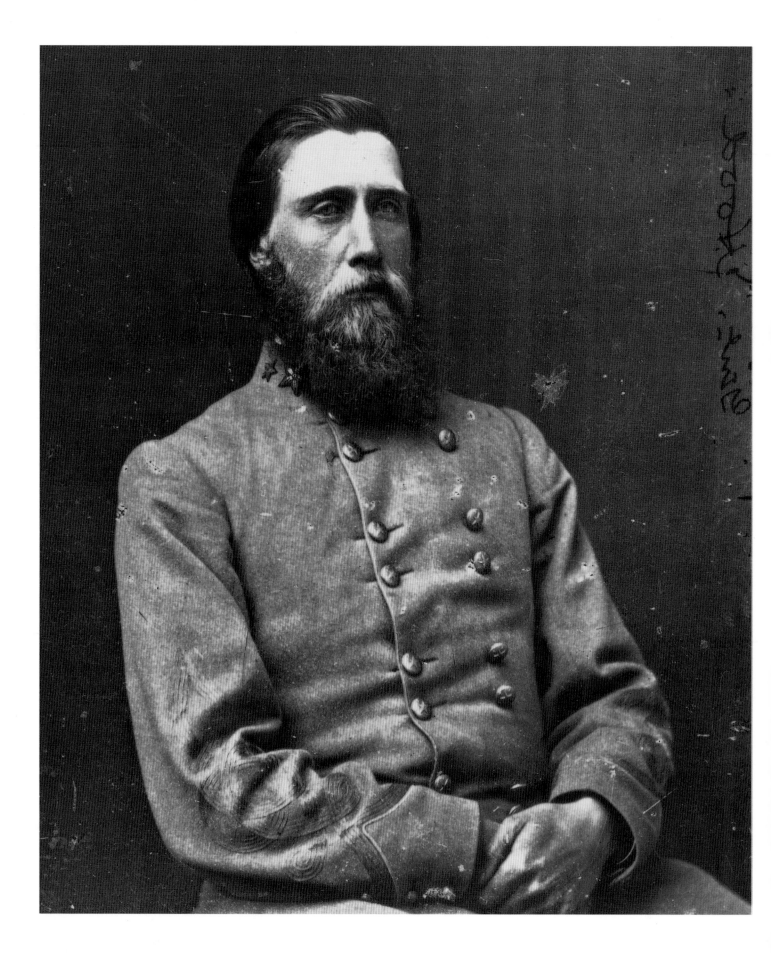

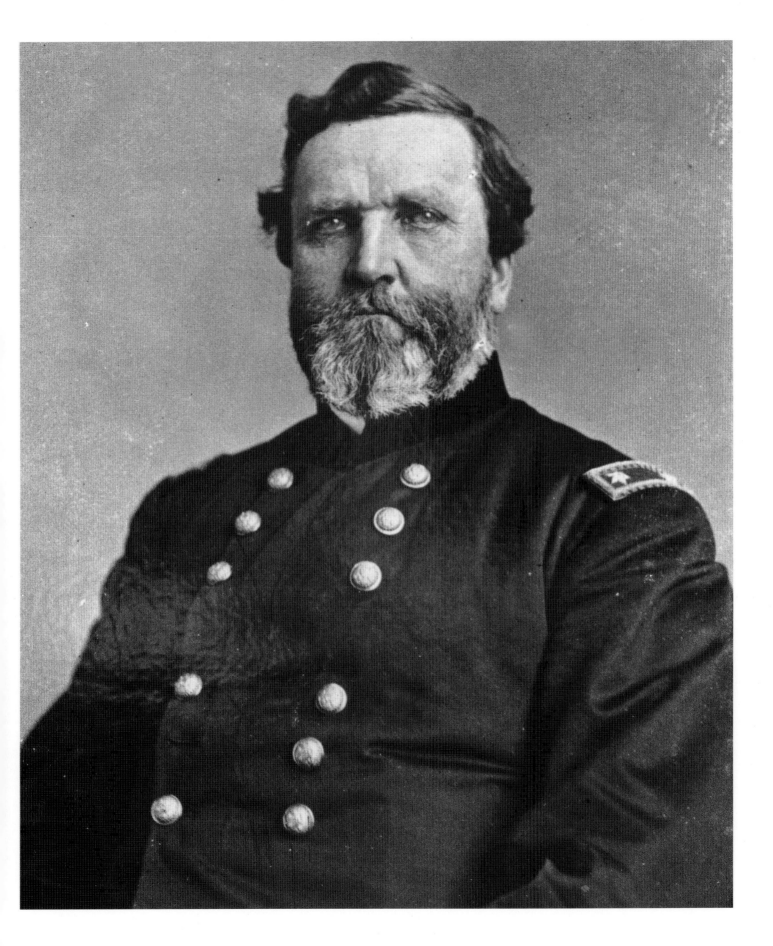

ABOVE

The outer perimeter of Thomas's defenses
surrounding Nashville, with the camp fires of
some of his men preparing their meals and
trying to stay warm. Few soldiers are in
evidence, for most are out engaged in the
action at this very moment as Thomas coun-
terattacks Hood decisively.

ABOVE
The only real threat to Sherman in Tennessee came from Confederate raiders striking his supply lines, which was one of the reasons he tried to take as much of his necessary supplies as possible with him when he moved. One supply base here in Johnsonville was burned by Rebel raiders, and was still smoking when a cameraman came past.

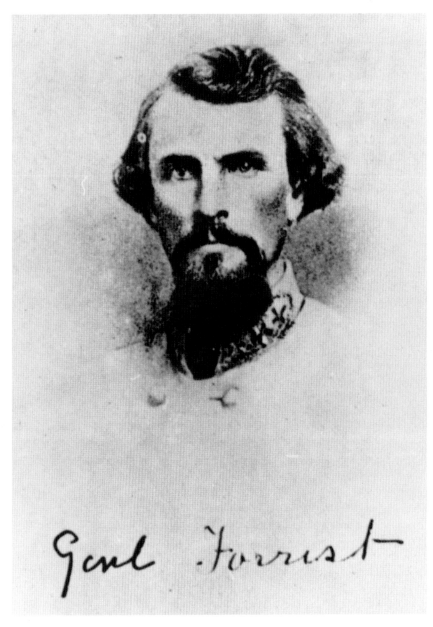

RIGHT
The most resourceful and successful of all those trying to hamper Sherman was Lieutenant General Nathan Bedford Forrest, who so bedeviled Yankee supply lines that Sherman wanted him killed if at all possible, though targeting generals was not commonplace in this war.

Artillery

The variety of big guns employed in this war was dazzling, everything from attempts at multi- or rapid fire "machine" guns, to massive 20-inch seacoast columbiads that could propel a projectile farther than gunners could see. The workhorses, however, were the field artillery that moved with the armies, and the heavier siege guns used in the forts along the rivers and in the siege works. As always, the Union enjoyed an enormous advantage in manufacturing, the war providing a catalyst for an explosion of invention.

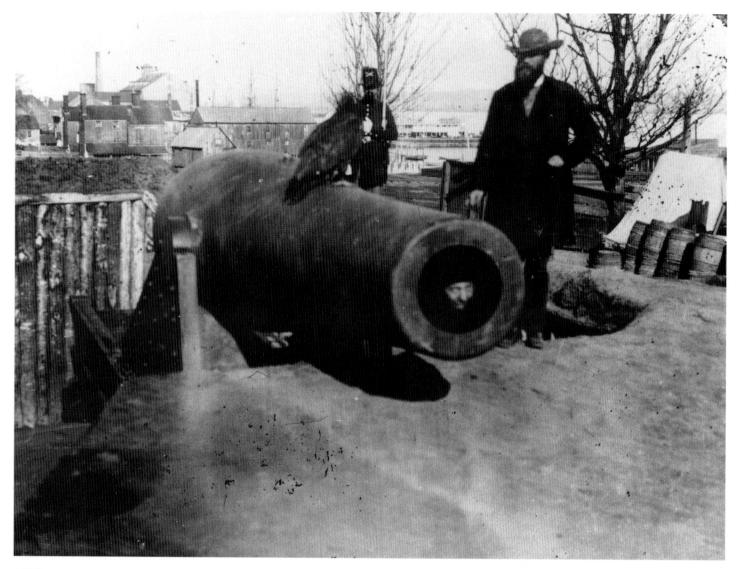

ABOVE

With the really big guns, like this Rodman smoothbore in Battery Rodgers, one of the forts defending Washington, the soldiers spent more time playing than firing, for Washington only came under attack once, and Battery Rodgers never. A smaller soldier could actually pose inside the barrel.

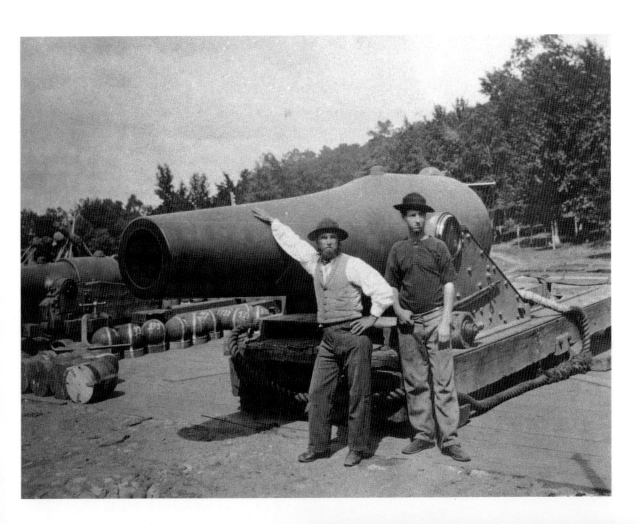

ABOVE

This huge 15-inch Dahlgren smoothbore was hardly the largest gun cast in the Union's foundries, but it was still massive, and would never see combat. Its great round shot are to the left, and behind them an equally massive Parrott rifle.

RIGHT

The Washington Arsenal was where every variety of experimental field artillery types of artillery were tested. A Wiard gun stands in the foreground at right, with row upon row of 3-inch ordnance rifles, 12-pound gun-howitzers, and other designs to the rear.

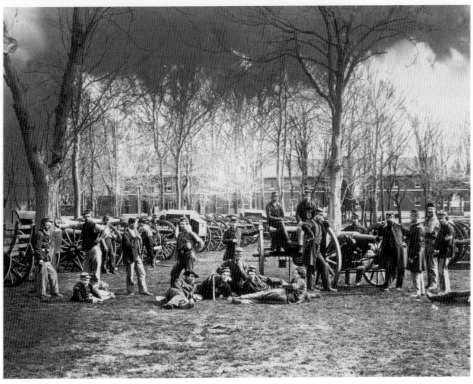

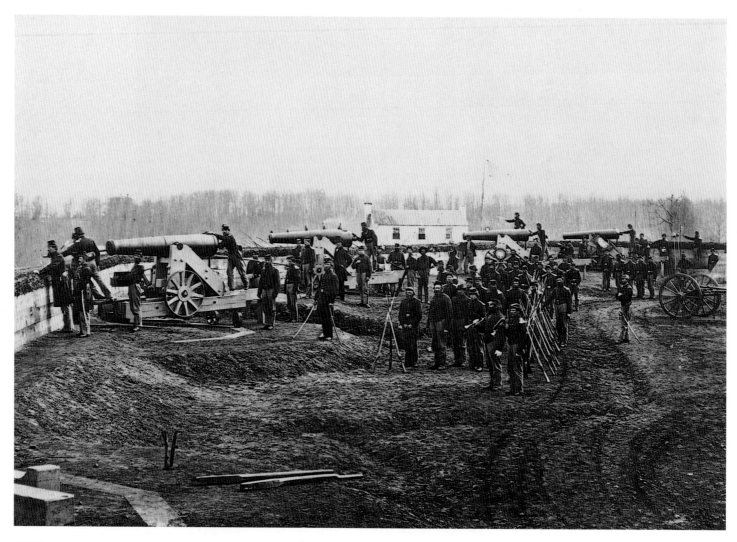

ABOVE
Siege guns line the parapet of Fort Corcoran, the principal Union fort guarding southern Virginia approaches to Washington. It, too, would never see action, the one and only Confederate attack on the capital coming from the Maryland side, in part perhaps because no one wanted to face these formidable siege guns.

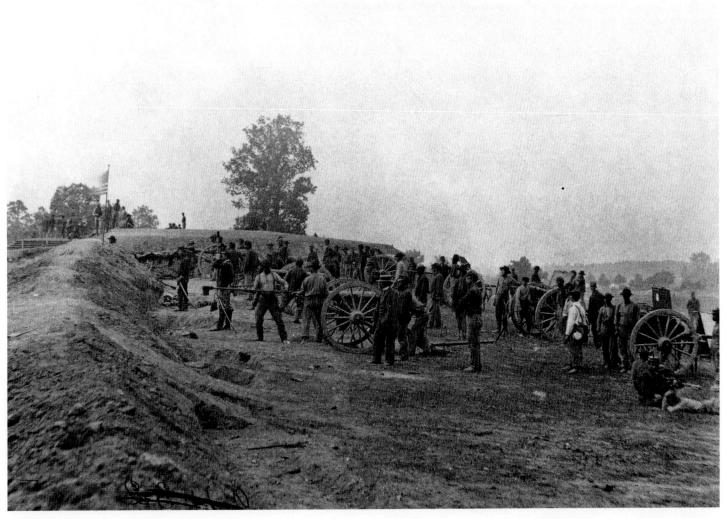

ABOVE

A typical field battery emplaced for long service. This is the 12th New York Artillery near Petersburg on June 20, 1864, its guns emplaced in a captured Confederate embrasure. Two days after this was taken, the Rebels would recapture it. Mathew Brady stands center in the straw hat.

The Regiment

The regiment was the basic unit of both armies, ideally about 1,000 men, though in practice perhaps 600–800 in the North, and as few as 200–300 in the South, and less as the war progressed. Made up of ten companies, it lived, drilled, and fought as a unit, all of the men coming from the same state, and most of the companies coming from a single community, to produce marvelous cohesion and esprit. There would be more than 3,000 of them North and South, not counting artillery batteries and smaller companies.

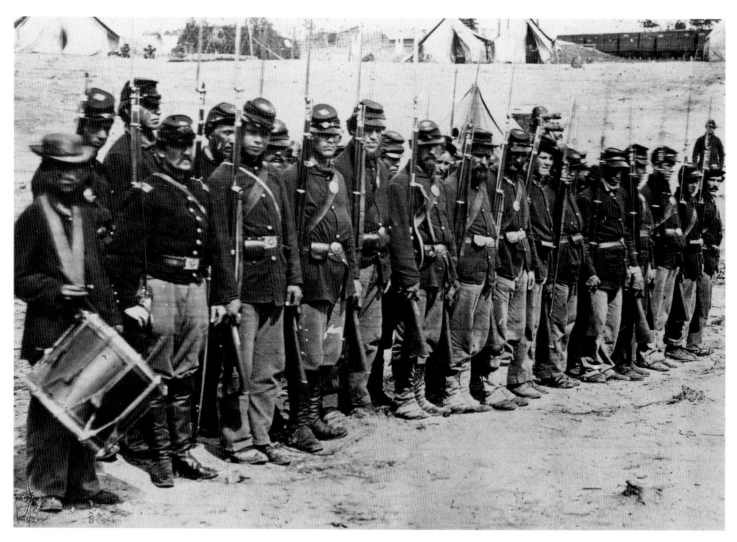

ABOVE

The faces in the line of this Yankee squad of about 20 men show the variety of ages by 1864, from the smiling youthful recruit, to the grizzled bearded veterans. Before it is over one out of every five of them will die in battle or of disease and camp sickness.

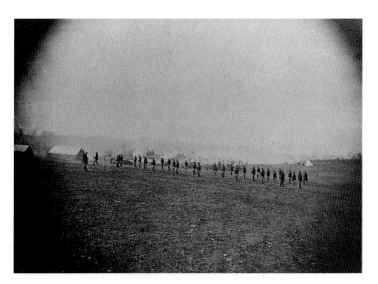

LEFT
In the winter of 1862–3, a squad from the 40th Massachusetts Infantry practices bayonet drill in its camp at Minor's Hill, Virginia. The men quickly grew weary of the endless round of drill. Part of it was genuinely necessary training; the rest was to keep them busy and out of trouble.

RIGHT
Infantry and cavalry rarely fought against each other, but infantrymen were taught a defense against mounted troopers that went back to ancient Rome, the "hollow square." In four lines forming a square, their backs to each other, their bayonets outstretched, they could be a daunting prospect. It was probably never seen in action.

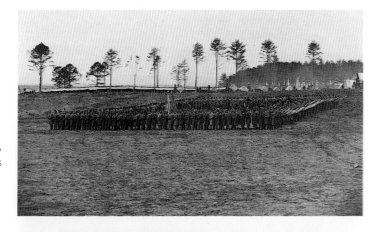

BELOW LEFT AND BELOW RIGHT
Confederate soldiers of the 9th Mississippi Infantry lounge at left in their camps at Pensacola, Florida, in the spring of 1861. The Orleans Cadets from Louisiana stand at parade near Fort Barrancas, demonstrating the rarity of a Confederate regiment in matching uniforms.

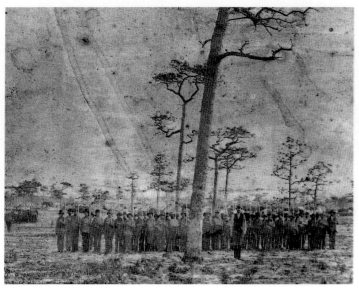

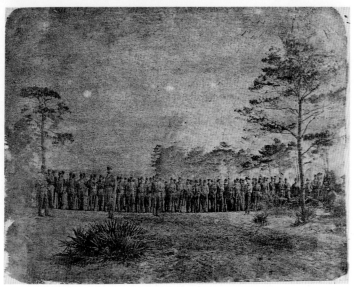

Partisans and Guerillas

The murkiest side of the war took place in the shadows, where small bands of organized partisan rangers, and even smaller informal units of guerillas and bushwhackers, operated on the fringes of the armies. Authorities found them hard to control, often prone to pillage and worse, and all too often serving their own purposes first. Yet some on both sides did very effective service as well.

RIGHT
Captain John H. McNeill raised a company to serve with the 18th Virginia Cavalry, but then was detached to lead it as the 1st Virginia Partisan Rangers in operations against Federals in the Shenandoah Valley, including daring raids into West Virginia, before his mortal wounding in 1864.

BELOW
Most daring and famed of all Confederate partisans was Colonel John Singleton Mosby, standing here second from left with men and officers of his 43rd Virginia Partisan Ranger Battalion. He so dominated Northern Virginia that part of it was called "Mosby's Confederacy."

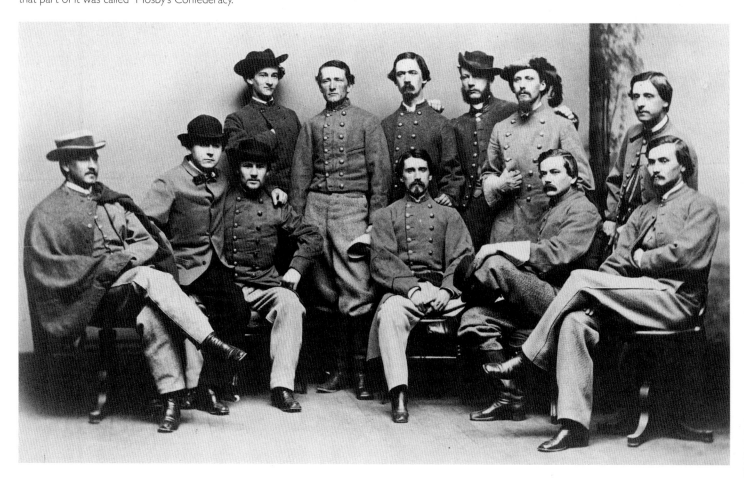

RIGHT
The Yankees, too, were resourceful. W.J. Lawton was a Union scout who frequently went behind enemy lines dressed as a Confederate officer, and even posed in his disguise for a photographer, the cigar in his mouth completing the demeanor of daring nonchalance.

LEFT
One of the better-known Union guerillas was Captain "Tinker Dan" Beatty, shown here seated at right in civilian clothes beside a scout known only as "Dr. Hale." Especially in the wildness of east Tennessee, men like these flitted through the mountains and woods, striking, then melting away.

OVERLEAF
The Union would experiment with secret service organizations, eventually forming an official bureau, just as the Confederacy launched the first genuine secret service office in Richmond. In the main, however, the Union largely depended on private contract "spies" and officers like these with Grant in 1864.

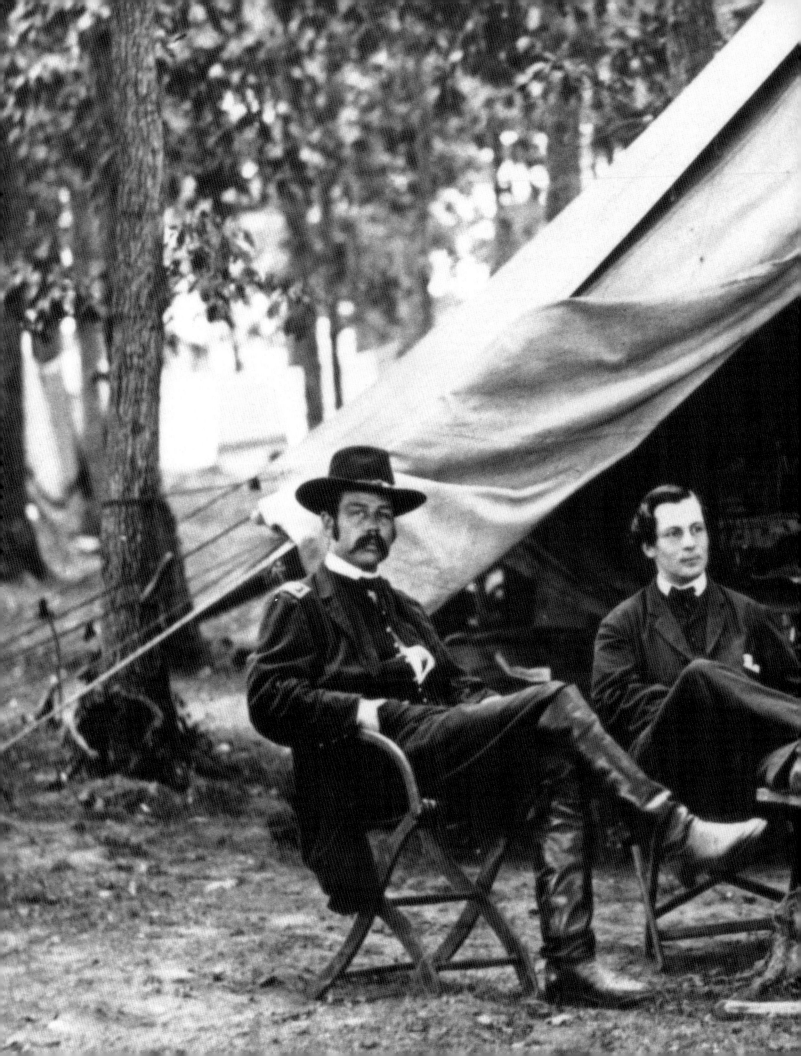

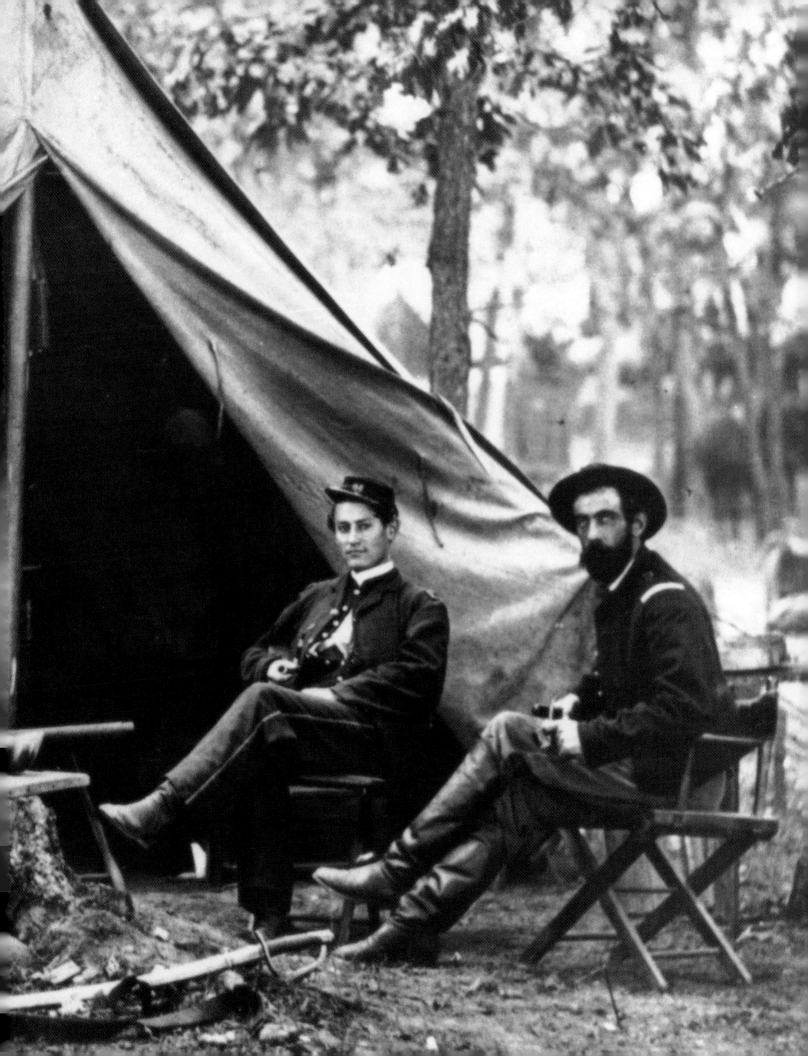

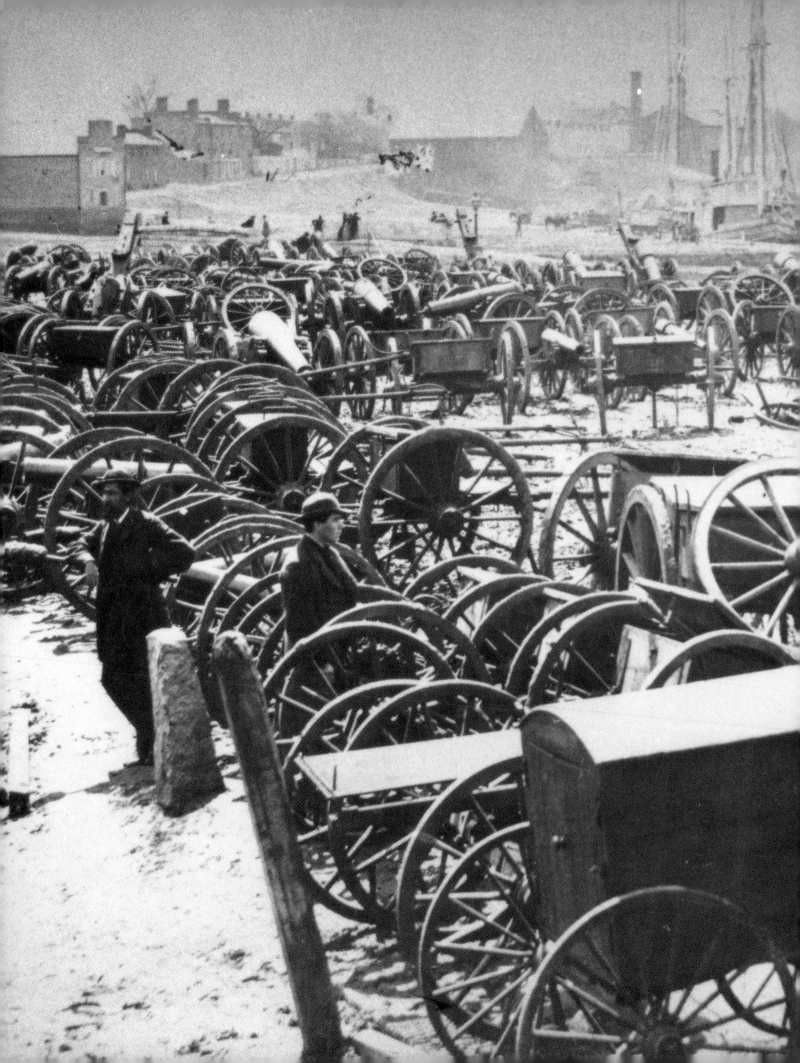

1865

AN END AT LAST

At the dawn of the fourth and last year of the war, it had to be apparent to most reflective Americans that the conflict was all but over, and that the Confederacy could not last out the year. Its territory was overrun, whole states gobbled up by the Yankees, its armies either at bay or disintegrating, and its population worn out. And yet there were thousands ready to fight on in a triumph of hope over experience.

Just as 1864 ended with Sherman's conquest, so did the New Year begin. Having taken Savannah, Sherman now set his sights on the denouement of Grant's grand strategy, the destruction of Lee. While Grant and Meade held Lee in place in and around Petersburg and Richmond, Butler's until now dormant army was to move against the Virginia army, and Sherman was to march north through South and North Carolina. The three armies could simply surround and overwhelm Lee, and at the dawn of 1865 there seemed to be little in the way of Sherman's accomplishing his mission except scattered remnants of cavalry and local militia.

OOD'S ARMY OF TENNESSEE had been shattered at Franklin and Nashville, but fragments of it were finding their way into South Carolina to coalesce into a reconstituted army to be commanded by Joseph E. Johnston once more. It could hardly hope to match Sherman's might, but it could try at least to slow his progress and give Lee time to deal somehow with Grant. It was a desperate hope in a desperate hour.

Now Sherman was operating without a supply line, but in mid-January a joint army-navy operation captured Fort Fisher, the massive and extensive earthwork fortification protecting the port at Wilmington. When Wilmington fell, Sherman had a good port in which to build up a supply base by sea and thus keep his army fed and equipped during the ensuing campaign. That done, he was ready to march north on February 1. Meanwhile his command had been augmented by nearly 30,000 soldiers from farther west, ensuring that he could roll over anything put in his way by the Confederates.

Sherman moved north from Savannah in several columns, heading generally for Columbia, South Carolina's capital. It was a complex plan, with several objectives. He did not even bother to attack Charleston, which had held out for almost four years against Yankee bombardments and occasional attacks, for moving north into the interior of the state automatically cut that city off, and in February it simply surrendered. With more than 60,000 men at hand, Sherman faced scarcely more than 22,500 Confederates at first. It was hardly surprising that the Yankees took Columbia without a fight, and then devoted several days to destroying railroad and manufacturing infrastructure, while on February 17 some of Sherman's vengeful soldiers wreaked their own kind of destruction on Columbia itself, despite attempts by their officers to control them. The city was gutted by fire and looting, paying the price for being the heart of the first state to secede.

The only real enemy stalling the Union advance was the

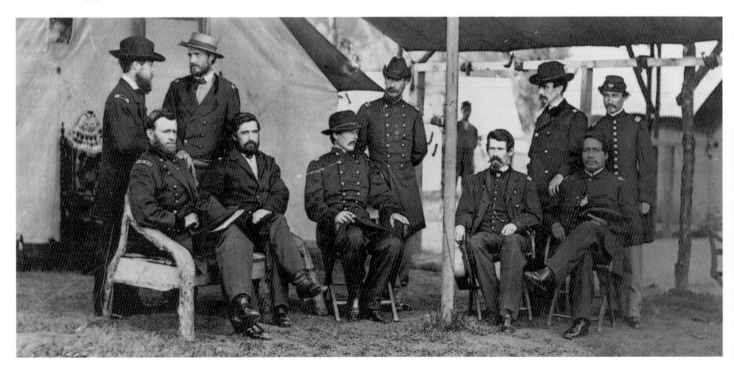

ABOVE General U.S. Grant, seated at left, with his staff at Petersburg.

weather, in the form of unusually heavy rains throughout the winter. As a result, Sherman did not finally get out of South Carolina and into southern North Carolina until early March, and by this time the Confederates were trying to organize a more resolute resistance. In January Lee had been made general-in-chief of all Confederate armies, and he had himself ordered Johnston to take command in South Carolina and rebuild the Army of Tennessee, with Beauregard as his executive officer. Johnston hoped to combine several small commands in and around Fayetteville, North Carolina, which appeared to be on Sherman's line of advance, but delays dogged his efforts, too, with the result that Fayetteville fell without a battle on March 12. When Confederates did try to halt the Union advance, as at Kinston, North Carolina, on March 7–10, they were easily brushed aside.

Johnston then faced the question of where Sherman was headed when he marched out of Fayetteville and turned northeast. One goal could be the state capital at Raleigh, and the other Goldsboro, where the Yankee could link his main force with the column that had captured Fort Fisher. Either alternative promised severe trouble for the Confederates, and in the end, from his own dire situation in Petersburg, Lee told Johnston to attack one or the other of the two enemy forces before they could unite. Elements of Johnston's army tried to stop Sherman himself at Averasborough on March 16, but failed. Then Johnston planned a major attack that was launched at Bentonville three days later. Concentrating every available man, he put more than 40,000 men on the field, but Sherman held off his assaults and meanwhile concentrated his own forces. Two days later, now thrown on the defensive, Johnston had no choice but to withdraw. After two more days Sherman reached Goldsboro, and in joining forces with his other column brought his strength up to more than 80,000. Nothing in his front now could resist him, and Johnston knew it. The fight for the Carolinas was over.

Coincidentally, just as the Johnston–Sherman contest wound down, it was about to heat up between Grant and Lee.

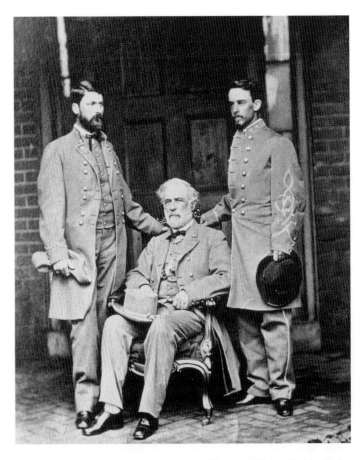

ABOVE General Custis Lee, General Robert E. Lee, and Colonel Walter Taylor.

In the lines slowly encircling Petersburg, little action had taken place in the winter of 1864–5. There were a few skirmishes in February, mostly on Lee's endangered right flank southwest of Petersburg as the Yankees continued spreading west to cut off rail lines of supply. Grant also sent Sheridan out on another raid in the Shenandoah, where he destroyed the remnant of Early's tiny command, and then tore across northern Virginia, further disrupting infrastructure and supplies vital to Lee. It was preparation for spring, when the roads would be dry enough that Grant could continue and complete his encirclement.

No one could see that better than Lee, who had spent the most miserable winter of the war simply watching and waiting

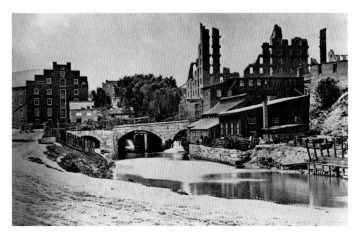

ABOVE Richmond ruins on the James River.

as the enemy grew stronger and his own command grew weaker through attrition and desertion. Late in March, anticipating that it was his last chance to seize a brief initiative, Lee planned a concentrated attack on Union positions at Fort Stedman on the eastern flank of Grant's lines. If he could break through the enemy line there, he could push for the enemy supply base at City Point on the James. He presumed that this might force Grant to halt the westward spread of his own lines. It would buy Lee time and perhaps allow him to send some modest reinforcement to Johnston in North Carolina. Lee had already formulated the only remaining possible strategy for the two remaining Confederate armies in the East. Somehow they must join forces before either could be pinned down and forced to capitulate. Then they would turn and attack first Sherman. If they could push him back, then they would turn on Grant. It was almost hopelessly improbable, but there was nothing else left to them.

Early on March 25 Lee launched the attack. At first it took Fort Stedman by surprise and captured it and more than half a mile of Yankee works. The victors immediately pressed onward toward City Point, but soon a Union counterattack forced them back, and in the end captured almost 2,000 as the rest withdrew to their own lines. Lee then knew that there was nothing left that he could do to save Petersburg and

Richmond, and he advised the government to prepare to evacuate any day. A week later, on April 1, with Sheridan returned to the army, Grant ordered him to attack Five Forks, key to the Southside Rail Road, Lee's last rail link out of Petersburg and his only hope of a supply and transportation line for the movement to join Johnston. The defenders at Five Forks, including ill-starred General Pickett of Gettysburg fame, were simply pushed aside, and many cut off from the rest of the Confederate army. When that happened, Lee told President Davis that he must evacuate immediately while the railroad was still open. On April 2, as the government began its departure from Richmond, Lee's troops fought rearguard actions to cover his own withdrawal.

Once more Lee and the remnant of his army were out in the open and on the move, though all the old spirit and dash were gone. Now it was a race for life, with fewer than 50,000 Southern troops being pursued by almost double that number of Federal infantry in the rear, and Sheridan's cavalry moving out in advance to try to cut off their line of retreat. Meanwhile, early on April 3, Federal cavalry rode into the streets of Richmond, and President Lincoln, who was visiting Grant's headquarters, actually toured the city and sat in President Davis's chair in the Confederate executive mansion. Clearly the war would be over in a matter of days.

Grant anticipated Lee's plan to go west to Lynchburg or Danville and then turn south to link with Johnston, and he acted quickly. To do so, Lee would have to reach Amelia Court House on the railroad, where supplies were to meet his army. Riding ahead, Sheridan's cavalry misdirected the supplies so that when Lee arrived they were not there, further slowing his hungry army. Then Sheridan cut off Lee's route south from Amelia, forcing the Confederates to head further west. By April 6 the Southerners, limited in the routes they could take, became strung out and separated, and at Sayler's Creek the Federals struck at the gap and cut off and captured almost a third of Lee's army at a stroke. Two days later Sheridan had gotten sufficiently ahead of Lee's army that the last line of

retreat was cut off. On the night of April 8 Sheridan captured the last supply trains awaiting Lee at Appomattox Station, and then pushed on the few miles to Appomattox Court House, where the remnant of Lee's army lay camped.

The next morning Lee made his final attempt at a breakout, launching a weak attack that he hoped would push Sheridan aside and clear the road so that he could continue his retreat. At first he was successful, but then he encountered some of Grant's infantry just arriving, and had to pull back. As long as he faced only cavalry, Lee felt he could keep trying. But once he knew that Union infantry was coming up on the road ahead of him, he realized there was no place to turn.

In fact, Lee had already been in correspondence with Grant under a flag of truce for two days. To prevent "any further effusion of blood," Grant on April 7 suggested that Lee surrender. Lee declined, but kept the correspondence going through the next day, even asking what Grant's terms would be, and Grant replied that he would be as liberal as possible, requiring only surrender and a promise not to fight again. After the failure of the morning attack on April 9, Lee wrote once more to Grant, this time acknowledging that he was ready to make terms of surrender. The two generals met in the village of Appomattox Court House itself, in the home of farmer Wilmer McLean. Ironically, McLean's home at Bull Run had been Beauregard's headquarters four years before in the first battle of the war, and now that war—in Virginia anyhow—was going to end in his front parlor. In terms that were a model of magnanimity, Grant and Lee signed the surrender document that afternoon. Three days later the remnant of Lee's army, just 26,765 men, laid down their arms and started for home.

When word of Lee's surrender reached Johnston, he knew there was no point in further resistance, and sought permission from President Davis, then fleeing through North Carolina with the government, to open talks with Sherman for a cease-fire. Davis agreed, thinking nothing would come of it, but Johnston and Sherman, with the strong influence of two members of Davis's cabinet, emerged with a document calling for all Confederates in the field to lay down their arms and even declaring a restoration of the Union under terms very favorable to the South. Washington soon rejected this, however, and on April 26, without seeking Davis's permission, Johnston, too, surrendered.

There were still small scattered commands at large in the South, but one by one they surrendered. All resistance east of the Mississippi ended on May 4 with the capitulation of a small army in Alabama, and Kirby Smith surrendered the area west of the Mississippi three weeks later. The war was over.

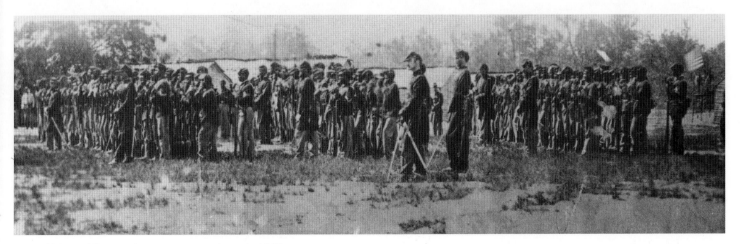

ABOVE Union soldiers ready to press on to victory in 1865.

RIGHT
One of the generals largely responsible for
the final victory over Lee was Michigan's
George Armstrong Custer, shown here in
1865 at the height of his fame. Just eleven
years later, he and his command of the 7th
United States Cavalry will be killed at the
Battle of the Little Big Horn.

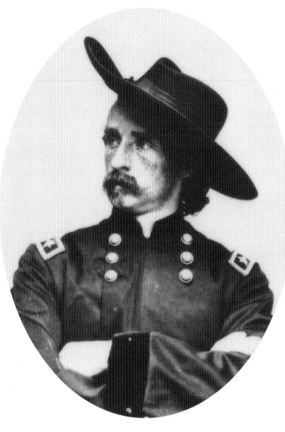

BELOW
On April 3, 1865, just after Lee's army has been
forced to evacuate the defenses of Petersburg
and Richmond, jubilant Union soldiers stand atop
the parapets of their earthworks, no longer
having to worry about Confederate
sharpshooters on the other side.

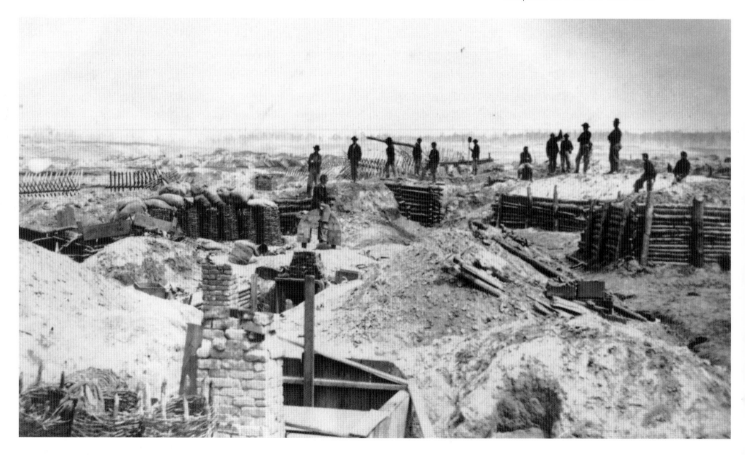

LEFT
The city hall in downtown Richmond, now with Yankee soldiers standing on its portico. The city became a virtual 12th Confederate state, contributing mightily to the country's resolve and resources. In turn, it suffered as much as any state or city in the South.

BELOW
The Virginia governor's mansion in Richmond was on Capitol Square, just down from the state house, and right in the heart of the city. Now, after the occupation of the city on April 3, Union soldiers stand in front of the building. Its occupant, Governor (and General) William Smith, had left with Lee's retreating army.

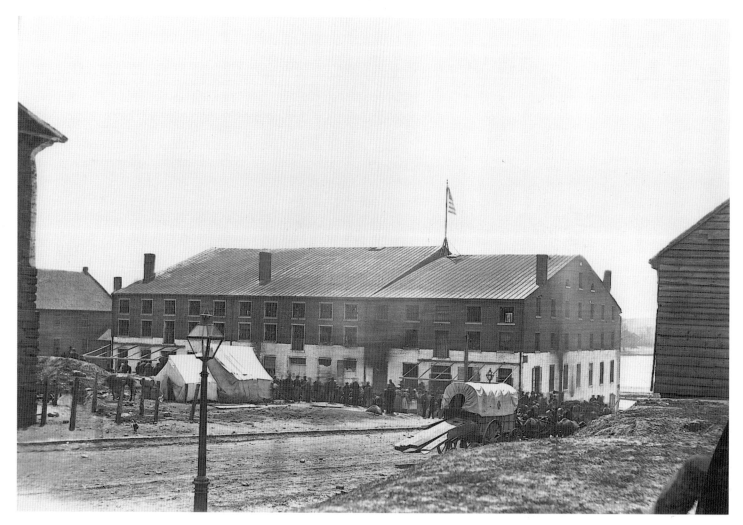

ABOVE

When Grant's soldiers marched into Richmond, they were able at last to open the doors of the infamous Libby Prison, formerly a warehouse and ship chandlery. Used chiefly to house Union officers, it was the scene of one of the most famous prison escapes of the war, when several dozen men tunneled their way out.

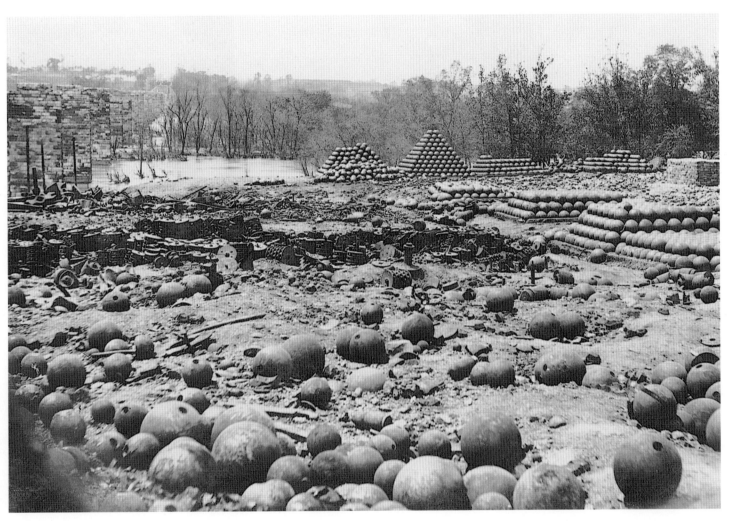

ABOVE
When Lee left Richmond, what he could not take was put to the torch, but there was no way to destroy mountains of ordnance ammunition like these at the Confederate arsenal by the James River. Besides, the South no longer had the ships or fortifications to use the big guns these required.

ABOVE

More ruins along the James River. In the distance is the Tredegar Iron Works, the Confederacy's principal foundry for casting large cannon and rolling the iron armor for its gunboats. It was this ironworks that had cast and rolled the plate to armor the ironclad CSS *Virginia*.

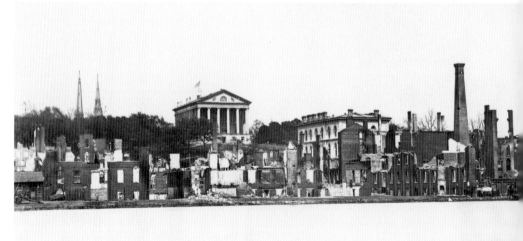

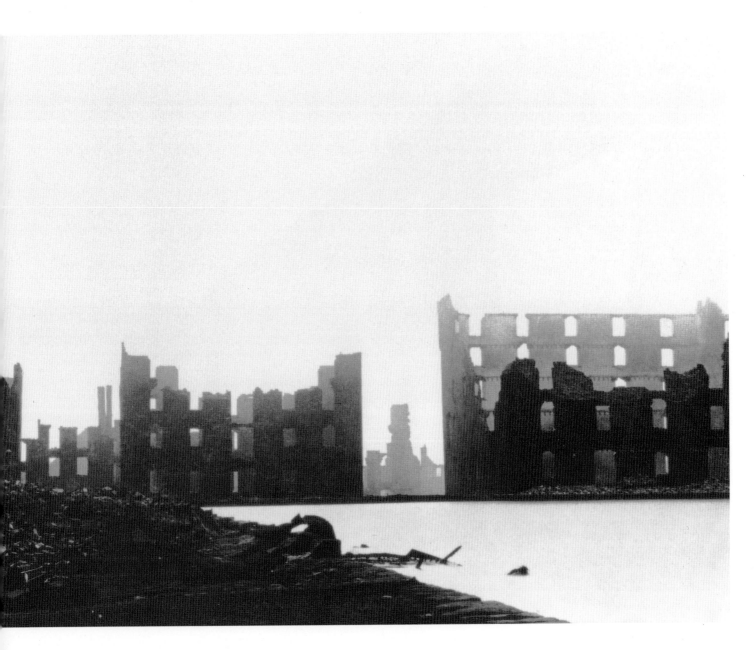

LEFT
Richmond's skyline, seen from across the James, revealed some of the devastation of the fires set and accidentally started during the evacuation. The state house, which had also served as the Confederate capitol, survived almost miraculously, and can now seen beneath the conquerors' Stars and Stripes.

ABOVE
Fully half of the city went up in flames when burning munitions and archives cast cinders into the air, which were spread by the wind. These had been flourmills, but were left a ghostly testimony to war's destruction. More than a century later, this section of Richmond is still called "the Burnt District."

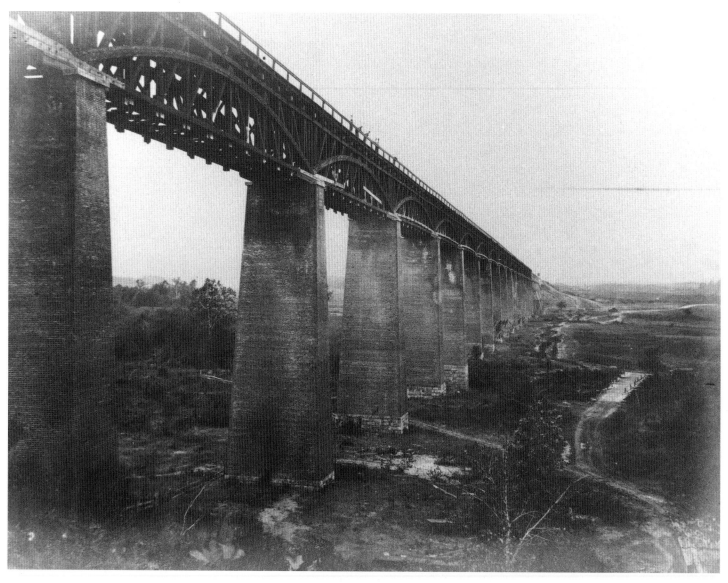

ABOVE
On his retreat from Richmond, Lee tried to impede Grant's pursuit as much as possible, especially by burning High Bridge, a vital crossing of the Appomattox River. The effort failed, however, and the Yankees were able to pursue Lee until they cornered him at Appomattox Court House.

RIGHT
Forced to surrender on April 9, 1865, Lee went back to his Richmond home. A few weeks later, Mathew Brady appeared at his door and persuaded the general to don his uniform and pose with his son, General Custis Lee, standing at left, and his adjutant, Colonel Walter Taylor, at right. It was Lee's last moment in uniform.

FOLLOWING PAGES
The calm of resolution and near-victory in his face, General Ulysses S. Grant sits at left in his field headquarters, surrounded by his staff, including, seated at right, his military secretary Ely S. Parker, a Seneca who became the first Native American to rise to general's rank, and that on April 9, 1865, the day of Lee's surrender.

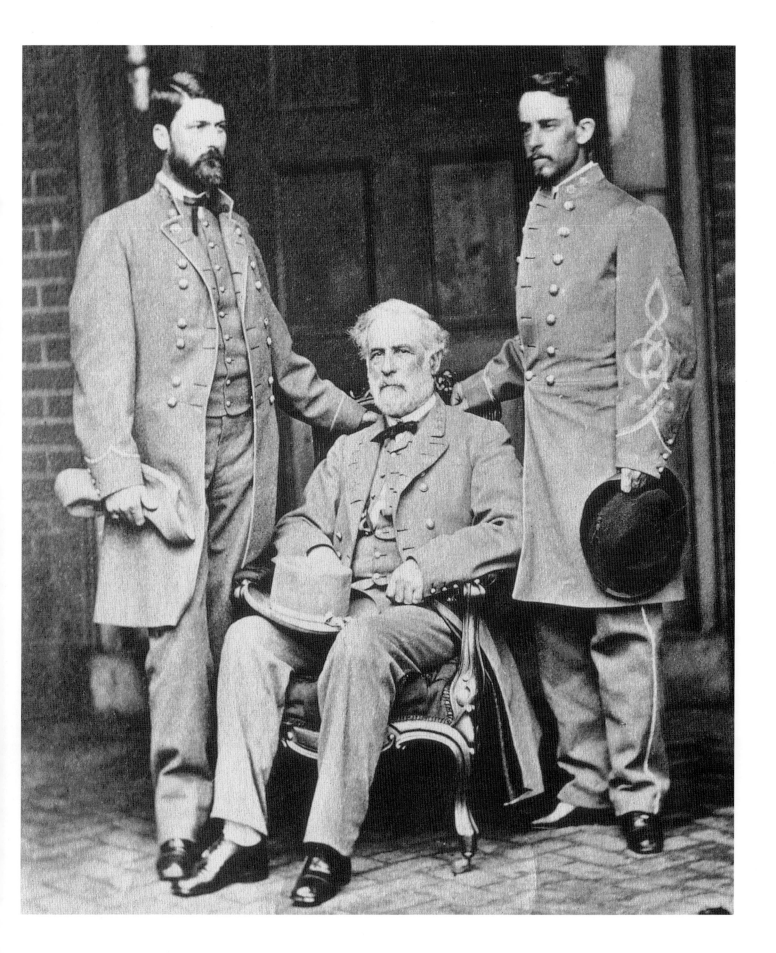

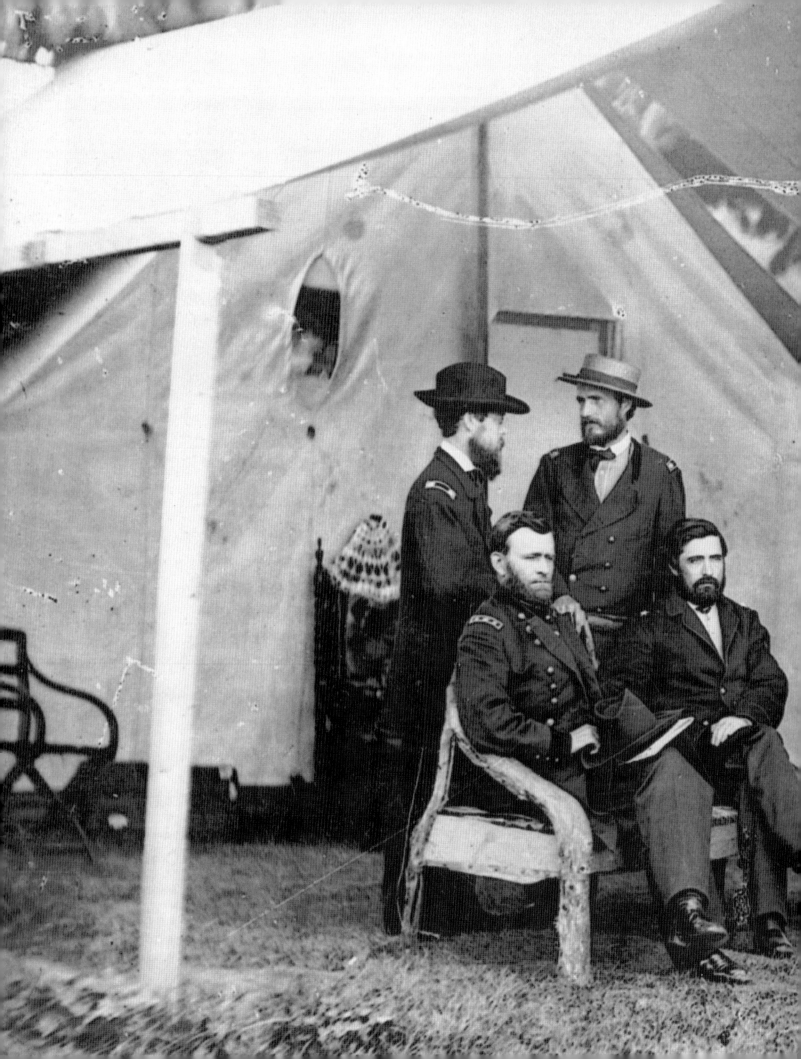

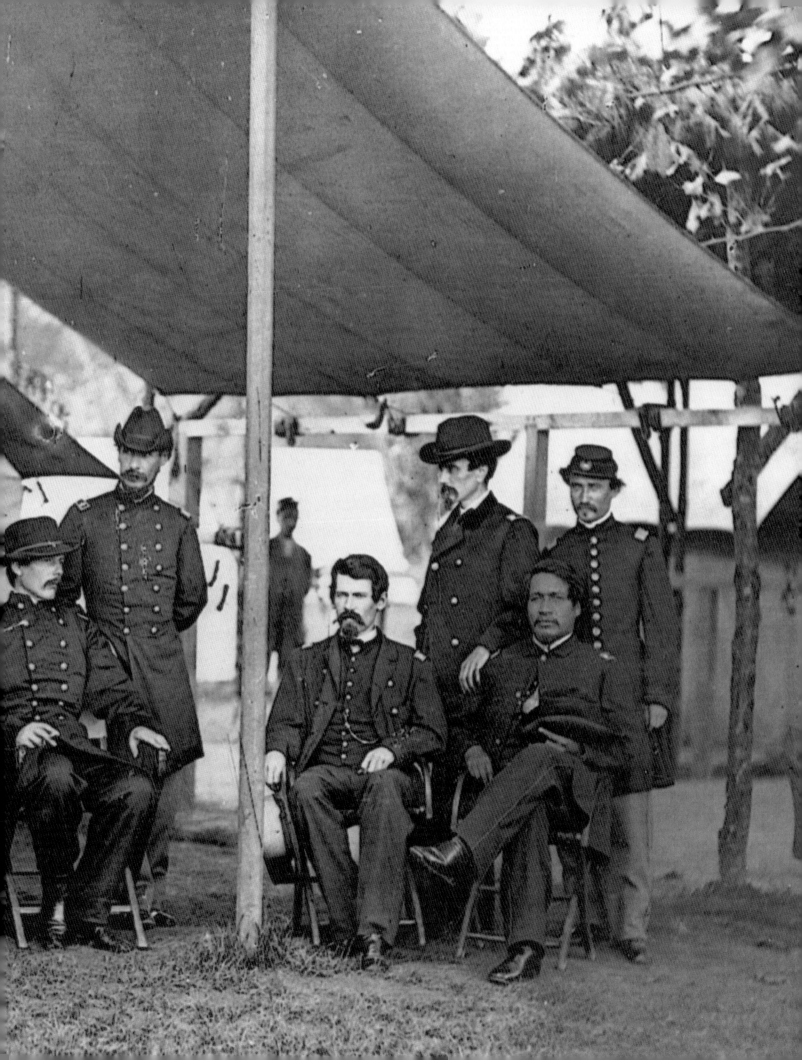

ABOVE
Parker sits here in front of his quarters amid other members of the headquarters staff. Grant developed one of the first truly modern staff organizations, freeing him to concentrate on his primary mission. In contrast, Lee, who did too much himself, was given the name "the Tycoon" by his comparatively minuscule staff.

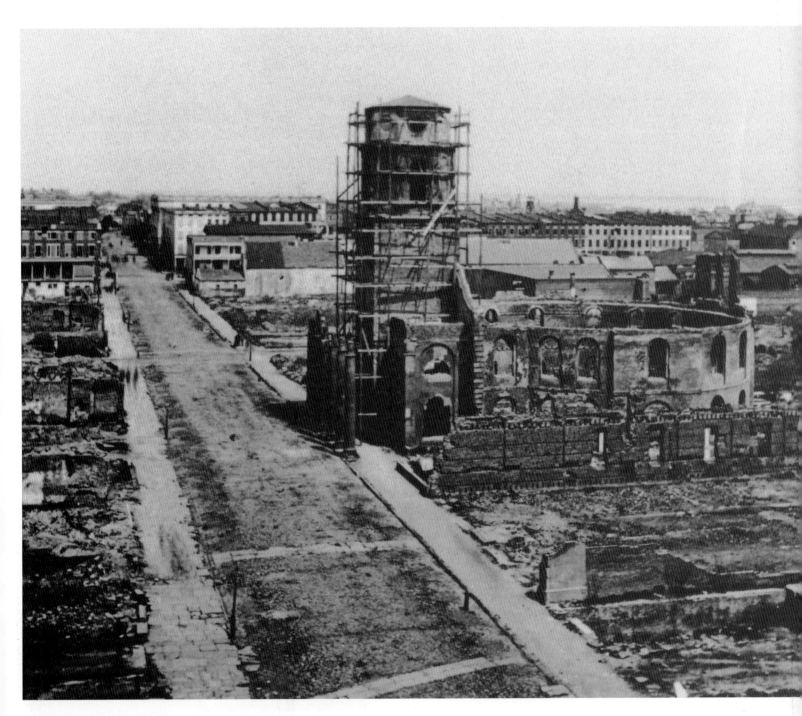

ABOVE

Like Richmond, Charleston, South Carolina, the city where it all began, felt the harsh heel of war. Looking at some streets, one might think that the city had escaped largely unscathed after two disastrous fires and sustained Union bombardment. Other streets told a different story: fires devastated the prominent Circular Church, though scaffolding reveals that its rebuilding is already under way. Next to it only the semblance of walls remain of Institute Hall, where the secession ordinance was passed in 1860.

LEFT
Charleston fell in February 1865, but the authorities waited until April 14 for a formal ceremony in Fort Sumter, where the ailing General Robert Anderson raised the flag he had taken down four years before to the very day, bringing the war full circle for him at least.

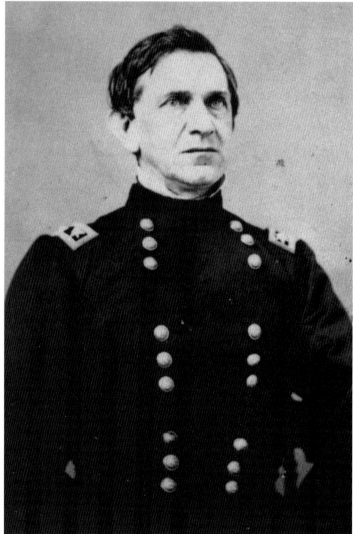

RIGHT
The war would last another few weeks out in the western theater. The last surrenders of Confederate armies would come in May, Major General E.R.S. Canby receiving them both. Eight years later, he would be slain during a peace parley with Modoc Indians in California.

ABOVE
By June 1865 it was time for the ceremonies
and celebrations and dedications to begin.
Indeed, the first battlefield markers went up
while the war was still going, but here on the
fields of Manassas Union authorities erected
two red sandstone pyramids to honor the
men slain in two Bull Run battles.

LEFT
All across the reunited nation, symbolic ceremonies took place, some of them posed for the camera. Here a former Confederate soldier raises his hand and takes the oath of allegiance from a Union officer, in a near-religious ceremony witnessed by women and children in angelic white.

RIGHT
Sentiments of reunion and brotherhood suffered a great setback, however, on the evening of April 14, 1865, in this box at Washington's Ford's Theatre, as President Lincoln, seated behind the flag on the right, was shot in the head by assassin John Wilkes Booth.

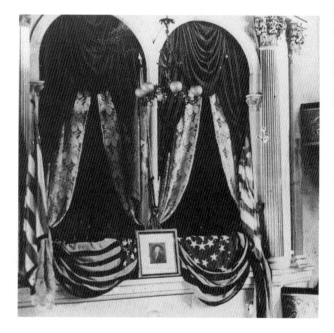

LEFT
Ford's Theatre would remain ever after, and even today, a landmark to the first presidential assassination in America, and the mad act of a lone gunman unable to accept Confederate defeat. The government would take it over and turn it into offices rather than allow merriment and entertainment to go on there.

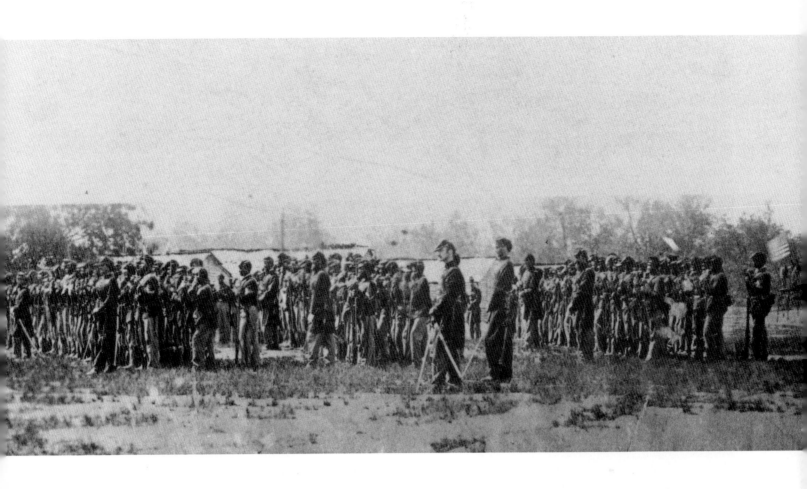

ABOVE
The greatest change wrought by the war, of course, was the end of slavery and the first steps toward equality for black Americans. One of the first measures was the enlistment of blacks into the military. Here the 1st United States Colored Infantry poses at rest in November, 1864.

RIGHT
There was much to be done for the three-and-one-half million freed slaves. It would take a long time, more than a century, and the work might never be done. Here on Edisto Island, South Carolina, a Freemen's school begins the work of education of black children and adults.

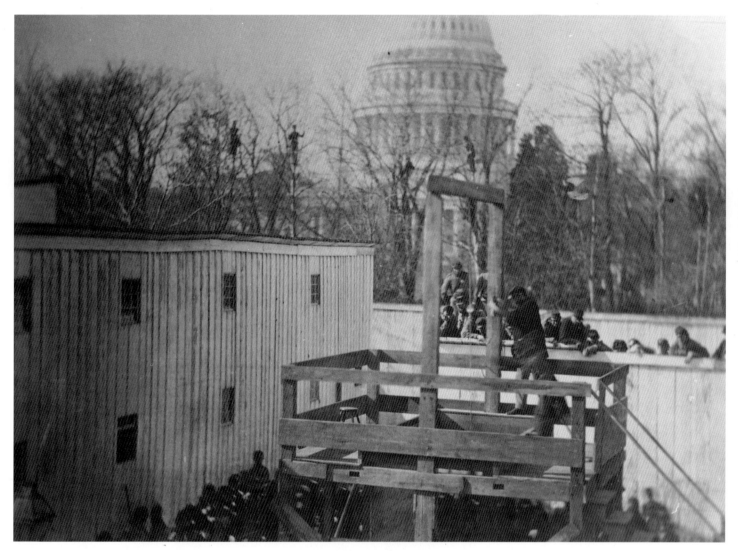

ABOVE

There was also justice to mete out. Those behind
the murder of Lincoln were caught, tried, and
hanged. There was also injustice, alas. The
commandant of the notorious prison camp at
Andersonville, Georgia, Major Henry Wirz, is
here executed for "war crimes" almost certainly
beyond his control.

RIGHT
When all the killing finally ended, authorities could turn to caring for the dead. Massive cemeteries like this one at Alexandria, Virginia, were created to re-inter many of the dead buried on battlefields, as well as to hold those in hospitals who finally died of their wounds and diseases.

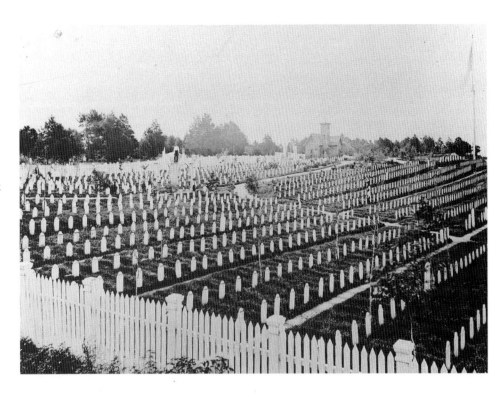

BELOW
No fallen soldier received a funeral to match that given to the slain President Abraham Lincoln. Here in Washington ranks of soldiers march down Pennsylvania Avenue in the procession. Afterward, his body would travel by rail across the nation to its final rest in Springfield, Illinois.

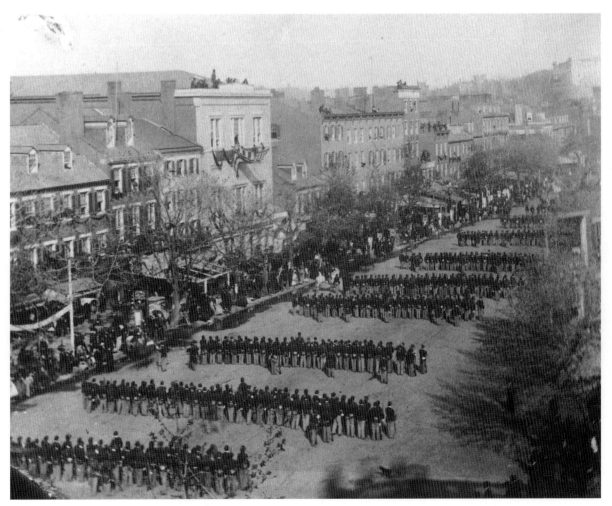

LEFT
What lay ahead were troubled generations in which both gains and losses had to be tallied. Civil rights and equality for blacks would be guaranteed by constitutional amendments, yet soon ignored as the politics of reunification pushed the former slaves into the background once more.

BELOW
Men who had struggled to rise from servant to soldier, from wearing the "hand-me-down" clothing of white soldiers as these "contrabands" do in late 1863, to earning uniforms in their own right, would continue to fight to secure their place in American society.

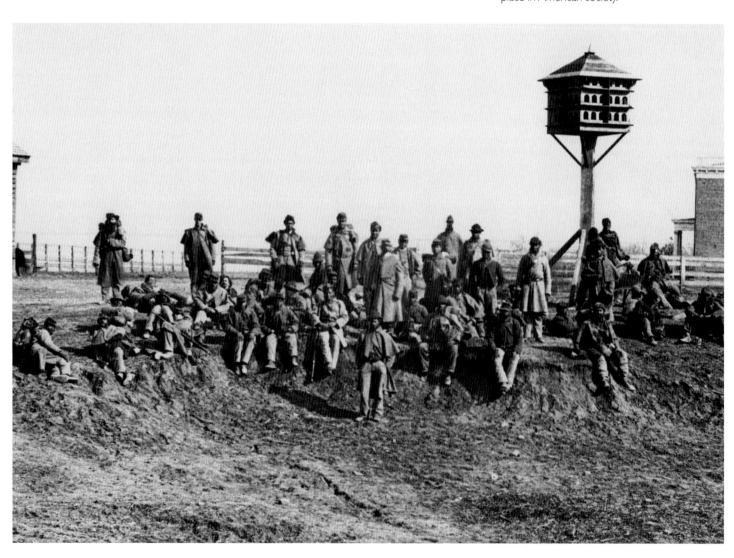

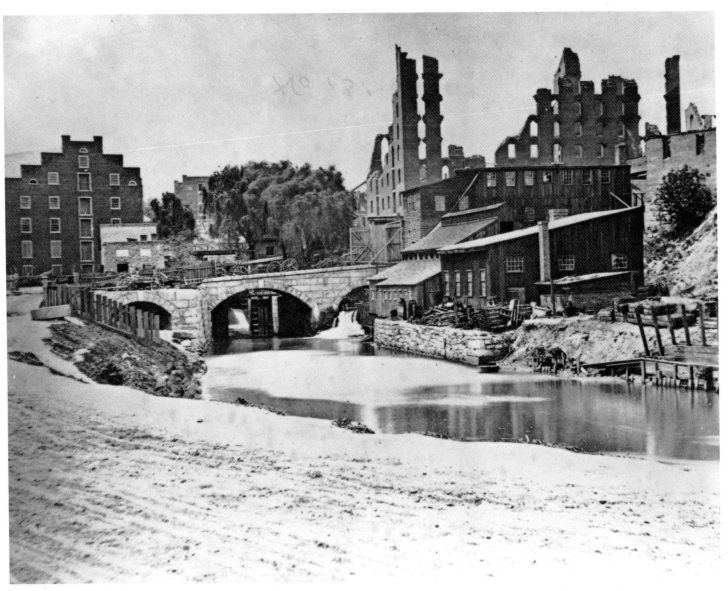

ABOVE
And the defeated Southerners faced a
generation of rebuilding. Cities like Atlanta,
Charleston and, shown here, Richmond, had
been devastated by the war. Hundreds of
thousands were dead or maimed, homes and
farms were ruined, and hopes and dreams would
have to be rekindled to bring the South out of
war's depression.

Hospitals

Neither North nor South was at all prepared for the strain the war would place on inadequate and outdated medical capabilities. At the outbreak of the war in 1861, there were less than a dozen thermometers in the entire Union Army, and only two or three effective drugs or painkillers were known about. Medical and surgical science was primitive by later standards, and yet remarkable strides were made in treatment and care. Nevertheless, first to last, the war would be a medical nightmare for those who suffered.

RIGHT
Women made great strides during the war, and contributed much to medical care as nurses. Some did more, like Dorothea Dix, who organized a corps of nurses for the Union. Her contemporary Clara Barton would use her Civil War experience in founding the Red Cross.

ABOVE

From being entirely unprepared to handle the wounded, both sides went on to develop large and sophisticated military hospitals, like this one at Camp Holt in Jeffersonville, Indiana. The Confederates' Chimborazo Hospital in Richmond would become the largest military hospital in America.

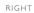

RIGHT

This poor Union sergeant has two empty sleeves to attest to the amputations he suffered, most likely after an exploding shell shattered his arms. In an age before public welfare and sophisticated prosthetic equipment, his prospects were almost certainly bleak.

237

LEFT
A Yankee hospital steward pretends to be pouring a nostrum into a spoon. The sad fact was that they had almost nothing useful to give the men other than opiates for pain, with the result that many of the wounded became addicted. Other treatments included mercury, which actually poisoned many patients.

BELOW
The rows of crutches and empty trouser legs are painful evidence of the price paid by these Confederate soldiers, most of them injured and captured in the Battle of Gettysburg. Here they are pictured recuperating at Camp Letterman, established in Gettysburg to deal with the small army of the wounded.

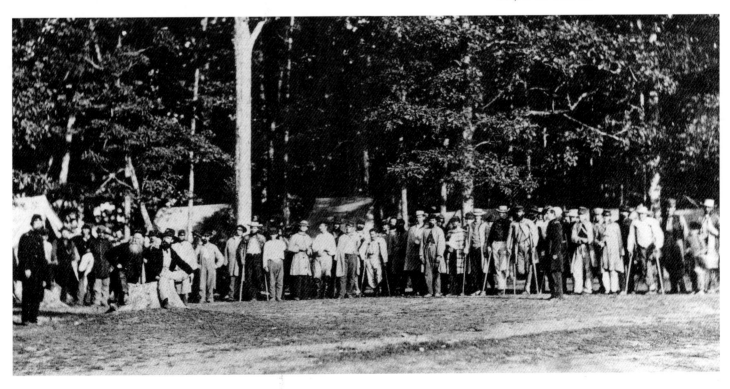

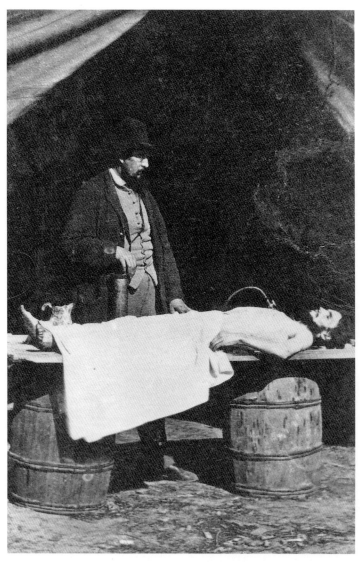

ABOVE
For those beyond hospital treatment, embalmers followed the armies. Almost all of these were private businessmen who pumped chemicals into the bodies of the slain to preserve them for safe shipment home to loved ones and burial. However, most dead soldiers were buried where they fell on the battlefield.

BELOW
Contrary to popular mythology, most amputations were conducted quickly and efficiently under general anesthetic. Unfortunately, for wounds in arms or legs in which the bone had been shattered by a bullet, amputation was almost the only practical treatment.

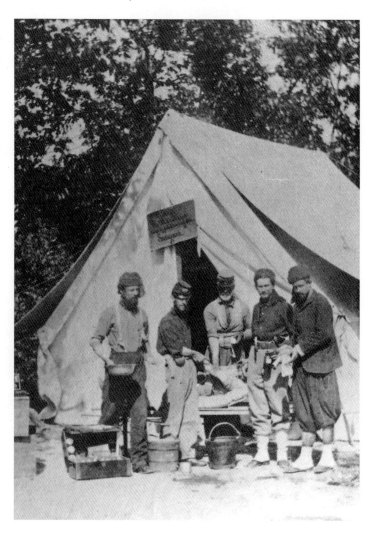

Prisons

Just as the combatants were unprepared for all the sick and wounded, so also were they entirely unready for the hundreds of thousands who would be captured. At first prisoners were kept in warehouses and old forts, but their numbers quickly outgrew capacity, and large prison facilities were designed and built in both North and South. The overcrowding, ignorance of sanitation, vermin, and boredom, all guaranteed that they would be almost as lethal as the battlefield.

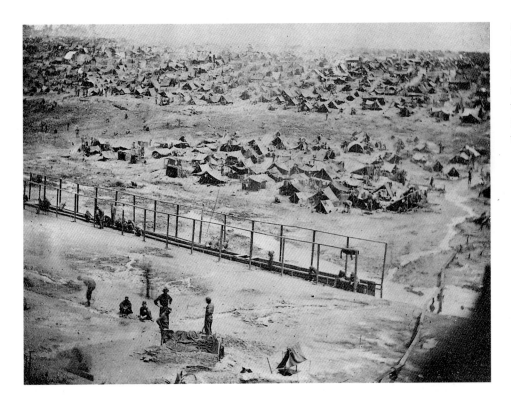

Most notorious of all prison camps was Camp Sumter, at Andersonville, Georgia. It had 30,000 Union prisoners of war at one point, and in all some 12,000 would die there. This was due not to intentional Confederate neglect or mistreatment, but simply to the same shortages that affected Confederates themselves.

In Washington, political prisoners were at first housed in Old Capitol Prison, so called because after the British burned Washington in the War of 1812, this building had temporarily been the capitol while the Capitol itself was being repaired and rebuilt.

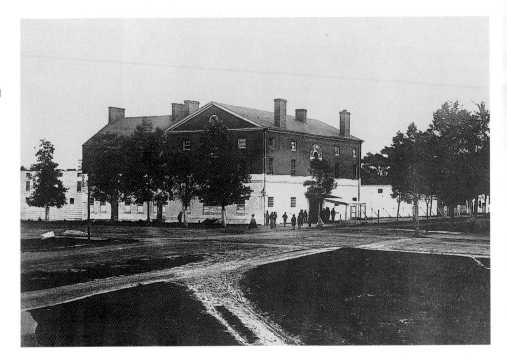

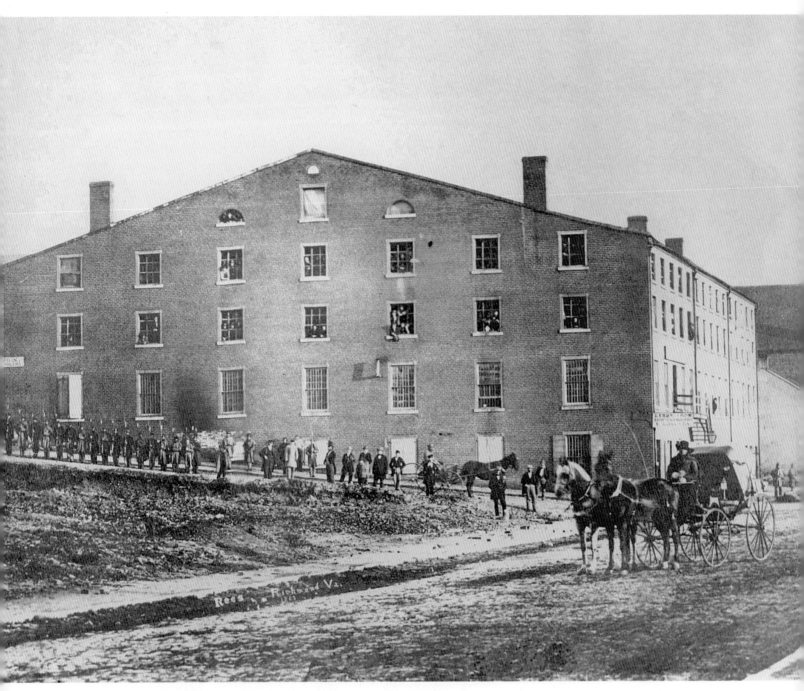

ABOVE
In 1864 a Confederate photographer made this
image of Libby Prison in Richmond, the windows
filled with Union prisoners of war peering at the
camera while the guard lines up below. Libby
became so well known that in 1892 it would go
on "tour," being dismantled and reassembled in
Chicago for an exposition.

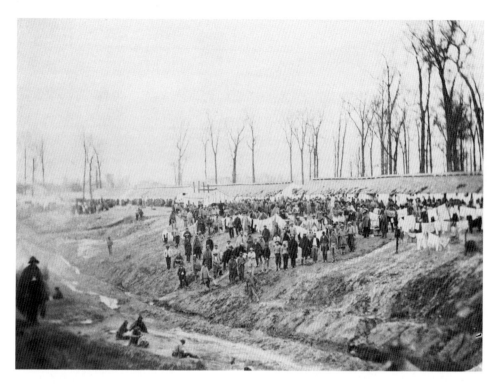

LEFT AND BELOW
A typical Union prison was Camp Morton near Indianapolis, Indiana. Living in drafty frame barracks, with only rudimentary sanitation facilities, Confederate prisoners wore blankets for warmth in the unaccustomed cold, and passed the weary months with nothing to do but daydream.

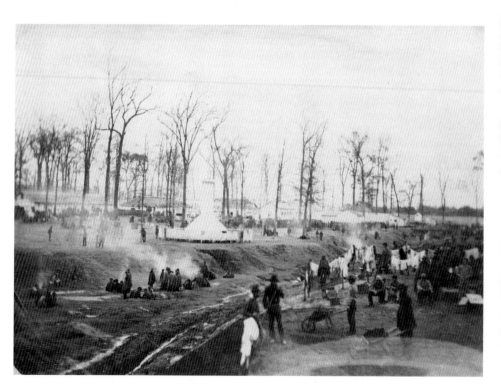

PHOTOGRAPH FROM ORIGINAL NEGATIVES

BY J. E. LARKIN, IN THE FALL OF 1864.

Elmira Prison Camp.

The only Photograph ever made showing the whole Prison, which takes in an area of over forty acres. This Prison was located on the south side of West Water Street, commencing at Hoffman Street, and extending west to Randall Avenue; but few traces of the Prison now remain, the old site being built up with some of the finest residences in the city. The first detachment of Confederate prisoners arrived here July 6th, 1864—649 in number. During the month of July, 1864, 4,424; in August, 1864, 5,195; and from September 1st, 1864, to May 12th, 1865, 2,503—making a total of 12,122 prisoners of war.

The number of deaths to July 1st, 1865, were . 2,917
" " escaped, 17
" " in Hospital, July 1st, 1865, . 218
" " Released, . 8,970
 12,122

ABOVE

The North's counterpart to Andersonville was the prison stockade at Elmira, New York. Deaths rates here were alarmingly high, especially after Washington reduced the prisoner rations because of their lack of activity, and also to save money and retaliate for believed intentional suffering visited on Yankees in Rebel prisons.

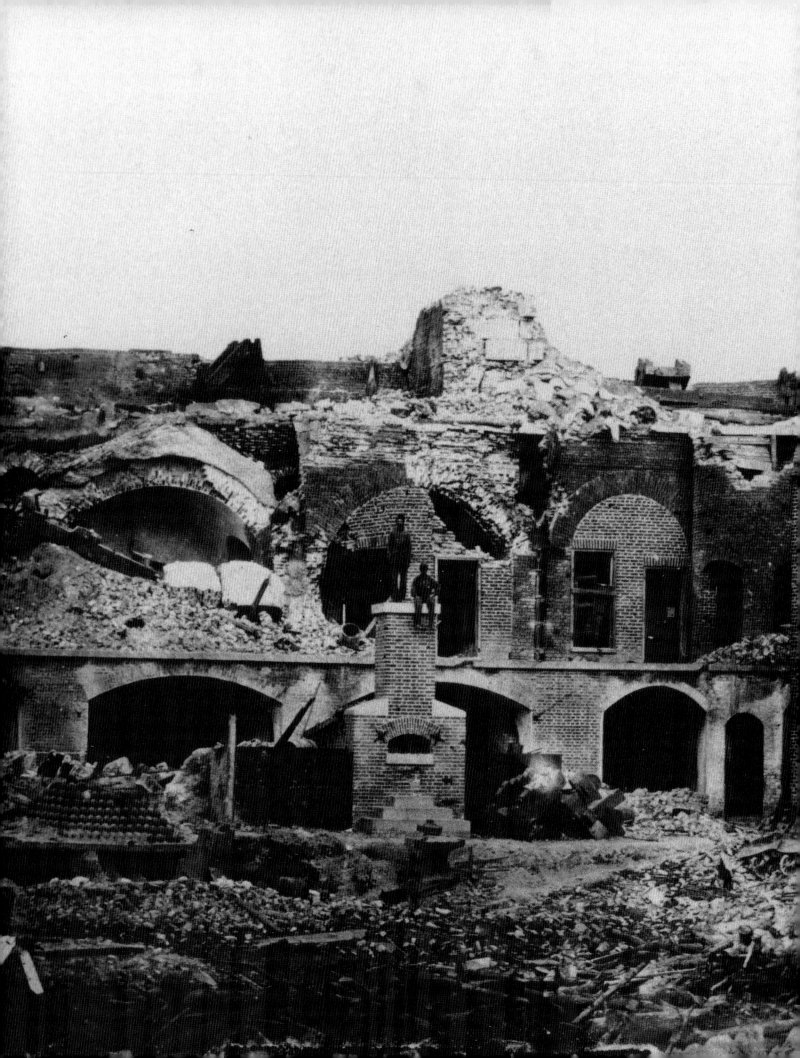

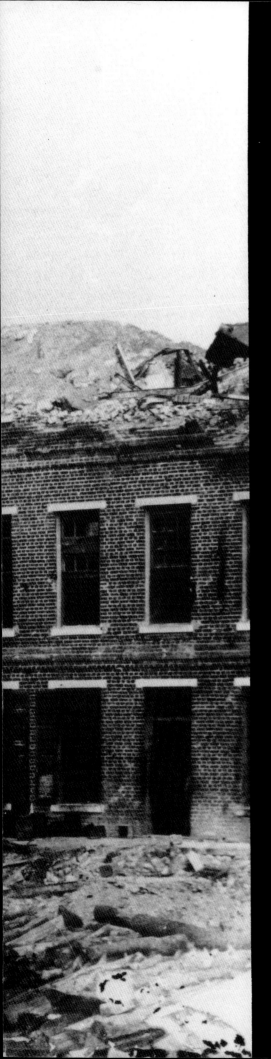

EPILOGUE

It had been the most traumatic episode in American history. More than 620,000 men died during the war itself, and tens of thousands who left the armies wounded or diseased would die lingering deaths even after the surrenders. The unseen cost to posterity of blighted hopes and futures, ruined families, and deep-seated animosities was beyond calculation. The landscape itself had suffered, especially Virginia and Georgia. From the Potomac to the Rio Grande, peace stopped the bleeding but did not at once heal the wounds.

In the immediate aftermath of the surrenders, both North and South were stunned, the euphoria in the one stunted by the assassination of President Lincoln, and the relief in the other paled by the emotional letdown of defeat. No one had thought the war would ever last so long, and after a time some believed that it never would end. The fact that there was no definitive surrender by the Confederate government would itself drag out the process of victory and defeat. Once they left Richmond, Davis and his cabinet moved south first to Danville, by train, then on through North Carolina and into South Carolina, eventually switching to horseback and wagons. Along the way, as it became increasingly obvious that all was lost, one cabinet minister after another dropped off to go home or make his separate peace with the Yankees.

By late April the cavalrymen escorting the president made it clear that they would stay with him only long enough to see him safely out of the country, but had no intention of following him through any more war. For his part, Davis became increasingly detached from reality, hatching grandiose schemes for marching across the Deep South, rebuilding a grand army from stragglers and local militia, and continuing the fight out west of the Mississippi, even going to Mexico to refit and then reemerge. No one would follow. Finally, on May 4, at Washington, Georgia, Davis left his escort behind and set off to make his way to the Florida coast and a boat to take him away. He never got there. Six days later, outside Irwinville, Georgia, he was surprised and captured by Federal cavalry.

What to do with Davis became an immediate problem for the Union, and an element of the larger issue of how to deal with the defeated Confederates and make them a part of a reunited United States. There were many voices demanding reprisals, not only for the terrible cost of the war, but also in the wake of Lincoln's murder. Indeed, for a time the Union War Department would cynically attempt to secure, even through bribery, perjured testimony linking Davis with the assassination, but the attempt failed. It is well that it did, for the sentiment in the South was volatile. It was bad enough to

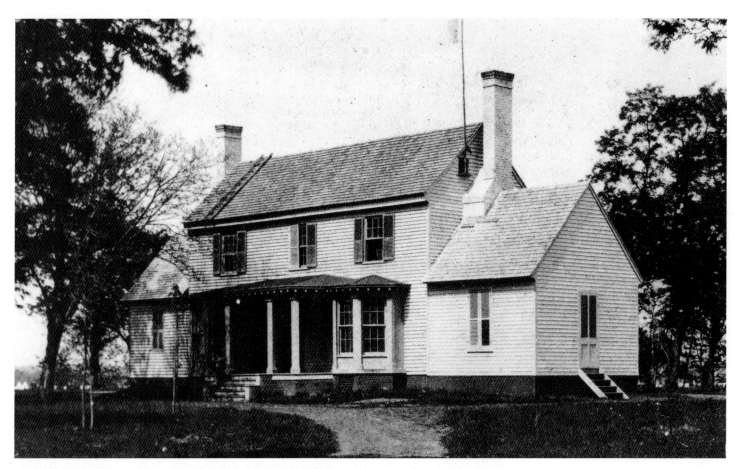

ABOVE White House, on the Pamunkey River in Virginia, just part of what was lost in war's destruction.

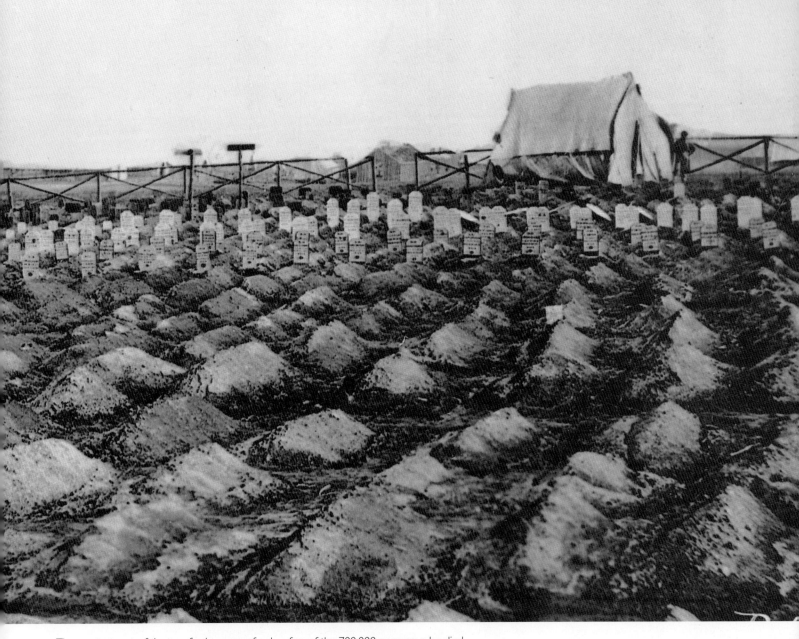

ABOVE The greatest cost of the war; fresh graves of only a few of the 700,000 or more who died.

be defeated, and that so totally. But if their leaders were to be dragged through show trials with convictions and perhaps executions to follow, then reconciliation would be a hopeless dream for a generation or more.

Instead, and though the Southerners themselves in the main did not feel so inclined at the time, cool heads put in train the most lenient repatriation ever handed out to a defeated separatist movement. Davis would spend two years in prison, at first in irons but then in increasingly comfortable circumstances, and in the end the government simply released him and decided not to prosecute. No Confederate officials or officers were tried

for treason, there were no mass confiscations of property, full rights of citizenship were restored to all who would take an oath of allegiance, and even high-ranking men such as former Vice President Alexander H. Stephens could apply for restoration of all civil privileges and run for and hold Federal office. Only one man was tried and executed for "war crimes," Major Henry Wirz, commandant of Camp Sumter, at Andersonville, Georgia, the notorious killing-ground prison camp. Even he was probably not really guilty, but emotionalism over the thousands of prisoners of war who died there was so great that someone had to pay, whether it was just or not.

LEFT
Captured Confederate ordnance, just some of the "swords" that must now be beaten into plowshares.

As for Reconstruction itself, it began with President Andrew Johnson issuing a series of proclamations of amnesty. Then each of the seceded states was "readmitted" to the Union as soon as a required proportion of its citizens affirmed their oath of allegiance and state conventions ratified the Thirteenth Amendment to the Constitution abolishing slavery. It was not without pain, and Johnson soon lost control to more extreme elements in Congress, who imposed increasingly humiliating and restrictive acts on the South, including the Fourteenth Amendment granting black citizenship, and, in 1866, military occupation when Southerners sought to resist. For ten years, until 1876, Reconstruction would continue, a festering sore, a source of some justice and some injustice, creating a legacy of misunderstanding and animosity that still lasts today. Yet it all could have been so much worse.

Most of the old warriors worked for peace. Lincoln, of course, was dead, and what he could have accomplished must remain a mystery. Davis spent his later years defending his actions and those of the South, yet accepting the verdict of the battlefield and in the end even saying it was better that North and South be one country. Grant would succeed Johnson as president, and though dogged by corruption and inefficiency, he would ever be an ardent champion of reconciliation, just like Lee, who became a college president and sought to rebuild through education. Of the three million men who had served, a quarter did not live to see a reunited nation. The rest returned to their homes and farms and stores, or what was left, and began the struggle for renewal. They were all changed by the experience, soldiers and civilians alike. The Civil War had been the greatest moment of their generation, a central fact of their lives that none could ever forget. They, and what they did, are still remembered today, and will be as long as humankind values courage and sacrifice.

INDEX

Note: sub-entries are mainly in **chronological** order. Page numbers in *italics* indicate *specific* content of illustrations.

PICTURE CREDITS

The publishers would like to thank the following sources for their kind permission to reproduce the pictures in this book:

Front cover Corbis; spine Corbis; back cover NARA 165-A-441; title page USAMHI; frontispiece LOC; pp6-7, 8, 9 USAMHI; p10 LOC; p11 Missouri Dept of Archives & History/author's collection; pp12, 14 Library of Congress; p15 Museum of the Confederacy, Richmond VA; p16 LOC; p17 John A. Hess; p18 NARA 111-B-488; p19 LOC; p20 Rhode Island Historical Society; p21t USAMHI; p21b Museum of the Confederacy, Richmond VA; p22 Chicago Historical Society; p23 Charleston Library Society; p23t Tulane University/Louisiana Historical Collection, Manuscripts Dept; p24 USAMHI; p25t Tulane University/Louisiana Historical Collection, Manuscripts Dept; pp25b, 26t South Carolina Historical Society; p 26b LOC B8184 5141; p27 Museum of the Confederacy, Richmond VA; p28c Gulf Islands National Seashore; pp28b, 29, 30t Southern Historical Collection, Univ. of N. Carolina; p30b USAMHI; p31 NARA 77-HL-99-1; p32 USAMHI; p33 Florida State Archives FSPA 254; p34 Minnesota Historical Society; p35 Corbis; p36 Minnesota Historical Society; p36tr USAMHI; p36tl John A. Hess; p37 USAMHI; p38 LOC; pp39, 40 USAMHI; p41 Rosenberg Library, Galveston, Texas; p42 LOC; p43t,b USAMHI; p44 Corbis; p45tl, tr,br John A. Hess; p46t LOC; p46c USAMHI; p46b Corbis/Medford Historical Society; p47b USAMHI; p47t NARA 165-SB-4; p48t Corbis/James F Gibson; p48b USAMHI; pp49, 50 LOC; p51 USAMHI; p52 Kean Archive/Civil War Times Illustrated; p53t LOC; p53c USAMHI; p53b Tulane University/Louisiana Historical Collection, Manuscripts Dept; p54tr Georgia Dept of Archive and History; pp54cl, b 55t, b USAMHI; p56tr Valentine Museum; pp 56cl, br 57tl, cr, bl, 58tr, cl, bl, br, 59tl, tr, b John A. Hess; p60 LOC; p61 John A. Hess; pp62-3, 64 LOC; p65 USAMHI; p66 LOC; p67 USAMHI; p68 LOC; p69t USAMHI; p69bl, bc, br John A. Hess; p70 LOC; p70-1 Tennessee State Library; p72t LOC; p72b Chicago HS; pp73, 74t LOC; pp74b, 75 USAMHI; p76 Museum of the Confederacy neg 5105 fr.34; p77 USAMHI; p78t LOC; pp78b, 79 USAMHI; p80 Valentine Museum, Richmond; p81 USAMHI; p82 LOC; p83 USAMHI; p84tl, br Tim Landis; p85 Emory University Photographic Services Neg 16057-A; p86-7 USAMHI; p88 LOC; p89t USAMHI; pp89b, 90b LOC; p90t NARA 111-BA-1190; p91t USAMHI; pp91b, 92-3 LOC; p93tr USAMHI; p94t LOC; p94b USAMHI; p95t, b LOC B811-2433; pp96, 97t, b USAMHI; p98l Virginia Historical Society; p98-9 National Library of Medicine; pp100t, b 101, 102-3 USAMHI; p104t Missouri Historical Society; p104b Dept Archive & Manuscripts, Louisiana State Univ.; p105 LOC; p106tl Valentine Museum, Richmond; p106tc New York Historical Society; pp106-7b, 107r, 108t,b USAMHI; p109t Michigan State Archives; p109 bl William Gladstone; p109 br LOC; p110t Pensacola Historical Society; p110 b Moravian Music Foundation; pp111t, b, 112-3 USAMHI; pp114, 115 LOC; p116 USAMHI; p117 NARA; p118t Museum of the Confederacy; p118c USAMHI; p118b Duke University Library; p119 LOC; pp120-1, 122tl, bl USAMHI; p123 NARA; pp124, 125, 126t LOC; pp126b, 127t USAMHI; p127b LOC; p128t NARA B-127; pp128b, 129t, b, 130 LOC; p131 USAMHI; p132 NARA CN-8738; p133t LOC; p133b Chicago Historical Society; p134t USAMHI; p134b Chicago HS; p135 Old Courthouse Vicksburg; p136 LOC; p137t Chicago HS; p137b Minnesota HS; p138-9 USAMHI; p140tr NARA 111-B-4826; p140-1 NARA 111-B-2001; p142t, b USAMHI; p143 John A. Hess; p144t Corbis/Medford Historical Society Collection; p144b USAMHI; p145 Chicago HS; p146 LOC; p147 USAMHI; p148 LOC; p149t Mariners Museum, Newport; p149c USAMHI; p149bl LOC; p149br USAMHI; p150 Mariners Museum, Newport; p151cl Old Courthouse Museum, Vicksburg; p151t USAMHI; p151br Tulane University/Louisiana Historical Collection, Manuscripts Dept; p151t Corbis/Mariners Museum; p151cl Corbis; p152cl, br LOC; p153t,b USAMHI; p154-5 NARA B-129; p156 Apalachicola Historical Society; p156br LOC; p157t Maritime Museum of the Atlantic; p157c Naval Historical Center; pp157b, 158-9, 160, 161, 162, 163, 164t LOC; pp164b, 165t, 166 USAMHI; p167b Corbis/Mathew B. Brady; p167t Richard F. Carlile; pp168l, 168-9, 169r LOC; pp170, 171t USAMHI; p171b LOC; p172t Confederate Museum; p172b USAMHI; p173t Corbis; p173b USAMHI; p174 LOC B8184 5966; p175c USAMHI; p175b LOC; p175tr Chicago Historical Society/Alexander Gardner; p176t LOC; p176b NARA 111-B-6112; p 177 Corbis; pp 178, 179 USAMHI; p180 NARA 273-CC-951; p182-3 NARA B-544; p183br USAMHI; p184 NARA 111-B-531; p185 Valentine Museum Richmond; pp186, 187t, b, 188-9, 190, 191 LOC; pp192t, 192-3, 194t,b USAMHI; p195 Richard F Carlile; p196 Valentine Museum Richmond; p197tr US Naval Historical Center Washington; p197 LOC; p198 Minnesota Historical Society; p199t, b LOC; p200 USAMHI; p201t LOC; p201b Corbis; p202 NARA 111-B-489; pp203, LOC; p205tl USAMHI; p205bl Pensacola Historical Society; p205br Tulane University/Louisiana Historical Collection, Manuscripts Dept; p205cr NARA B-244; p206tr USAMHI; p206b Maryland Historical Society; pp207t, b 208-9 USAMHI; p210-1LOC; p212 NARA 111-B-2008; p213 Corbis Medford Historical Society Collection; p214 LOC; p215 USAMHI; p216t John A. Hess; p216b LOC; p217t, b USAMHI; p218 NARA B-119; p219 NARA 111-B-4063; p220tl USAMHI; p220br LOC; pp220-1, 222 USAMHI; p223 Corbis; p224-5 NARA 111-B-2008; p226 NARA; p227t James Heavilin; p227b USAMHI; p228tl Corbis; p228br LOC; p229 NARA; p230t John A. Hess; p230c USAMHI; p230b LOC; p231b USAMHI; p231 USAMHI; p232 LOC; p233t, b USAMHI; p234t John A. Hess; p234b Corbis; p234b Corbis/Bettmann; p235 LOC; p236 USAMHI; p237t Indiana Historical Society; pp237bl, 238t John A. Hess; p238b USAMHI; p239tl, br John A. Hess; p240t NARA B-8171; p240b NARA 111-B-8; p241 Valentine Museum, Richmond; p242t, b Corbis/Medford Historical Society; p243 Chicago Historical Society; pp244-5, 246 USAMHI; p247 NARA 111-B-595; p248 Chicago Historical Society.